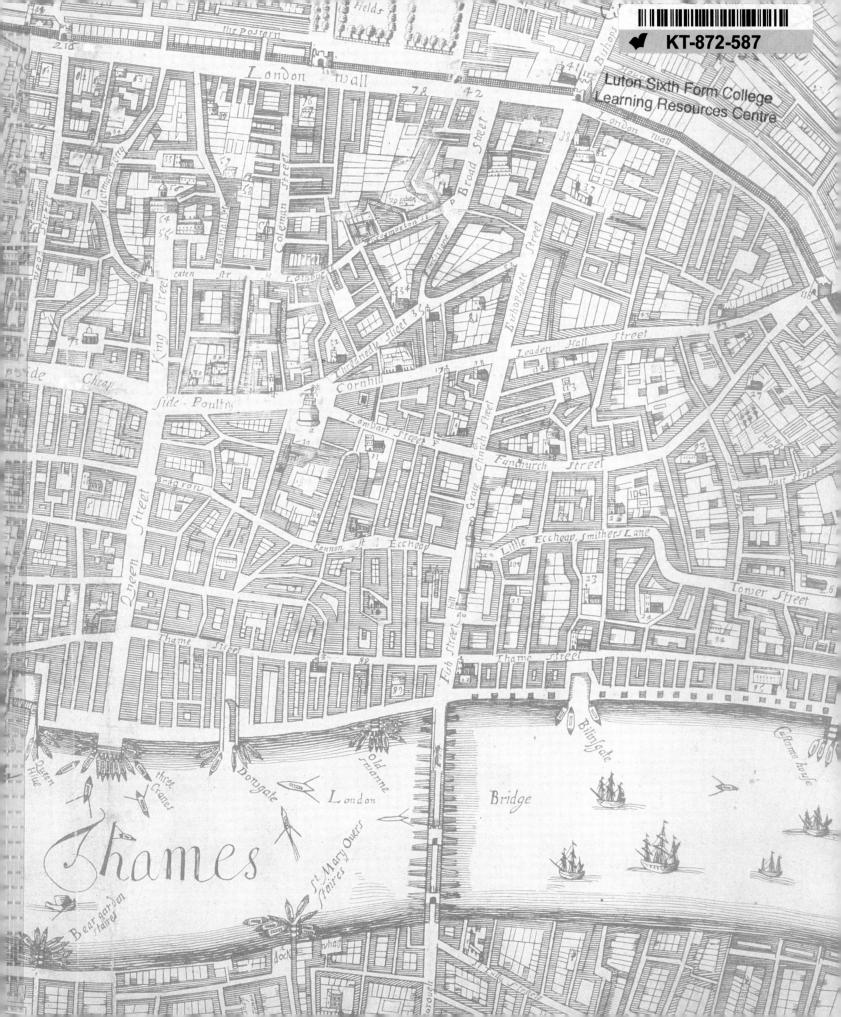

KT-872-587

Luton Sixth Form College
Learning Resources Centre

the Postern

London wall

Coleman Street

King Street

eaten Str

fide Poultry

Cheap

Broad Street

Throgmorton St.

Lothbury

Threadneedle Street

Cornhill

Lombard Street

Bishopgate Street

Leaden Hall Street

Grace Church Street

Fanchurch street

Queen Street

Bridg row

Cannon St. Eccheap

Little Eccheap Smithers Lane

Thame Street

Fish Street hill

Thame street

Tower Street

Queen Hive

three Cranes

Dowgate

Old Swanne

London

St. Mary Overs Staires

Bridge

Bilinsgate

Custome house

Thames

Bear garden staires

dock

Artists' London

Luton Sixth Form College
Bradgers Hill Road, Luton
Beds. LU2 7EW
Return on or before the last date stamped below

2 7 MAR 2007

WITHDRAWN

10064179

Luton Sixth Form College

Artists' London

Holbein to Hirst

Kit Wedd
with Lucy Peltz and Cathy Ross

MERRELL

10064179.
Luton Sixth Form College
Learning Resources Centre
709.41

This book has been produced to accompany the exhibition
Creative Quarters: the art world in London 1700–2000 at
Museum of London
London Wall
London EC2Y 5HN
30 March – 15 July 2001

Text © Museum of London
Illustrations © the copyright holders;
see right

All rights reserved. No part of this publication may be reproduced, stored in a retrieval system, or transmitted in any form or by any means, electronic, mechanical, photocopying, recording or otherwise, without the prior permission in writing from the publisher.

First published 2001 by Merrell Publishers Limited

Distributed in the USA and Canada by Rizzoli International Publications, Inc. through St Martin's Press, 175 Fifth Avenue, New York, New York 10010

A catalogue record for this book is available from the British Library

ISBN 1 85894 141 5 hardback
(*Artists' London: Holbein to Hirst*)
ISBN 1 85894 142 3 paperback
(*Creative Quarters: the art world in London 1700–2000*)

Produced by
Merrell Publishers Limited
42 Southwark Street
London SE1 1UN
www.merrellpublishers.com

Designed by Robbie Mahoney
Edited by Julian Honer, Iain Ross and Charlotte Rundall

Printed and bound in Italy

Front jacket/cover:
Tom Hunter and James Mckinnon, *London Fields East: The Ghetto*, 1994 (fig. 143), detail

All pictures not credited below form part of the collection at the Museum of London

2 By courtesy of the National Portrait Gallery, London
3 Society of Antiquaries of London
4 © Crown copyright: Historic Royal Palaces
5 The Royal Collection © 2001, Her Majesty Queen Elizabeth II
7 By courtesy of the National Portrait Gallery, London
8 The Royal Collection © 2001, Her Majesty Queen Elizabeth II
9 Photo © Woodmansterne
10 By kind permission of the Dean and Chapter of St Paul's Cathedral
11 James Philip Gray Collection, Museum of Fine Arts, Springfield, MA
12 Coram Foundation, Foundling Museum, London, UK/Bridgeman Art Library
13 The Worshipful Company of Stationers
16 Guildhall Art Gallery, Corporation of London
17 Coram Foundation, Foundling Museum, London, UK/Bridgeman Art Library
18 Derby City Museum and Art Gallery
19 Derby City Museum and Art Gallery
20 National Gallery of Scotland
21 By courtesy of the National Portrait Gallery, London
27 By courtesy of the National Portrait Gallery, London
28 © The British Museum, London
31 Archives and Museum, St Bartholomew's Hospital, London
32 Coram Foundation, Foundling Museum, London UK/Bridgeman Art Library
33 Royal Academy of Arts, London
34 Royal Academy of Arts, London
35 Royal Academy of Arts, London
36 Royal Academy of Arts, London
38 © The British Museum, London
41 Orleans House Gallery, Richmond upon Thames Borough Art Collection
42 Yale Center for British Art, Paul Mellon Collection, USA/Bridgeman Art Library
43 © Tate, London 2001
44 Guildhall Library, Corporation of London
46 Geffrye Museum, London
49 © The British Museum, London
50 Bury Art Gallery and Museum
51 The Courtauld Institute Gallery, London
52 Hildegard Fritz-Denneville Fine Arts Ltd, London
53 V & A Picture Library, London
55 V & A Picture Library, London
56 V & A Picture Library, London
57 Reproduced by kind permission of the Syndics of the Fitzwilliam Museum, Cambridge
58 Reproduced by kind permission of the Syndics of the Fitzwilliam Museum, Cambridge

59 Reproduced by kind permission of the Syndics of the Fitzwilliam Museum, Cambridge
60 V & A Picture Library, London
63 Westminster City Archives, London
64 National Portrait Gallery, Smithsonian Institute, Washington, DC
65 © The British Museum, London
66 The Courtauld Institute Gallery, London
68 Roy Davids Ltd, Oxfordshire
69 London Metropolitan Archives
70 © The British Museum, London
71 College Art Collections, University College London
73 © The British Museum, London
75 © Tate, London 2001
76 Birmingham Museums & Art Gallery
77 © Tate, London 2001
78 The Trustees of Patrick Allan-Fraser of Hospitalfield
81 The Royal Borough of Kensington & Chelsea Libraries and Arts Service
83 By courtesy of the National Portrait Gallery, London
84 © Tate, London 2001
85 National Gallery of Art, Washington, DC/Bridgeman Art Library
86 Reproduction by kind permission of the Syndics of the Fitzwilliam Museum, Cambridge
87 By courtesy of the National Portrait Gallery, London
88 William Morris Gallery, London E17 (London Borough of Waltham Forest)
89 Hunterian Art Gallery, University of Glasgow, Birnie Philip Bequest
90 © The British Museum, London
92 The Detroit Institute of Arts, USA/Bridgeman Art Library
93 V & A Picture Library, London
94 Special Collections Department, Glasgow University Library
95 By courtesy of the Estate of Sir William Orpen/National Portrait Gallery
96 Private collection
97 William Morris Gallery, London E17 (London Borough of Waltham Forest)
98 Board of Trustees of the National Museums and Galleries on Merseyside (Lady Lever Art Gallery, Port Sunlight)
100 © Crown Copyright. NMR
101 Courtesy of The Royal Borough of Kensington and Chelsea, Libraries and Arts Service
102 Reproduced by kind permission of the Provost and Fellows of King's College, Cambridge
103 By courtesy of the National Portrait Gallery, London
105 © Christie's Images Ltd, 2001
106 Nottingham City Museums & Galleries; Castle Museum & Art Gallery. © Estate of Walter R. Sickert/2001/. All rights reserved, DACS
107 Kirklees Metropolitan Council: Huddersfield Art Gallery
108 Laing Art Gallery Newcastle upon Tyne (Tyne and Wear Museums)

109 © Tate, London 2001
111 Private collection. © Estate of Walter R. Sickert/2001/. All rights reserved, DACS
112 Private collection
113 ©Tate, London 2001/ © Crown Copyright
115 © Manchester City Art Galleries
117 © The British Museum, London /Angela Verren-Faunt/2001/all rights reserved, DACS
118 Pritchard Papers, University of East Anglia
120 © Tate, London 2001/St John Wilson Trust. © June Andrews.
121 By courtesy of the National Portrait Gallery, London
122 Robert and Lisa Sainsbury Collection, University of East Anglia, Norwich © Estate of Francis Bacon/ARF, NY DACS London 2001
123 The Royal Pavilion, Libraries and Museums, Brighton and Hove
124 Nottingham City Museums & Galleries; Castle Museum & Art Gallery
125 Private collection
126 By courtesy of the National Portrait Gallery, London
127 The British Council. © Eduardo Paolozzi /2001/. All rights reserved, DACS
128 © The Tate Archive and Artist's Estate
129 © The Tate Archive and Artist's Estate
130 © Tate, London 2001 The Estate of Nigel Henderson
131 Southampton City Art Gallery, Hampshire, UK/Bridgeman Art Library
132 Kirklees Metropolitan Council: Huddersfield Art Gallery
138 Private collection
139 © Artangel 1994
140 © Tate, London 2001 c/o White Cube Gallery
141 © Tracey Emin and Sarah Lucas 2001
145 Private collection

Contents

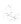

Acknowledgements

The authors gratefully acknowledge the help given by the following: Brian Allen, Ruth Applin, Wendy Baron, John Bartlett, Andrew Batt, David Bindman, Roger Bowdler, Nikki Braunton, Heidi Brittain, Julia Brown, Jon Catleugh, Michelle Chambers, John Chase, Sarah-Jane Checkland, Deborah Cherry, Michael Clark, Katie Coombes, Peter Cormack, Tim Craven, Tom Cross, Rebecca Daniels, David Evans, Torla Evans, John Fisher, Peter Funnell, Frederick Gore, Revd John Haliburton, Jonathan Harvey, Karen Hearn, Janet Henderson, Michael Heindorff, Albert Irvin, Philip Ward Jackson, Jody Lamb, Victoria Lane, Karon Lester, Tim Linnell, Margaret MacDonald, Roger Mayne, Ellen Miles, David Minckler, Bernard Nurse, David Panton, Steven Parissien, William Payne, Martin Postle, Katharine Price, Jane Riches, Colston Sanger, John Sargent, Ann Saunders, Emma Shepley, Jane Sillis, Jacob Simon, Kim Sloan, the Society of Antiquaries, Emily Stone, Richard Stroud, Pamela Tudor-Craig, Will Vaughan, Janet Wallis, Sue Webber, Alex Werner, Anthony Whishaw, Matthew Williams, Michael Willis, Sue Wilson, Hillier Wise.

Special thanks should also go to Mireille Galinou, whose commitment to the issue of art in London did so much to enhance the collection of the Museum of London.

This book has been published with the generous support of The Harcourt Group at the Museum of London:

Mrs Tessa Manser (Chairman)

Mr Adam Afriyie and Miss Romi Chitty
Lord and Lady Alexander of Weedon
Lord and Lady Ashburton
Mr and Mrs Simon Baynes
Mr and Mrs Andrew Beeson
Mr and Mrs Conrad Black
Mr and Mrs Robert Boas
Sir Richard and Lady Brooke
Mr and Mrs Charles Brown
Mr and Mrs Peter Brown
Mr and Mrs John Cousins
Mr and Mrs Padraic Fallon
Mr and Mrs Roderick Fleming
Mr and Mrs William Garrett
Sir Nicholas and Lady Goodison
Mr and Mrs Thomas Griffin
Mr and Mrs Rupert Hambro
Mr Charles Howard
Mr and Mrs Thomas Hughes-Hallett
Mr and Mrs Greg Hutchings
Mr and Mrs Peter Leaver
Mr and Mrs David Lewis
Mr John Manser
Mr and Mrs Robin Monro-Davies
Mr Christopher Moran
Mr and Mrs Anthony Oppenheimer
Mr and Mrs Charles Peel
Mr and Mrs John Ritblat
Mr and Mrs Richard Roberts
Mr Leopold de Rothschild
Dr and Mrs Mortimer Sackler
Mr and Mrs Wafic Said
Sir David and Lady Scholey
Mr and Mrs John Simpson
Mrs Mary Slack
Mr and Mrs Bernard Taylor
Mr and Mrs Richard Thornton
Mr and Mrs Leslie Waddington
Mr and Mrs Brian Williamson
Mr and Mrs Geoffrey Wilson

London's Creative Quarters: An Overview

Who were the artists and why were they attracted to that area?

How did the area influence the life and work of its artist inhabitants?

What impact did this concentration of artists have upon the independent life of the area?

By plotting this topography of London's artistic centres, and putting the presence of artists into context with other aspects of London's past, this project provides a distinctive approach to the history of art in London from 1700 to 2000. Although the artists themselves are the central figures, the story is neither solely a collection of biographies nor an account of the art-historical influences on their work. It is also a story about London itself. In different periods, artists' communities have led to the foundation of art institutions and schools, the development of exhibition spaces and commercial opportunities, and the growth of a confident viewing and buying public. From the seventeenth-century City, where painters worked under the constraints of the guilds, to the modern East End, where artists provided a model for the reuse of formerly condemned properties, the location and structure of London's artists' quarters reveal much about the capital's wider social and cultural currents.

In this survey of three hundred years of artistic movement, certain patterns and contrasts emerge. The first relates to the status and aspirations of artists within society. Until the middle of the nineteenth century most artists' aspirations were closely bound up with the need to build relationships with private patrons. This factor above all determined artistic migrations around the map of London for the first half of the period under consideration here. In the sixteenth and seventeenth centuries, status and visibility were among the key advantages of being a member of the Painter-Stainers' Company, which represented quality control and good practice, and had the power to award to all its members the Freedom of the City. The City thus provided the focus for professional activity; seventeenth-century artists who were not guild members lived in parishes immediately outside the City walls, which allowed them to practise reasonably near the recognized centre of commercial production.

The twin issues of aspiration and status became more crucial with the advent of a commercial market for art and increasing competition between those who supplied it. From the start of the eighteenth century, artists followed the migration of wealthy patrons as fashionable London moved westwards, along the Strand to the new squares of Covent Garden and Leicester Fields (Leicester Square). With no official institution to represent their needs or exhibit their works, artists banded together to define their emerging profession and collaborate in creating opportunities for self-promotion. In an era of rapid social mobility,

London's Creative Quarters: An Overview

At the beginning of the twenty-first century, London's reputation as a world capital of the visual arts has never been greater. Nor have so many artists ever before gathered in one single part of London, in this case the East End. The East End is where, over the past thirty years, thousands of painters, sculptors, photographers and designers have transformed a largely derelict industrial area into a vibrant creative quarter. Although the East End's specific influence upon the art world is new, the connection between different areas of London and artistic activity is no modern phenomenon. British and international artists have always been attracted to the opportunities provided by London, the hub of England's economic, social and legal life. For centuries they have congregated together, either living in close proximity or working in collaboration. While there is much writing on the history of art in London and on the lives of individual London artists, together with the London institutions that sold and promoted their work, no single overview has ever provided a history of the capital's creative quarters, or explored their role in the development of British art.

Accompanying the Museum of London's exhibition *Creative Quarters: the art world in London 1700–2000*, this book charts the story of these areas and the artistic communities they hosted, their growth and decline, their celebrated stars and now forgotten followers. Selecting one area of London as the focus for each period, both exhibition and book set out to explore the following key questions:

it was important for artists to emulate the apparent refinement of the patron classes in order to highlight their creative credentials and professional honesty. They dressed and lived well, rubbing shoulders with entrepreneurs and aristocrats. Even after the founding of the Royal Academy in 1768 artists remained keen to emulate the gentry, in a period when moral probity and civic propriety were the height of social aspiration.

The nineteenth century marks both the apogee of this pursuit of gentility and the beginning of a new aspirational trajectory. For the second generation of Royal Academicians, the consolidation of a West End base – this time around the newly built and respectable Newman Street – marked the formalization of their professional identity. By the later nineteenth century, the most successful artists could afford to sustain lifestyles almost indistinguishable from those of their patrons, even to the extent of determining which areas would become fashionable. In Kensington they erected 'palaces of art' in which they could work, entertain and dazzle the public with their exotic good taste. By the 1860s the Royal Academy had become so suffocating in its conservatism that some artists sought another path, one that led them even further west, away from high-society Kensington to a more easy-going Chelsea. Directly influenced by their experience of the arts in Paris, young artists who had studied abroad articulated their disaffection with the staid English system of training and practice by turning their backs on social and artistic conventions, asserting their right to produce art for art's sake, rather than for wealthy patrons' walls. Chelsea became the first of London's artists' quarters to be popularly described by the word 'Bohemian'.

The twentieth century saw the end of the painterly migration westward and a return to the centre. The new focus on central London reflected many things: tubes, trams and buses enabled artists to live, work and socialize in different parts of the city; new methods of earning an artistic living liberated artists from the need to live cheek by jowl with wealthy patrons. An increased number of commercial galleries and, more critically, the location of London's major art colleges also gave artists good reasons to look to the centre. Unlike the earlier creative quarters, such areas as Bloomsbury, Fitzrovia and Soho were not necessarily places where artists lived together, but locations where a highly charged social life could be vigorously pursued. Although artists' colonies of a residential kind continued to erupt – Hampstead in the 1930s with its concentration of archmodernists being a good example – the twentieth century seemed to herald a new type of 'lifestyle' creative quarter. It certainly consolidated the 'Bohemian' status of artists. For both Hampstead modernists and the Soho avant-garde, aspirations were firmly wedded to aesthetic rather than social ends: the patron, although still important, was no longer a figure of influence. In the final thirty years of

the twentieth century, with the great migration east, the reversal of status is complete. Now it is the patrons and dealers who are following the artists round the map of London, rather than vice versa.

In addition to exploring the artists' position in society, the exhibition and book have charted the impact of their presence on the city itself. Here, too, there are contrasts: artists have acted as forces of both regeneration and degeneration at different points in time. During much of the eighteenth and nineteenth centuries, artists had to invest considerable amounts of capital in their domestic surroundings in order to assert their success and sophistication. Consequently, they lived in fashionable areas, alongside London's middle to well-off classes. Indeed, by the late nineteenth century the erection by artists of palatial houses positively added to an area's cachet. The East End is perhaps the best example of the ability of artists to add value to property by bestowing an aura of fashion on a place. However, the presence of artists in an area has at times depressed property values. The once fashionable Newman Street had degenerated by the 1820s, as houses that had at one time been home to successful artists were subdivided into apartments and garrets. Support trades, schools and hacks capitalized on the former reputation of Newman Street and precipitated its decline into an area perceived as commercial rather than respectable. The decline of Newman Street mirrored the decline that had already seen Covent Garden and Leicester Square fall from respectability: here, as in Newman Street, the arrival of hopeful and often penniless artists in search of cheap rooms had contributed to the process of decay.

One further theme this project has addressed is the artistic response to the chosen creative quarter. In some periods, particularly when artists' thoughts are keenly fixed on the theory and politics of their profession, the art that emerges from an area shows little interest in place. Although all of London's creative quarters are characterized by their intellectual interaction and their support systems, some of them have arisen because of the particular local scenery or general ambience they offered. This is particularly true of Hampstead in the early nineteenth century and Camden Town in the early twentieth. It is also to some degree true of the East End in the late twentieth century, some of the artists who live and work there drawing inspiration from the rich visual stimulation provided by an intensely varied physical environment. But the story of London's creative quarters is not a simple one of artists obediently depicting the sights that surround them. What this book and exhibition hope to show is that the effect of London on its artists is far more complex than the merely topographical.

The City in the 17th century

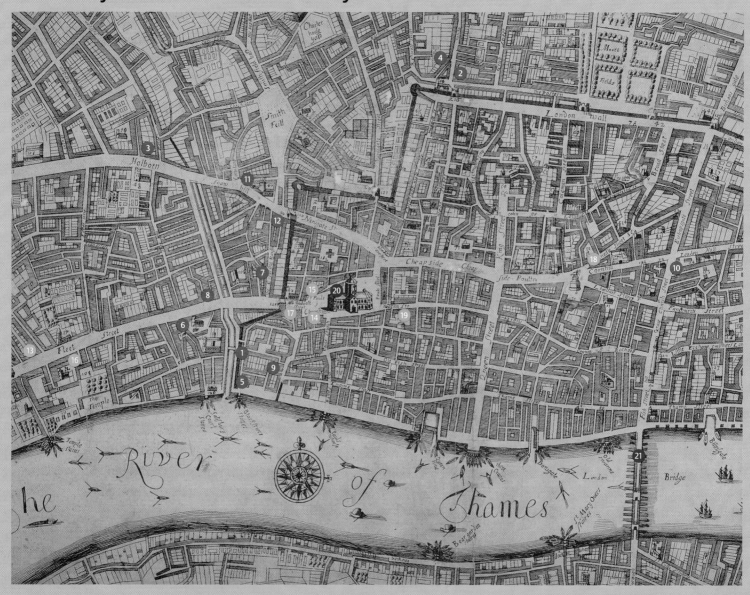

Studios & homes

1. Cornelius Johnson
St Ann Blackfriars, 1625

2. Robert Streeter
St Giles Cripplegate, 1630s

3. De Critz family
St Andrew Holborn, 1630s

4. George Gower
St Giles without Cripplegate, 1580s

5. Anthony van Dyck
Blackfriars, 1630s

6. Laurence Hilliard
St Bride Fleet Street, 1610s

7. Isaac Oliver
Fleet Street, c. 1561

8. Rowland Lockey
Fleet Street, 1565–1616

9. Miniaturists' quarter
St Ann Blackfriars

10. Hans Holbein
St Andrew Undershaft, Cornhill, 1532

11. William Larkin
St Sepulchre without Newgate, Holborn, 1590s

12. Robert & William Peake
Holborn Conduit, Snow Lane, 1610s–1620s

Supporting trades & organizations

13. John Calfe
St Luke's Head without Temple Bar, 1690s

14. John Gipkym Senior
The Spread Eagle, St Paul's Churchyard, 1550s

15. Thomas Bowles
St Paul's Churchyard, 1691–1767

16. Peter Stent, 1665–69
John Overton & Sons, 1640–1713
Whitehorse without Newgate

17. Christopher Browne
The Globe, Ludgate Street, 1688

Meeting-places

18. The Royal Exchange
1566–

19. Painter-Stainers' Hall
9 Little Trinity Lane, est. 1532
rebuilt 1670

Inspiring sites & architecture
20. St Paul's Cathedral
21. London Bridge

Robert Walton
England's Glory, A new mapp of the City of London
1676

1560–1690
From the City to the West End

1560–1690
From the City to the West End

The art world between City and Court

London's first artists' quarters developed out of necessity rather than free choice. Within the City of London, the painter's trade, like most other crafts, was controlled by a guild. Most of these guilds, or livery companies, had medieval origins and their jurisdiction was tailored to the dense social and commercial fabric of the ancient City. From the early sixteenth century it was the Painter-Stainers' Company, an amalgamation of two thirteenth-century guilds, that attempted to police the privileges and livelihood of painters living within the City walls (fig. 1). At the time of the Company's incorporation, in 1581, membership was open to any appropriately trained Englishman who wielded a brush loaded with colour, from a 'limner', or miniaturist, to a painter and decorator of domestic interiors. Those who painted pictures to be framed and hung might be referred to as a "picture maker", and the categories of painter admitted to the Painter-Stainers' included "Face painters [portraitists], History Painters, Arms [heraldic] Painters and House Painters".[1] Inside the City walls the Painter-Stainers' tried to run a closed shop, which excluded foreigners, and insisted that only their liverymen could work as painters. Membership, or the lack of it, determined where an artist arriving in London could expect to settle and work.

Painters who did not qualify for membership of the Painter-Stainers' Company tended to congregate just outside the walls that defined the western edge of the City. Artists' quarters sprang up in the parishes of St Giles Cripplegate; St Andrew Holborn; St Sepulchre without Newgate; St Bride Fleet Street – and, from the 1630s onwards, in the newly created parish of St Paul Covent Garden. These inner suburbs offered several advantages; they were less cramped and crowded than the poorly lit alleys and streets within the walls; they were nearer to the Court at Westminster, and therefore closer to royal and aristocratic patrons; and, crucially, they were beyond the control of the Painter-Stainers' and yet a stone's throw away from the commercial, legal and ecclesiastical heart of the country.

Each of these parishes had its own distinct flavour that was largely determined by the dynastic nature of the art world, in which established workshops passed to sons, or sons-in-law, for many generations. So, for example, the presence of the Flemish De Critz family and their compatriots made St Andrew Holborn a cosmopolitan place. Similarly, St Ann Blackfriars was the prime parish for miniaturists, possibly because the river helped provide the "great and fair" light that Nicholas Hilliard (c. 1547–1619) advised his brother limners to seek out.[2] Although St Ann Blackfriars was just inside the City walls, it was one of the "liberties" whose residents were free of some of the restrictions, searches and taxes imposed by the City companies. These freedoms had occasionally to be asserted, and the authorities slapped down: in 1580 the inhabitants of the Liberty of Blackfriars petitioned Queen Elizabeth I to allow "all artifficers & Craftesmen whatsoeuer (although theie be no free men of the Cittie) lawfullie to exercise there trades, misteries & occupacons without controllment of the maior or other officer of the cittie".[3]

The parish of St Giles Cripplegate (where the Barbican and the Museum of London now stand) was especially noted for the numbers of artists who lived there. By the late sixteenth century over a hundred parishioners described as "painter" appear on the parish registers. This number can be explained by the presence in or near the parish of several Serjeant-Painters, including William Herne (died 1580) and George Gower (died 1596), who employed "a companie of painters" to help carry out their complex and labour-intensive commissions.[4] Serjeant-Painters were appointed by the monarch and generally held the post for life. It was no sinecure. The Serjeant-Painter was responsible for all the interior and exterior painting and decorating of the royal palaces, for heraldic devices on ceremonial furniture and fittings, for designing scenery and decorations for special occasions, and even for the painting of such practical items as fire buckets. The Serjeant-Painter probably spent much time at Court, where he served as the Painter-Stainers' ambassador, and picked up commissions to dispense among members. Gower supervised a large team of men who were kept busy painting, graining, whiteleading, distempering and gilding throughout his fifteen-year tenure of the office.[5]

1
Anon. (Dutch School),
London from Southwark,
c. 1630, oil on panel,
57.7 × 85.7 cm, London,
Museum of London

One noteworthy fact about the painter population of St Giles Cripplegate was that they were largely English citizens but not all were members of the Painter-Stainers' Company. Despite the parish being outside the City walls, the Serjeant-Painters chose to practise in the space, ventilation and light afforded by this precinct. Subsequent generations were attracted by the industry and infrastructure thus established.

Since few foreigners were eligible for membership of the Painter-Stainers', they too ended up in free parishes, such as Blackfriars and St Giles, where they could be close to the centre of commerce yet still at liberty to practise. Waves of immigration followed successive wars and political upheavals on the Continent. As a Protestant stronghold, London provided a safe haven for large numbers of religious refugees fleeing The Netherlands and France. Although these immigrants set up their own communities they did not live in ghettos, and since many were involved with artistic professions they quickly had a lasting impact on the quality and design of London's luxury goods.

By the mid-sixteenth century, the competition from foreign artists was increasingly marked. Rather than nurture native artists, England's courtiers were seduced by the comparatively impressive images they saw when they travelled abroad. Hans Holbein the Younger (1497–1543) is the most famous example of the Court's international taste, particularly in portraiture. Invited in 1526 to join Thomas More's household, Holbein was later seconded to the service of Henry VIII, granted dwelling near Covent Garden and given licence to work beyond the reach of the powers of the guild.

Holbein had an enormous impact upon the artistic image of the English aristocracy. There was no native artist available to take his place, however, and his successors at Court, Guillim Scrots (died 1544) and Hans Eworth (*fl. c.* 1540–1574), were both Netherlandish. Although there was some cross-fertilization, the perpetuation of the apprentice system meant that English painting was often isolated and parochial. Matters were not helped by the migration of artists such as Cornelius Johnson (1593–1661; fig. 2), who was born in London to a family of Dutch refugees but who was probably sent to Holland to train.[6] The comparative sophistication of Dutch art was even more marked around 1616 to 1620. It was at this time that the Dutch-born and -trained portrait painters Daniel Mytens (1590–*c.* 1647) and Paul van Somer (*c.* 1576–1621/22) elected to come to London to exploit a gap in the market.

While the Court followed Continental taste, little is known of the interests and preoccupations of the merchant classes. *Preaching at St Paul's Cross* (fig. 3), painted *c.* 1616–21

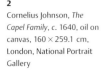

2
Cornelius Johnson, *The Capel Family, c.* 1640, oil on canvas, 160 × 259.1 cm, London, National Portrait Gallery

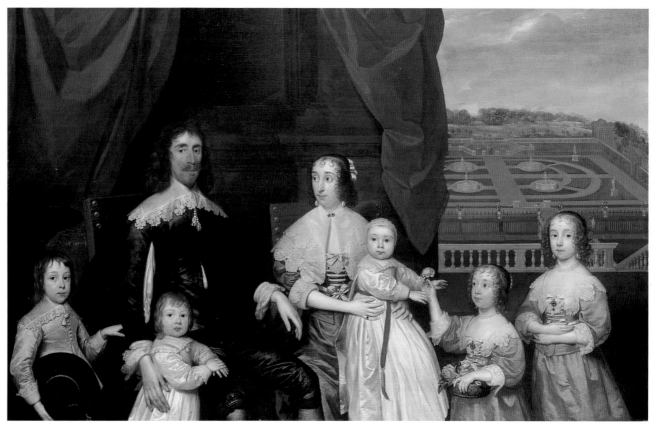

by John Gipkym (born *c.* 1565), is a unique surviving example of a different type of art. It depicts one of the weekly sermons given outside old St Paul's Cathedral, on this occasion to an audience that included James I. It was commissioned by Henry Farley, who was a member of the Scriveners' Company, to accompany a pamphlet he had written called *The Complaint of Paules, to all Christian Soules* (1616). Gipkym's diptych was intended as part of Farley's propaganda to raise support for the rebuilding of St Paul's, which had lost its spire in a fire in 1561. The painting's literary basis is representative of the interests of the place depicted: St Paul's Churchyard was the centre of London's publishing trade, and, with the preacher's sermons echoing in the air from Paul's Cross, it was a place of rhetoric.[7] Gipkym's publisher-father had a stall in St Paul's Churchyard around 1551,[8] and despite his foreign (probably Flemish) nationality he managed to achieve liveried status within the Stationers' Company. Although he was deaf and dumb, the younger Gipkym managed to claim membership of the Stationers' by patrimony, and was able to transfer to the Painter-Stainers' late on in his career.[9] This unusual training may account for Gipkym's uncertain perspective and the way he has arranged the crowd in ranks of faces – derived from medieval systems of organizing pictorial space. It also suggests how unaware a Londoner might be,

despite the circulation of engravings, of the works of Continental contemporaries such as Rubens (1577–1640), Velázquez (1599–1660) and Frans Hals (1581/85–1666). While the Netherlandish Paul van Somer (*c.* 1576–1621) and Daniel Mytens (1590–1648) worked for the most discriminating collectors at Whitehall, such artists as John Gipkym satisfied the rougher taste of their City patrons. Nevertheless, despite Gipkym's training as a printer, by the end of his career he was receiving charity from the Painter-Stainers', who thus signalled their acceptance of his art.

The protectionist instincts of the Painter-Stainers' led them to form policies that limited any professional interaction between native and immigrant artists. They instigated a series of regulations that prevented the employment of foreign-born apprentices, permitted only denizens of the City to open new shops, and forbade the employment of more than four alien servants.[10] The stale artistic environment thus created actually made it harder for native painting to flourish, leading to the complaint that the English were "constrayned, if we wyll have any thinge well paynted, kerved, or embrawdred, to abandone our own countraymen and resorte unto straungers".[11]

Despite the sustained lobbying of the Painter-Stainers' against "strangers using our art of painting",[12] they received

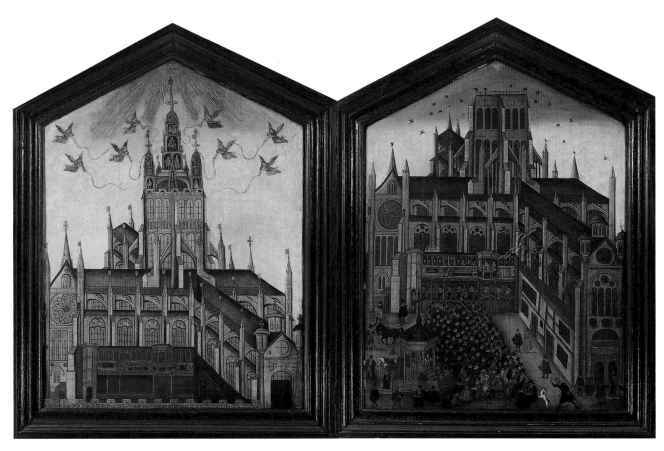

3
John Gipkym, *Preaching at St Paul's Cross*, diptych, *c.* 1616–21, oil on panel, 132.5 × 204 cm, London, Society of Antiquaries

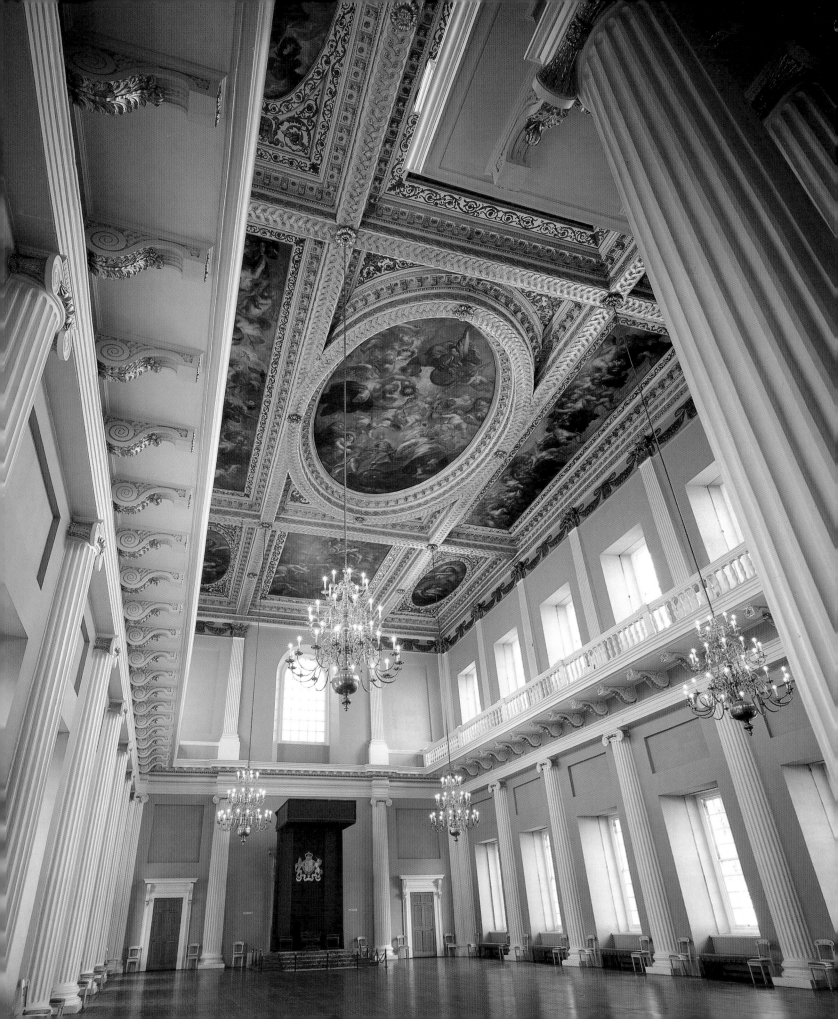

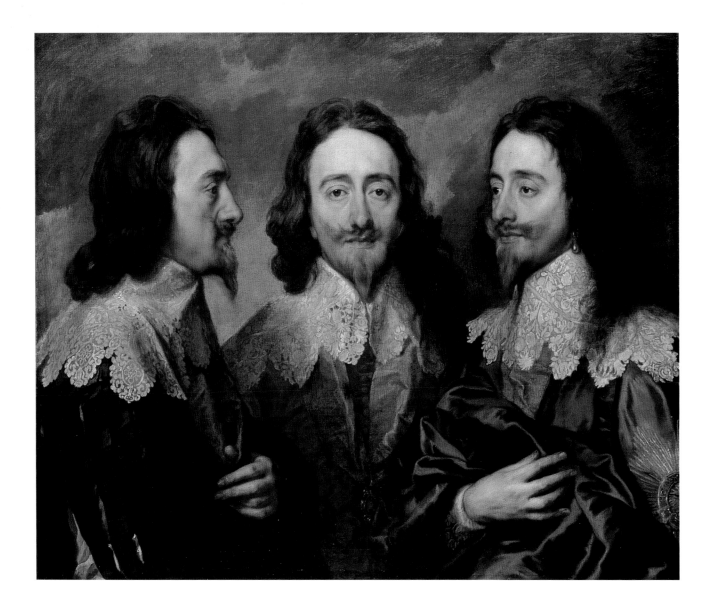

little support from the Crown. Indeed, the Crown was at the heart of their problem. Charles I conceived his own public identity in direct competition with his Continental counterparts, and commissioned an international pantheon of artists to style his public image. Inigo Jones (1573–1652), although a member of the Company, trained in Italy and returned to revolutionize architecture and theatre design through his work at court. When he built the Banqueting House (completed 1622), he gave an Italian Renaissance focal point to the "ill-built ... heap of houses"[13] that then constituted the Palace of Whitehall, thus providing the monarch with a golden opportunity to commission art on a grand scale. James I instigated the commission for Rubens, and Charles I made the most of this opportunity when he revived the scheme for a complex allegorical ceiling decoration to adorn the Banqueting House (1630–34; fig. 4).

Charles was a connoisseur and a discerning patron whose sophisticated, Continental tastes were given full rein in a programme of patronage that was as wide-ranging as his limited means would allow. Sir Anthony van Dyck (1599–1641) was another royal protégé, and one of the many foreigners who settled comfortably in the Liberty of Blackfriars, safe from guild intervention and under licence to the Crown. He worked in England between 1632 and his death in 1641, and lived in some style at his house by the Thames, where the Crown paid the rent and subsidized improvements such as "a new Cawsey way and a new paire of Staires" built at a cost of £20 so that the King could alight from the royal barge and enter the house via the garden when he came to inspect work in progress, on one of several royal portraits (fig. 5), in the summer of 1635.[14]

Royal patronage was problematic, however. For one thing, there was relatively little of it. Parliament was unsympathetic to the King's requests for money, regarding his collecting as fatally indicative of extravagance, absolutism and popery. For another, the absence of any other significant patrons meant that the King and his courtiers' fondness for foreign artists made it more difficult for native-born artists to compete. In 1627 the

4
The Banqueting House, Whitehall Palace, showing Sir Peter Paul Rubens's allegorical paintings (1630–34, oil on canvas) of the reign of James I

5
Sir Anthony van Dyck, *Triple Portrait of Charles I*, 1635, oil on canvas, 84.5 × 99.7 cm, The Royal Collection

Painter-Stainers' petitioned the King with a complaint about his employment of certain painters, including Mytens, Gentileschi, Van der Doort and Steenwijck, which constituted a threat to their livelihood.[15] A third problem was that, apart from the insatiable demand for portraits among a broader section of English society, the habit of collecting and commissioning paintings was principally confined to the Court. England's limited interest in art at this time is demonstrated by the fact that most of the important Old Master works collected by Charles I were eventually dispersed to foreign purchasers.

The period of the interregnum is not a high point in the story of English art. In the wake of Charles I's connoisseurship

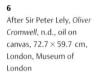

6
After Sir Peter Lely, *Oliver Cromwell*, n.d., oil on canvas, 72.7 × 59.7 cm, London, Museum of London

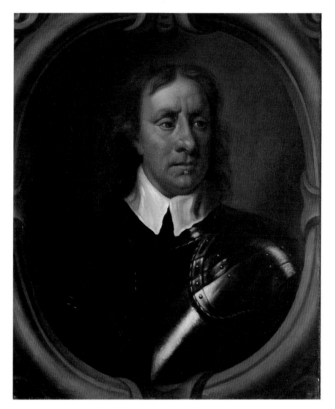

and relative ostentation, the ensuing generation tended to keep a lower profile, using artists principally to bolster their own propaganda, especially through engravings, which could be more widely enjoyed than paintings. The German–Dutch origins of Peter Lely (1618–1680) may have helped him work through the interregnum with little apparent fear of being accused of disloyalty by either royalists or parliamentarians (fig. 6). His long career survived the Commonwealth and he went on to become the pre-eminent portrait painter in the court of Charles II. After the Restoration, something of the fashion for fine art returned to London, and with it some of the loyal artists who had fled on

the heels of the Crown and its supporters. William Aglionby's relief was palpable when he proclaimed that "with our King Charles the second ... all Arts seemed to return from their exile".[16]

Born in Lübeck and trained in Holland, Sir Godfrey Kneller (1646–1723) arrived in England at the age of thirty after spending some years in Italy. After a brief period positioned conveniently near Whitehall Palace in Durham Yard, Kneller needed new premises, expressly to accommodate his fast-growing business. Following the ongoing dynamic of fashionable London, he took a grand property in Covent Garden Piazza.[17] Not only had he stepped directly into the shoes of the recently deceased Lely, who had previously cut a figure in the Piazza, but Kneller was quick to cultivate his landlords, the Russell family, as his staunchest patrons (fig. 7). By the end of his career, Kneller had run a busy studio, been master of the Painter-Stainers' Company, and had painted ten international monarchs. The knighthood bestowed on him in 1692 confirmed his place as chief image-maker to the Establishment. Anyone of standing or importance in Stuart England sat for Kneller, and despite his foreign birth he became a national institution in his own right.

Covent Garden and the commerce of art

At the start of the eighteenth century the London art world was still in a 'primitive' state. The economy, however, was prospering, and London's artists looked for ways to capitalize upon this. The traditional patrons – royalty and the landed élite, who wanted large-scale paintings to record their dynastic inheritance and decorate their vast mansions – did not disappear, but their influence was tempered by the arrival of a new group of people who had disposable income. The new patrons were more likely to be lawyers, doctors or businessmen furnishing smart town houses in the West End. Rich on the fruits of trade, commerce and speculation, these prosperous city gents wanted shipping and trading scenes to celebrate the sources of their wealth, English landscapes to reinforce their patriotism, and genre scenes or views of London landmarks that reflected the energy and excitement of metropolitan life.

The peculiarly British combination of Protestant religion and constitutional monarchy had cut British art off from mainstream European tradition. The Reformation had removed any demand for the Assumptions, Depositions and Stations of the Cross that were the bread-and-butter trade of Italian and French painters. If the Church did nothing to promote a native school of painting, royalty, as we have seen, did little more. Charles I's lavish patronage of the visual arts had been a key factor in his downfall; his successors were, understandably, more circumspect. This lack of significant Church or State patronage left British artists in limbo, envious and resentful of their Continental counterparts. However, they still aspired to the sort of complex,

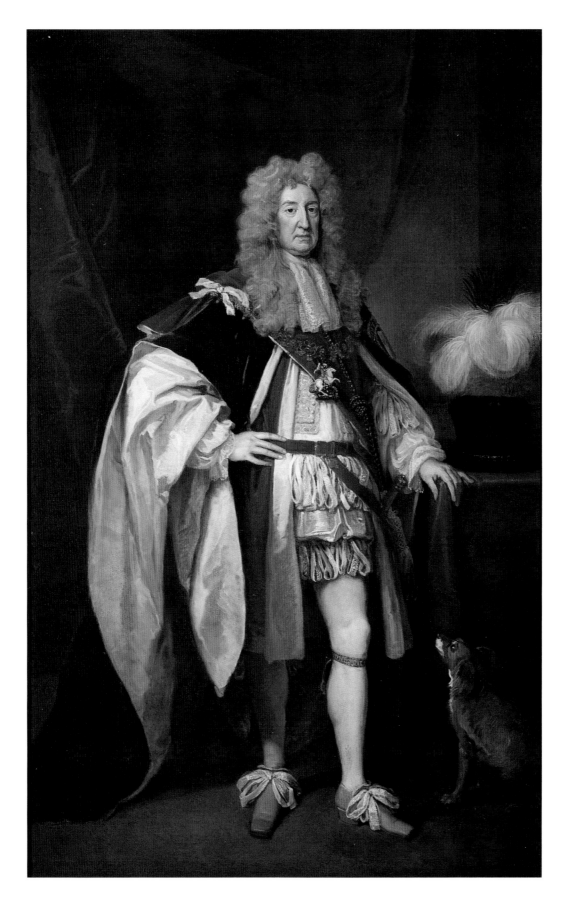

7
Sir Godfrey Kneller, *William Russell, 1st Duke of Bedford*, 1692, oil on canvas, 245.1 × 153.7 cm, London, National Portrait Gallery

8
Antonio Verrio, *The Sea
Triumph of Charles II*,
1674–75(?), oil on canvas,
Surrey, Hampton Court
Palace

narrative 'history painting' that Renaissance conventions promoted as the pinnacle of artistic achievement and proof of an artist's moral and intellectual standing.

Worse still, when such complex commissions did occasionally occur they went to foreign painters. Lacking the training or experience to undertake large-scale decorative schemes, two generations of British painters could only watch grudgingly as the Italian Antonio Verrio (1639–1707) was hired to decorate Windsor Castle and Hampton Court (fig. 8), the Frenchman Louis Laguerre (1663–1721) worked at Chatsworth and Blenheim, and more Italians, Sebastiano Ricci (1659–1734) and his nephew Marco (1676–1730), seemed to get in first everywhere else.

In 1715 Sir James Thornhill (1675/76–1734) began to redress the balance when, with much patriotic determination and the help of Archbishop Tenison, he eventually won the prestigious commission to decorate the dome of St Paul's Cathedral (1715–21; fig. 9) in a competition against Giovanni Antonio Pellegrini (1675–1741).[18] The commissioners had been slow to decide, and the battle between Thornhill and the Italian had been waged since 1710. Tenison, however, was adamant that an Englishman should win. Well aware of the significance of the St Paul's commission, Thornhill's decision to depict himself at work on a religious painting (fig. 10) may reflect his preparations for the dome, which depicts eight scenes from the life of St Paul.

This was the kind of portrait that the newly confident 'middling sort' of patron came to identify with: a contemporary celebration of achievement that reeked of self-promotion but did not idealize. The impassive oval face of the seventeenth-century aristocrat – the decorous mask of civic propriety worn by Kneller's lords – was dropped to reveal the individual, expressive features beneath. Flowing robes, Italianate landscapes and allegorical props designed to suggest a timeless Classicism were replaced by contemporary dress, domestic interiors and the material goods of a nascent consumer society. A conversation piece painted c. 1736 by Gawen Hamilton (c. 1697–1737) shows James Porten, a businessman from Putney, and his family playing cards and taking tea (fig. 11). The pompous architectural background may be fancifully aspirational, but the fine furniture, silver and porcelain that the family are using are all believable evidence of the material comfort that the Portens actually enjoyed.

Naturally, the modern, urban man of wealth and taste wanted to join the portrait-owning tradition of the upper classes, but on his own terms, by commissioning portraits that emphasized a bourgeois version of civic duty and social responsibility. The man who could not claim descent from a long line of gentlemen relied instead on charitable deeds to endorse his status, good breeding and honesty, and thus cancel out the vulgar associations of commerce. For his portrait of Captain

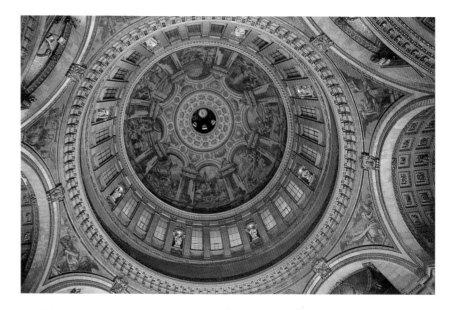

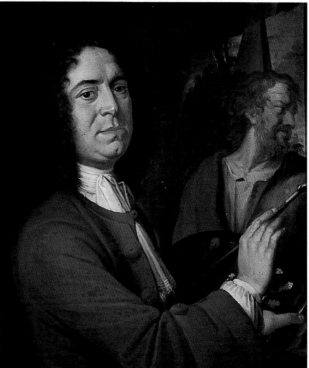

9
Interior of the dome of St Paul's Cathedral, with Sir James Thornhill's grisaille scenes from the life of St Paul, 1715–21

10
Attr. Sir James Thornhill, *Sir James Thornhill at Work*, c. 1710–15, oil on canvas, 94.8 × 82.8 cm, London, St Paul's Cathedral

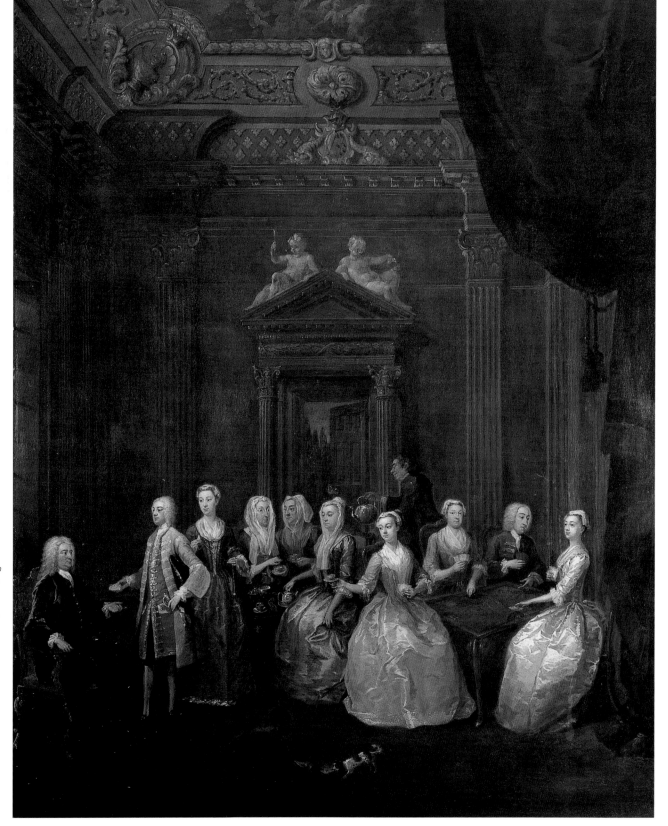

11
Gawen Hamilton, *The Porten Family Group*, c. 1736, oil on canvas, 125 × 100.4 cm, Springfield MA, Museum of Fine Arts, James Philip Gray Collection

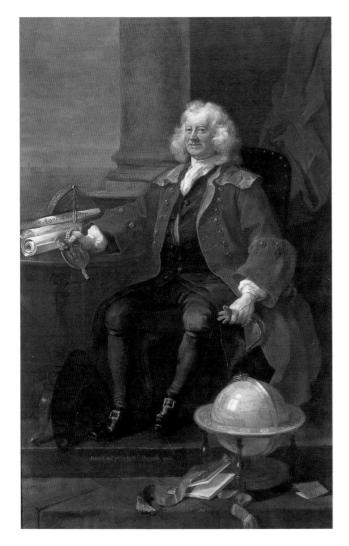

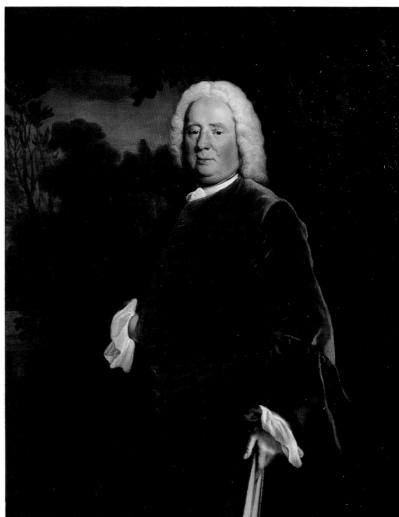

Thomas Coram (1740), William Hogarth (1697–1764) chose to employ a Baroque composition and handling to dignify this retired seafarer and philanthropist (fig. 12). Juxtaposing the Foundling Hospital's royal seal with the prominently placed globe, the portrait alludes to the fortune Coram made in shipbuilding and transatlantic trade that enabled him to found the Hospital, one of the great charitable undertakings of the eighteenth century.

In this world of confident achievers, successful entrepreneurship could more than compensate for humble birth, as the portrait of Samuel Richardson painted in 1747 by Joseph Highmore (1692–1780) intimates (fig. 13). Richardson was the self-published author of the first novel, *Pamela*, which took London by storm in 1740–41. Highmore shows the novelist dressed in a plain red velvet coat and with "nothing severe or forbidding" in his countenance, casually holding a book with his finger marking the page: an image not of aristocratic scholarship but of best-selling literary celebrity.

By now the focus of artistic activity in London had moved decisively westwards. The exodus of artists from the City was recorded by the engraver George Vertue (1683–1756) in his note that "formerly it seems many skillful Painters livd in Black Fryers. before Covent Garden was built" (fig. 15).[19] No area of London represented the vigour and energy of modern urban life better than Covent Garden. It had been developed in the 1630s as a high-class suburb for the nobility, and two hundred years later, when John Thomas Smith wrote *Nollekens and his Times* (1829), the memory of Covent Garden's former glory still inspired reverence as "the first square inhabited by ... persons of the first title and rank".[20] Such was its appeal that within a few years it was attracting a more mixed population, and this included painters and engravers. Robert Streeter (1621–1679) is an early example of a young painter who recognized that location was everything. The son of a painter, he was born in the parish of St Giles, but by 1640 was living with his family in Long Acre. He was working for

12
William Hogarth, *Thomas Coram*, 1740, oil on canvas, 239 × 147.5 cm, London, The Foundling Museum

13
Joseph Highmore, *Portrait of Samuel Richardson*, 1747, oil on canvas, 124.5 × 99.6 cm, London, The Worshipful Company of Stationers

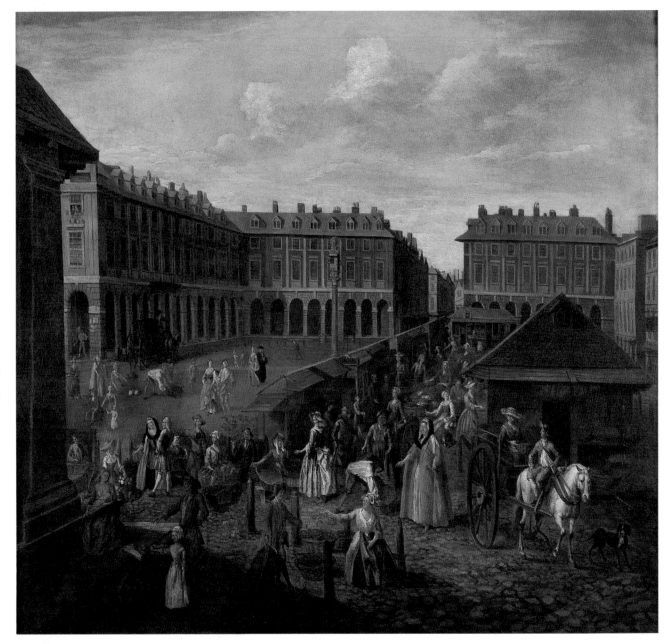

14
Joseph van Aken, *Covent Garden Piazza*, c. 1720–30, oil on canvas (before cleaning), 96 × 100.6 cm, London, Museum of London

the King in 1662 when, explaining that the development of his business was hindered by lack of space, he successfully applied for permission to erect a brick building "for his habitation and Workehouses" on a sizeable (50 × 200-feet or 15.24 × 60.96-metre) "wast peice of Ground" on the north side of Long Acre.[21] The investment evidently paid off: Streeter was appointed Serjeant-Painter in 1663. His son, also called Robert, became Serjeant-Painter upon his father's death and inherited the Long Acre property, together with all his father's "Prints Drawing and Plaister-Peeces [i.e. casts] belonging to my Trade".

Sons inheriting their fathers' property and position was commonplace at the end of the seventeenth century. More interesting is the legacy of certain London buildings or sites that seem to have attracted different artists in successive generations. Lely had a "busy portrait factory"[22] in the fifth house on the northeast side of the Piazza. It is unclear whether it was the same house or its neighbour that Kneller moved into in 1682, but we do know that Thornhill moved into Kneller's house in 1718, sixteen years after the German had moved to 55 and 56 Great Queen Street.[23] Although forty years separates the two, both men moved to Covent Garden Piazza at a time when their business and profile were massively increased. Certainly they needed the space and appreciated premises that were already adapted to their profession, but how much were they also attracted to buy into the fame of the previous residents? It is clear that a house and studio on the Piazza were something that a painter aspired to from the earliest years of the eighteenth century.

The side streets surrounding the Piazza were also populated with artists, but often ones who could not afford to live on the Piazza itself. Tavistock Row ran westwards from Henrietta Street, a little to the north of Tavistock Street (built c. 1704). One of its first inhabitants was the Dutchman Willem Vandevelde the Younger (died 1707), a court painter specializing in sea battles.[24] The marine painter Samuel Scott (c. 1702–1772) also lived at 4 Tavistock Row from 1718 until 1747, when he moved to a larger house just around the corner in Henrietta Street. Although he did produce some cityscapes, Scott specialized in shipping scenes (fig. 16), a profitable niche market at a time when Britain's sea power was a source of immense national pride and individual wealth. Until the building of the Adelphi in the 1760s the Strand still marked the line of the riverbank and offered views of the busiest wharves on the Thames frontage, so Scott's subject-matter was two minutes' walk away.

Covent Garden had been home since 1656 to London's most thriving fruit and vegetable market. It was an urban spectacle in its own right – teeming with life, it provided painters with irresistible subject-matter right on their own doorsteps. Joseph van Aken (c. 1699–1749) painted the bustling market at close quarters several times in the 1720s (fig. 14). Balthasar

15
Wenceslaus Hollar, *Covent Garden Piazza*, c. 1647, etching, 15.5 × 25.7 cm, London, Museum of London

16
Samuel Scott, *The Thames with Montagu House, from near Westminster Bridge*, c. 1749, oil on canvas, 68.6 × 118.1 cm, London, Guildhall Art Gallery

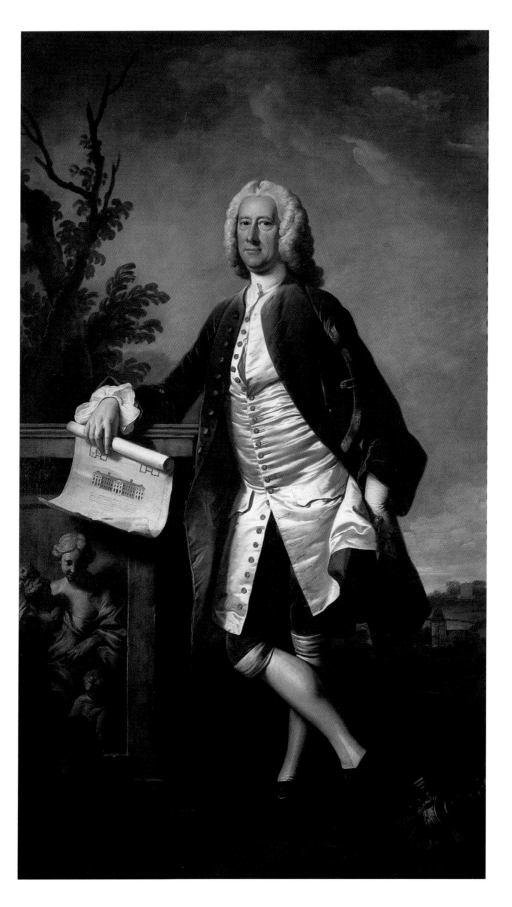

17
Thomas Hudson, *Theodore Jacobsen*, 1746, oil on canvas, 235.6 × 136.8 cm, London, The Foundling Museum

Nebot (*fl.* 1730–after 1735) painted wider views across the Piazza with St Paul's Church in the background; the same format was adopted by John Griffier the Younger (*fl.* 1738–1775) in the 1740s, Samuel Scott between *c.* 1749 and 1758, and John Collet (1725–1780) in the 1770s, for celebrations of urban scenery and trade that were nicely calculated to appeal to the London art market, and in particular to the owners and residents of the individual buildings depicted.

While urban life and social juxtapositions were visually exciting, their attraction was incidental to the evolution of the principal artists' quarter of the eighteenth century. Although artists did record street life in Covent Garden, they did not move to the area for this visual stimulation. Artists had their personal aspirations as well as commercial instincts. On the road to refinement, they followed their wealthy patrons and continued to fetch up in Covent Garden.

In 1746 the fashionable current carried Thomas Hudson (1701–1779) from Lincoln's Inn Fields to Great Queen Street, on the eastern fringe of Covent Garden close to the Inns of Court. Here he spent the next fifteen years turning out portraits and taking in apprentices from the provinces – including Joshua Reynolds (1723–1792), who from 1740 paid Hudson £120 per annum for the privilege of studying with the most successful portrait painter in London (fig. 17). Another was Joseph Wright (1734–1797), who returned to impress his native Derby with the training and sophistication that only a London apprenticeship could bestow (fig. 18). Hudson's pupils all learned their way around Covent Garden as they ran errands and carried their master's canvases to and from the drapery painter Joseph van Aken (*c.* 1699–1749) in King Street (this ran north towards Bloomsbury from Long Acre and was swept away by the building of Shaftesbury Avenue). It was just such a delivery that caused Reynolds to split from Hudson. One biographer records the occasion when Reynolds delayed his errand because of pouring rain, and Hudson was so incensed by this insubordination that he flew into a rage and terminated Reynolds's apprenticeship.[25]

It was essential for artists to live in close proximity to one another because nearly every painting was the product of collaboration between the face painter, his drapery man, and perhaps one or two others who filled in the background or the sky. For some artists, filling in the background for a more established painter was a stepping-stone to greater things. Many of the landscape backgrounds to portraits by Francis Hayman (1708–1776) during the 1750s were painted by the young Thomas Gainsborough (1727–1788).[26] He was one of several, as one journalist noted in 1766: "Mr Hayman's backgrounds have frequently been executed by a variety of hands; and it is well known that Mr Hudson, Mr Cotes, and several other painters of the first reputation seldom, if ever, finish an atom

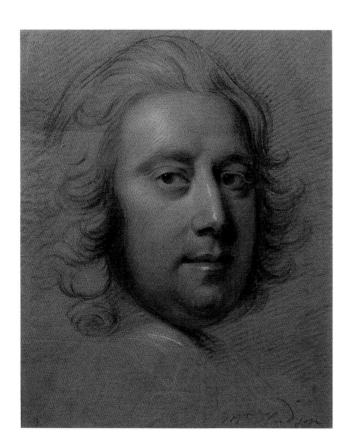

18
Joseph Wright of Derby, *Portrait of Thomas Hudson*, *c.* 1751, black and white chalk on blue paper, 38.1 × 31.1 cm, Derby, Derby Museum and Art Gallery

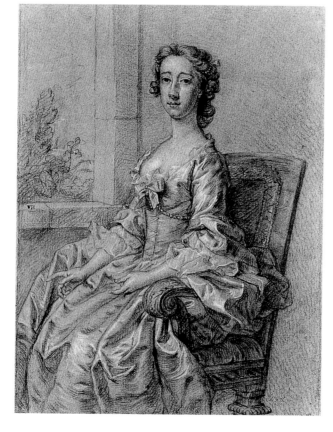

19
Studio of Allan Ramsay
(possibly by Joseph van
Aken), *Studies for the
Blackwood and Mansel
Children*, c. 1742, black
chalk and white highlights
on blue paper,
28.3 × 42.2 cm, Derby,
Derby Museum and Art
Gallery

20
Joseph van Aken, *A Young
Lady Seated near a Window*,
c. 1745, black and red
chalk, 59 × 44 cm,
Edinburgh, National
Gallery of Scotland

more than the face of their portraits".[27] Not every assistant could
be a Gainsborough, however, and one who was happy to accept
a supporting role was Van Aken, who arrived in London from his
native Flanders in 1720. In his early twenties he showed some
flexibility by moving between Dutch-influenced genre painting,
conversation pieces and London scenes, but soon abandoned
his attempt to make a career as an independent painter, finding
it more profitable to concentrate on painting drapery for
other artists.

Van Aken's anonymous art brought him great wealth
(figs. 19 and 20). He worked for Hudson and his rival, the Scot
Allan Ramsay (1713–1784), both of whom were described as "my
ffriends" when he named them as executors in his will.[28] He also
painted for Highmore, Hogarth and so many of the other success-
ful portrait painters of the 1740s that Horace Walpole remarked,
"As in England almost everybody's picture is painted, so almost
every painter's works were painted by Vanaken".[29] Surviving
drawings suggest that Ramsay gave detailed instructions about
how he wanted Van Aken to pose and dress his figures; others
were happy merely to supply the face – sometimes cut out and
tacked on to a larger canvas – and leave the rest to their sub-
contractor's reliable taste and judgement.[30]

To keep up with demand, Van Aken developed a working
shorthand that enabled him in his turn to delegate: "He had
invented technical names for the different plaits in a fashionable
coat, so that he could communicate his orders by words to his
brother, who worked under him".[31] Despite these shortcuts, the
quality of the resulting pictures was consistently high, and the
painters who bought in Van Aken's "draperys silks satins Velvets,
gold & embroideryes" found them "a great addition to their
works and … so much on a Level that its very difficult to know
one hand from another".[32] Van Aken was particularly valued for
his skilful rendition of costumes copied from Rubens's portraits.

Such was the demand for Van Aken's services that in 1745
several of his established clients banded together, threatening to
withdraw their custom if he accepted work from other painters.
But the symbiotic relationship between the studios was not one
that could be coerced: the drapery painter was confident that his
clients needed him more than he needed them, and he was right.
Upon Van Aken's death in 1749 his brother, an inferior painter,
stepped into the breach and exploited the family name and client
list for as long as he could; nevertheless, the smooth running of
several portrait painters' studios was disrupted for many months.
And though many artists continued to use drapery painters,
contemporaries did reflect with bemusement upon Van Aken's
hold over the "*Phiz-mongers* ... that scarsely could do any part
but the face of a picture".[33]

One of the other reasons why artists banded together in
one identifiable area was, quite simply, because it made them

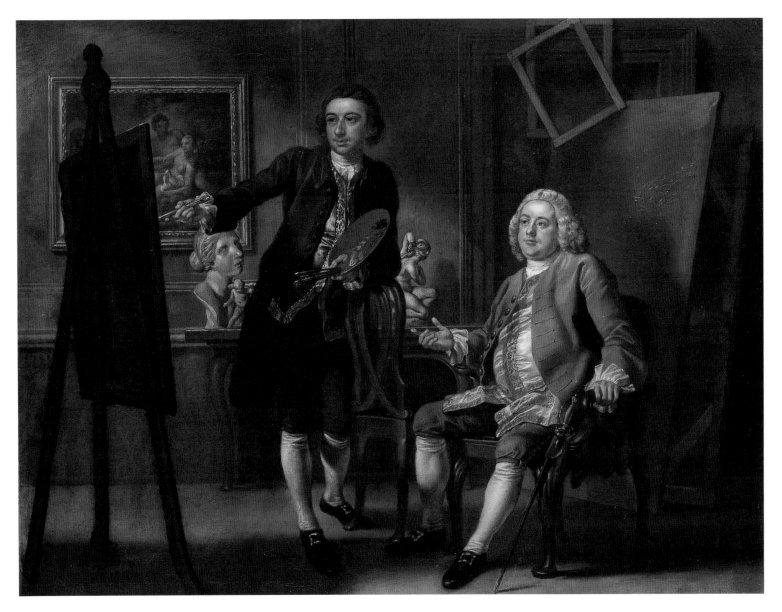

21
Francis Hayman, *The Artist and his Patron, Grosvenor Bedford*, c. 1748–50, oil on canvas, 71.8 × 91.4 cm, London, National Portrait Gallery

easy to find. Artists dealt directly with their patrons rather than through agents, galleries or other intermediaries, so portrait painters needed to live close to smart society, as well as to each other. A Covent Garden address – just a short carriage ride from the smart new houses going up around Piccadilly and Oxford Street – was not merely convenient for sittings; it was also a guarantee of propriety for clients visiting the studio, who could feel confident that they were in respectable surroundings. A well-appointed house in a fashionable street enhanced the painter's status and underlined the difference between his art and mere mechanical craft. The physical labour, mess and smells involved in grinding and mixing colours, priming canvases, or hammering frames into place could be relegated to a back room, while visitors met the painter in a studio carefully furnished with Classical busts and engravings of Old Masters. Hayman's double portrait of himself and Grosvenor Bedford in an idealized version of an artist's studio, painted c. 1748–50, conveys nothing of the process of getting paint on to canvas (although the artist holds a palette set with colours, they have not been touched). The scene is contrived to distance the painter from the artisanal aspects of painting and to provide instead a decorous, ordered setting for a rational discussion of art between two educated equals (fig. 21).

Social mobility could take an artist down as well as up. Richard Wilson (1713/14–1782), the "English Claude", who painted portraits in the 1740s before turning to landscape, had a studio in the Piazza furnished with a six-foot-high "model made in wood, of a portion of the Piazza ... This he used as a receptacle for his painting implements; the rustic work of the piers was divided into drawers, and the openings of the arches were filled with pencils, and oil bottles."[34] After a long stay in Italy in the early 1750s, Wilson devoted himself to landscape painting in the Classical Italian manner, managing to make even his English and Welsh views look like postcards from the Grand Tour. These did not sell well, and as his career declined Wilson was forced to leave Covent Garden for "meaner lodgings" out on a limb at 69 Charlotte Street, north of Oxford Street.[35]

Printsellers and colourmen

From the late seventeenth century, artists' fortunes were entirely intertwined with the print trade. Not only did designing for print publishers and booksellers provide an essential income for artists, it also helped keep the public aware of what they were doing when there were few opportunities to put one's art on public display. Not surprisingly, then, print sellers had closely followed the geographical shift of artists and clients. Sometimes they even overlapped: Johann Zoffany (1725–1810) had a studio in George Robin's auction rooms on the Piazza, one of several art dealerships in Covent Garden that catered for the westward expansion of fashionable London. Like artists, print sellers had

moved west, from their traditional City homes close to the booksellers of St Paul's Churchyard. Thomas Johnson is recorded as dealing in the Strand in the 1630s, and in 1642 Peter Stent set up shop in Giltspur Street, just outside Newgate. Exeter Exchange, a covered shopping centre on two floors between Covent Garden and the Strand, was the site of the first print auctions in the 1680s. The print seller Edward Cooper, based near by at the Three Pigeons in Bedford Street, dominated his trade in the first quarter of the eighteenth century,[36] against stiff competition from the Huguenots James Regnier (*fl.* 1712–1754), whose print shop at the Long Acre end of Great Newport Street was open by 1715, and Solomon Gautier (*fl.* 1715–1725), who imported and auctioned pictures and prints on the corner of James Street and the Piazza.

The creative community of painters and engravers was supported by a parallel community of tradesmen and suppliers. The supplier of artists' materials was known as a colourman: "He is, in some shape, the Apothecary to the Painter; as he buys the simple Colours and compounds some of them: He grinds such as require grinding ... A Painter may go into his Shop and be furnished with every Article he uses, such as Pencils, Brushes, Cloths ready for drawing on, and all manner of Colours ready prepared ...".[37] By 1703, the "Colour Seller" John Calfe had a shop at the sign of "St Luke's Head, without Temple Barr", where he sold "all sorts of Colours, Oyles, Varnish, Brushes, pencils for all sorts of painting, prim'd Cloths Colours ready prepared for House painting, Pictures & School Works Leafe Gold, & Silver Speccles and Mettals for Jappanning &c.",[38] and by the mid-eighteenth century the trade was well established west of Temple Bar by colourmen such as "Nathan Drake, successor to Robert Keating, at the White Hart in Long Acre" in 1763,[39] and Joseph Austin, "Oylman", "at the Flying Horse, Catherine Street in the Strand" in 1760.[40] Each artist had his favourite supplier: Richard Wilson patronized Newman's in Soho Square and then Gerrard Street; Gainsborough shopped at Scott's on the Strand.[41]

Colourmen also dealt in prints and drawings, and arranged drawing lessons. The versatile Archibald Robertson, "print-seller and drawing-master", ran a virtual department store for art at his premises "in Savill Row Passage, adjoining Squib's Auction Room" (fig. 22). Besides drawing and painting materials, copper plates and etching tools, and a selection of imported prints and wallpapers "in the newest taste", Robertson offered a picture-framing and glazing service and would engrave visiting cards to order.

Picture framing was a branch of the furniture and upholstery (*i.e.* interior decorating) trades, which had long-standing connections with Covent Garden. On 30 April 1669 Samuel Pepys went "to the frame-maker's, one Norris in Long Acre, who

showed me several forms of frames to choose by; which was pretty, in little bits of mouldings". A few days earlier he had left his "French prints to be put on boards" with Lilly, another framer and varnisher.[42] The cabinetmaker and upholsterer William Hallett (1707–1781) had premises in Great Newport Street and then, from 1753, in St Martin's Lane and Long Acre, alongside other notable firms including Vile & Cobb and Chippendale. In 1756 Hayman painted a portrait of Hallett and his family in a rural setting at Edgware, where Hallett had built a country villa. The elaborate carved frame to this portrait is likely to have come from Hallett's own workshop.[43] More usually, however, it was the artists' job to organize a frame; though the patron was expected to pay the frame-maker separately, the artist might receive a commission. Under those conditions, artists obviously had favourite frame-makers, and it might have been due as much to his generous commissions as to his fine craftsmanship that Hogarth, Ramsay and Gainsborough all patronized Isaac Gossett.[44] Since the same carving, gilding and joining skills were required for any frame, whether it surrounded a looking-glass, screen or painting, it is reasonable to suppose that any of the dozens of cabinetmakers and uphol-sterers who operated in Covent Garden, Leicester Square and Soho in the mid-eighteenth century would undertake to frame pictures, but some made a point of advertising their skills in this particular line. Daniel Bernardeau "at his shop at ye Golden Coffee Mill in St Martin's Court near Leicester Fields" specialized in hardwood turning and oval frames, according to his trade card of c. 1750.[45] Prints and drawings could be "fram'd and Glaz'd, Pictures Clean'd, Lin'd and Mended" by the carver and gilder Robert Johnson, who was trading at the Golden Head in Frith Street in about 1760.[46]

Within a few years of the first artists arriving in Covent Garden, and within a few streets of the Piazza, could be found everything – auctioneers, colourmen, framers, engravers and printsellers – needed to create, exhibit and sell paintings new and old. While the artists found it convenient to have all these trades on their doorstep, they wanted more and more to distance themselves from the plebeian associations of 'trade'. However, since art relied on trade, it was the existence of this infrastructure and the ensuing density of artists that ensured, when formal art organizations such as the Royal Academy were set up in 1768, that they would be situated close to this one small area of London.

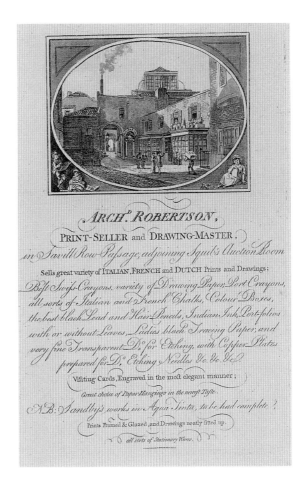

22
Paul Sandby, advertisement for *Archibald Robertson, Print-Seller and Drawing-Master*, c. 1787, aquatint and etching, 25 × 17 cm, London, Museum of London

Covent Garden 1685–1800

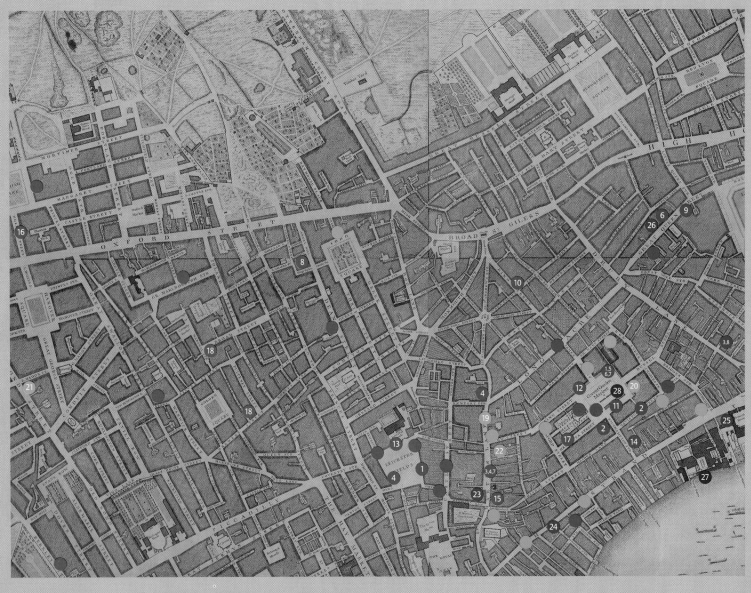

Studios & homes

1. William Hogarth
NE corner of Covent Garden Piazza,
1729–33
The Golden Head, Leicester Square,
1733–64

2. Samuel Scott
4 Tavistock Row, 1718–47
2 Henrietta Street, 1747–65

3. Francis Hayman
104 St Martin's Lane, 1753
Craven Buildings, Drury Lane

4. Sir Joshua Reynolds
104 St Martin's Lane
46 Great Newport Street, 1754–60
47 Leicester Square, 1760–92

5. Sir Peter Lely
NE corner of Covent Garden Piazza,
1662–80

6. Sir Godfrey Kneller
NE corner of Covent Garden Piazza,
1682–1702
55/56 Great Queen Street,
1709–1723

7. Sir James Thornhill
104 St Martin's Lane
Covent Garden Piazza, 1718–34

8. George Michael Moser
King Square Court
Craven Buildings, Drury Lane

9. Thomas Hudson
*Apprentices: Joshua Reynolds
& Joseph Wright of Derby*
Great Queen Street, 1746–61

10. Joseph & Alexander van Aken
King Street, 1720s–56

11. Richard Wilson
Covent Garden Piazza

12. Johann Zoffany
Covent Garden Piazza

13. Edward Fisher
36 Leicester Square

14. Hubert François Gravelot
Southampton Street

**15. François Roubiliac (died 1762)
Nicholas Read (1762–1787)**
Peter's Court, St Martin's Lane

16. John Vanderbank
Hollis Street

17. James Macardell
The Golden Ball, Henrietta Street

18. Paul Sandby
38 Great Pulteney Street, 1753
Dufour's Court, Broad Street, 1763

Meeting-places

19. Old Slaughter's Coffee House
74/75 St Martin's Lane, 1692–1843

20. Tom's Coffee House
Russell Street

21. Kings Arms
New Bond Street

Supporting trades & organizations

22. John Middleton
80/81 St Martin's Lane

Art schools & academies

23. St Martin's Lane Academy I & II
St Martin's Lane, 1735–67

24. Society of Arts
Durham Yard, 1754–

25. Royal Academy Schools
Somerset House, Strand, 1774–1836

26. Great Queen Street Academy
55 or 56 Great Queen Street,
1711–1715

Inspiring sites & architecture

27. Somerset House
Royal Academy of Arts, 1774–1836

28. Covent Garden Piazza

Unnumbered coloured spots indicate
lesser-known artistic locations

John Roque
*Plan of the Cities of London and
Westminster*
1737–46

1685–1800

Markets for Art: Covent Garden and Leicester Square

1685–1800
Markets for Art: Covent Garden and Leicester Square

By 1731, when Hogarth came to lodge with his mentor James Thornhill (whose daughter Jane he had married), Covent Garden (fig. 23) was no longer "the most, and indeed the only fashionable part of the town".[1] The 'quality' were moving out, to newer, smarter developments in Mayfair and the Grosvenor, Cavendish and Harley Estates, and the bucolic charm of the vegetable market, the fruit and flower stalls and the visiting yokels gawping at the grand houses was being eroded by the presence of 'bawdy-houses', taverns, gambling-dens, pimps, prostitutes and pickpockets.

The seamy side of Covent Garden could be exploited for locations and incidents that would titillate the purchaser of paintings and prints, even as they ostensibly illustrated an improving moral. Hogarth used the infamous Rose Tavern, notorious for drunken debauchery (and even, on one occasion, a murder), as the setting for Scene III in The Rake's Progress (1733).[2] Another notorious dive, Tom's Coffee House, appears in Hogarth's Morning (1738; fig. 24). Those who bought the print of Morning would have understood that Tom's was there to symbolize rowdy debauchery. Even so, Hogarth underlines his moral by adding a swordfight and a group of prostitutes, and by an ironic architectural juxtaposition: the coffee-house is transposed from its real location to a spot just in front of the portico of St Paul's Church on Covent Garden Piazza.

Low life exerted such a fascination for the public that special efforts were made to record the perpetrators of the most sensational or shocking crimes. There was a vigorous market for prints in general, and all sectors of metropolitan society seemed to have a fascination for malefactors that was driven by fear of crime, moral repugnance, admiration of daring exploits and a morbid fascination with capital punishment – exactly the same potent mix of emotions that provides an audience for death-row documentaries today. The robber Jack Sheppard (fig. 25) became a folk hero by escaping from Newgate Prison not once but twice, "to the great Admiration of the people".[3] One of the many visitors he received in the Condemned Hold between his recapture and hanging in 1724 was Thornhill, whose interest in the 'urban grotesque' is thought to have come from his early meetings with the young Hogarth.[4] Nine years later Hogarth visited Newgate and, perhaps in emulation of his father-in-law's celebrated portrait, painted the murderess Sarah Malcolm two days before she was hanged. The equivocal celebrity of Sheppard and Malcolm is reflected in the painters' ironic treatment of them: martyr-like, each convict assumes a contemplative pose, bathed in light as if at a moment of spiritual awakening. There was, however, nothing spiritual about the haste with which Hogarth, anxious to exploit the intense public interest in Sarah Malcolm, rushed out the print of his portrait. Reasonably priced at sixpence, it was on sale at Regnier's print shop in Newport Street within three days of the convict's execution.[5]

Covent Garden may have inspired him and supplied him with a support system of family and friends at the start of his career, but Hogarth was too ambitious to let its raffish charm seduce him. He was just passing through, allowing his wife's family to help him out for a couple of years until his own career was established. In 1733 he asserted his independence when he moved his house and printshop to a subleased house of his own, on the eastern side of Leicester Fields (Leicester Square; fig. 26). Hogarth lived here, "at the sign of the Golden Head", until his death in 1764. He adapted the house to his particular needs, making the signboard (a gilded bust of Van Dyck) himself out of "several thicknesses of cork compacted together",[6] and in due course adding a painting room at the rear to catch the northern light.[7] Since the house was his showroom as well as his home and workplace, it was important to have a separate workroom so that the appearance of gentility could be maintained. Finished paintings were displayed on the ground floor, where curious gentlefolk could come to view them and perhaps be enticed to commission pictures for themselves. But the three-dimensional signboard was a typical Hogarthian anomaly: such hanging tradesmen's signs were fast being outmoded. Hogarth may have chosen it precisely to show his commitment to traditional English rather than Continental artistic values.

To the eighteenth-century mind the different districts of London were more distinctly delineated than they are today. The fine houses of Leicester Fields represented a pocket of gentility

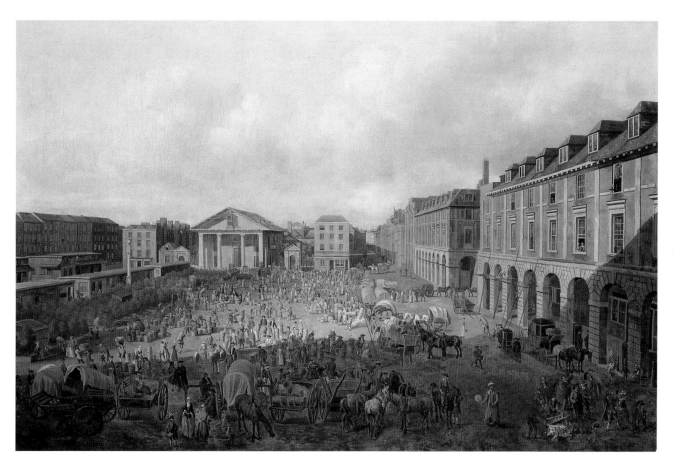

23
Samuel Scott, *Covent
Garden Piazza*, *c.* 1750,
oil on canvas,
110 × 166.7 cm, London,
Museum of London

in an area of busy shopping streets, inns and theatres, and Hogarth's move there from Covent Garden betokened a considerable step upward, both socially and financially. Artist-residents of the Fields at about this time included the portrait painter William Aikman (died 1731), the engraver Edward Fisher (1722–1785), the architect James 'Athenian' Stuart (1713–1788) and the enamellist and portrait painter Theodore Gardelle (died 1761), who was hanged for murdering his landlady (perhaps Leicester Fields was not so very far from Covent Garden squalor, after all). It remained a good address for many years. In the generation after Hogarth, Sir Joshua Reynolds followed a typical trajectory by starting his life in London in St Martin's Lane (no. 104), moving into a "commodious house" on the north side of Great Newport Street (no. 5) and finally, in 1760, purchasing "a superior mansion", 47 Leicester Fields, where he lived until his death in 1792.[8] He too altered the house to suit his professional requirements, investing £1500 "for a detached gallery, painting rooms" and an "elegant" reception room for his sitters.[9] The presence of Reynolds – the first president of the Royal Academy after 1768 – set the seal on the Fields' respectability.

Artists lived and worked at home, but most of their social life took place in public, in taverns and coffee-houses. These public resorts fostered debate on the subject of art in particular, and caused professional painters, amateurs, connoisseurs and collectors to come together in more or less formally organized groups. An early depiction of one such group is *A Conversation of Virtuosis at the Kings Armes (A Club of Artists)*, painted by Gawen Hamilton (c. 1697–1737) in 1735 (fig. 27). 'Virtuosi' were educated collectors, men of taste and artists. The company depicted in this conversation piece includes painters, engravers, architects, a sculptor and a landscape architect, as well as some who were proficient in several disciplines, such as William Kent (1684–1748; architect, landscape architect and painter) and John Wootton (c. 1686–1765; animal and landscape painter).[10] Such clubs were self-selecting, and in this case the men depicted shared Tory as well as artistic interests. As Vertue – who is also present – explained, this group "usually meet at the Kings Armes. New Bond Street a noted tavern".[11] As Tory sympathisers this group was in a minority. Their choice of meeting-place, away from Covent Garden, suggests the way that social life and patronage were shaped by political allegiances and professional loyalties. Their fraternal support is seen in this commission: each member paid Hamilton four guineas to do the painting, which was eventually raffled between them.[12]

Whether articulated in the context of a formal club or not, clubbability was an admired personal quality. More than just gregariousness, clubbability implied a particular cast of thought that enabled like-minded individuals to come together to exchange ideas, information and opinions, and to be sure of a

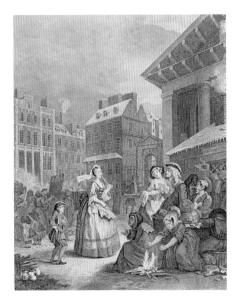

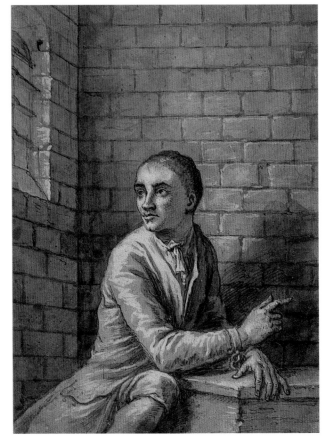

24
William Hogarth, *Morning*, 1738, engraving, 43.2 × 35.6 cm, London, Museum of London

25
Sir James Thornhill, *Jack Sheppard*, 1724, pen, ink and wash, 32.8 × 25 cm, London, Museum of London

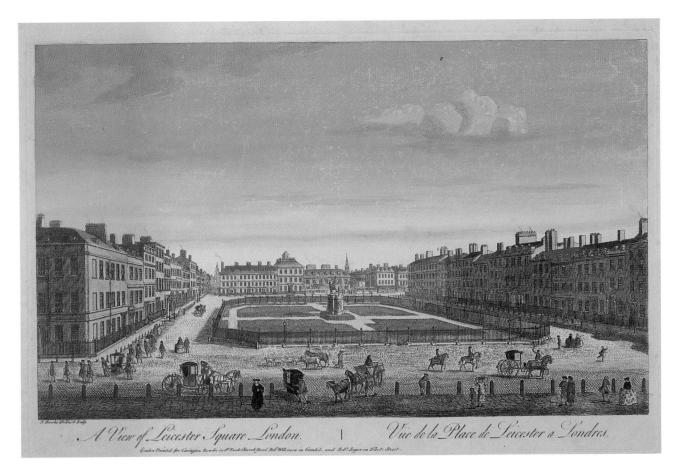

26
Thomas Bowles, *Leicester Square*, 1753, hand-coloured engraving, 30.3 × 46 cm, London, Museum of London

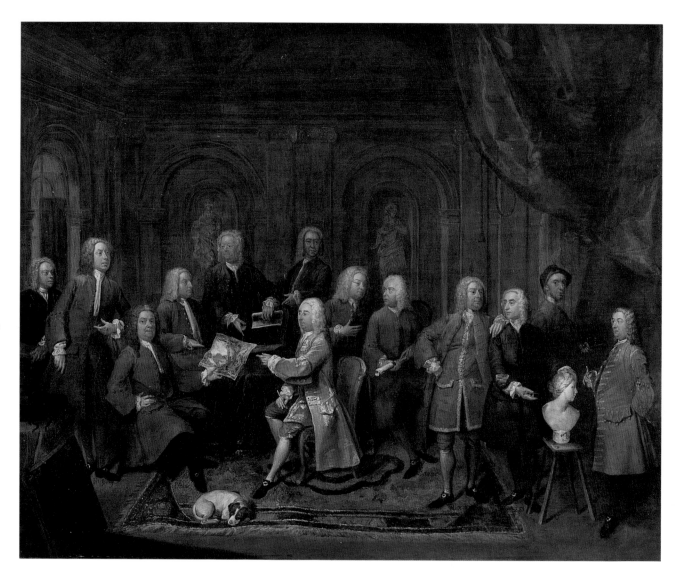

27
Gawen Hamilton, *A Conversation of Virtuosis at the Kings Armes (A Club of Artists)*, 1735, oil on canvas, 87.6 × 111.5 cm, London, National Portrait Gallery

sympathetic and intelligent reception regardless of their social status; rank and wealth were less important than the ability to contribute to polite and rational debate. The coffee-house was an essential forum for such meetings, a place where artists might mix with writers such as Henry Fielding, dilettanti such as Martin Folkes and actors such as David Garrick.

Garrick was a towering figure. He was a celebrated actor, a passionate patron of the arts and a shrewd businessman whose name, lent to a project, usually guaranteed its success (although he was to come badly unstuck over the Adelphi, the ruinous speculative development south of the Strand proposed by the architect Robert Adam and his brother). In close collaboration with a number of Covent Garden's leading artists, he conducted a carefully orchestrated campaign of image management designed to enhance his superstar status (fig. 29). Folkes like-wise moved in several overlapping circles: he was not only a medical doctor but was also president of the Society of Antiquaries and of the Royal Society, and a governor of the Foundling Hospital; these serious interests were counterbal-anced by his marriage to Lucretia Bradshawe, a celebrated actress, and his love of the theatre. He was exactly the sort of high-powered networker that ambitious artists seeking commis-sions needed to cultivate, for he could recommend the painters he admired to a wide circle of potential clients.

Both Garrick and Folkes were regulars at Old Slaughter's Coffee House, close to Leicester Fields. Thomas Slaughter had set up shop at nos. 74 and 75, on the west side of St Martin's Lane, near the corner with Great Newport Street, in 1692. In 1749 his successor John Barwood added a bow front to the building, and the name changed to Old Slaughter's.[13] The building was demolished in 1843, but its appearance was recorded in a water-colour by Thomas Shepherd (c. 1819–1860; fig. 28).

Slaughter's was a cosmopolitan "rendezvous of persons of all languages & Nations, Gentry, artists and others".[14] Among the group who met there were the engravers Hubert Gravelot (1699–1773) and John Pine (1690–1756), the sculptors John Cheere (1709–1787) and Louis François Roubiliac (1695–1762), the chaser and enamellist George Michael Moser (1704–1783), the architect Isaac Ware (1704–1766) and the painters Hogarth, Hayman, Hudson and Gainsborough.[15] Apart from being a place of real friendship, Slaughter's was a hotbed of artistic innovation and cosmopolitan exchange where English artists now enjoyed mixing with their French and Italian colleagues. Several Old Slaughter's regulars contributed to the decoration of Vauxhall Gardens, a pleasure garden run as a high-class tourist attraction by the entrepreneur Jonathan Tyers. The newly fashionable Rococo style, a decorative riot of shells and flowers, trellis and curlicues, was perfect for such a frivolous, ephemeral undertaking. Hayman painted the supper boxes, Roubiliac carved a statue of Handel for

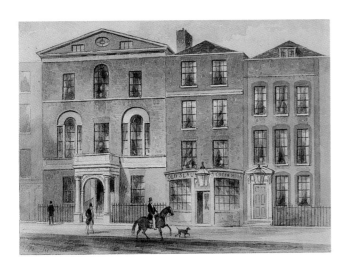

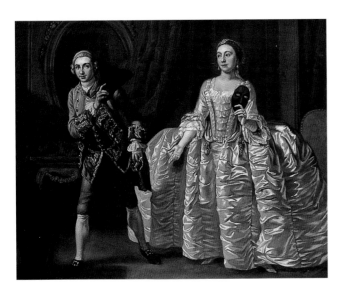

28
Thomas Shepherd, *Old Slaughter's Coffee House*, before 1843, pen, ink and wash, 17.6 × 21.8 cm, London, British Museum

29
Francis Hayman, *Hannah Pritchard and David Garrick in The Suspicious Husband*, 1752, oil on canvas, 63.7 × 76.6 cm, London, Museum of London

the entrance, and Gravelot and Moser collaborated on the decorations, jumping at the chance to display their work in a popular resort where high society – their potential patrons – met (fig. 30).

The decoration at Vauxhall Gardens perhaps belonged to what Sir Joshua Reynolds would eventually dismiss as "the humbler walks of painting which, however profitable, can never assure [the artist] a permanent reputation".[16] Following a tradition that had its roots in Renaissance thought, Reynolds was one of a succession of art theorists who insisted that history painting was the highest form of art, a point of view firmly emphasized in his description of its ideal subject-matter: "It ought to be either some eminent instance of heroick action, or heroick suffering. There must be something either in the action or in the object, in which men are universally concerned, and which powerfully strikes upon the publick sympathy ... Such are the great events of Greek and Roman fable and history ... Such too are the capital subjects of Scripture history."[17]

Through this branch of painting, ambitious individuals were desperate to prove themselves as *artists* rather than artisans, but there was a lack of patrons and projects. It seemed as though the only way for a British artist to secure a prestigious public commission was to do the work for nothing. In 1734 the governors of St Bartholomew's Hospital, responding to the conditioned reflex that required a foreigner to be commissioned for any important mural work, were about to award the job of decorating the Grand Staircase in their new administrative building to the Venetian painter Giacomo Amigoni (1685–1752), when Hogarth volunteered his services free of charge and whisked the job away from under the Italian's nose (fig. 31). In effect, Hogarth was using the income from a 'low' form of art, his hugely successful *Rake's Progress* and *Harlot's Progress* engravings, to subsidize an opportunity to tackle 'high' art in the Grand Manner, to have his work on permanent display to potential patrons on a billboard-sized site and to enhance his personal reputation by some high-profile charity work.

The Foundling Hospital, established in 1739 by Captain Thomas Coram, offered a similar opportunity. In a philanthropic gesture orchestrated by Hogarth, several leading artists, who socialized at Old Slaughter's Coffee House and practised at the St Martin's Lane Academy (see p. 44), donated paintings to the new charity. Hayman's contribution was *The Finding of Moses in the Bulrushes* (fig. 32), an appropriate subject for an organization devoted to rescuing outcast children. It was painted in 1747 as one of a series of pictures for the Court Room in the Hospital, and hung alongside identically framed paintings on similar themes by Joseph Highmore, James Wills (died 1777) and Hogarth, who also presented his portrait of Captain Coram. Other works were contributed by Edward Haytley (fl. 1740–1761), Richard Wilson and the sculptor John Michael Rysbrack

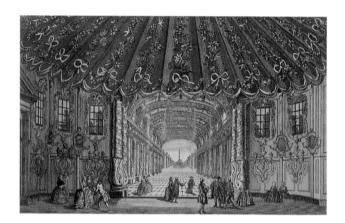

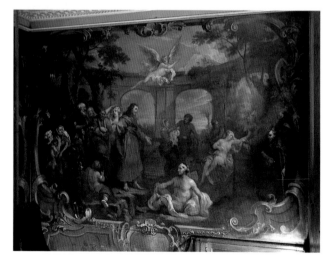

30
George Michael Moser, *Vue Intérieure de Vauxhall*, 1752, hand-coloured engraving, 28 × 46 cm, London, Museum of London

31
William Hogarth, *The Pool of Bethesda*, 1736, oil on canvas, London, St Bartholomew's Hospital

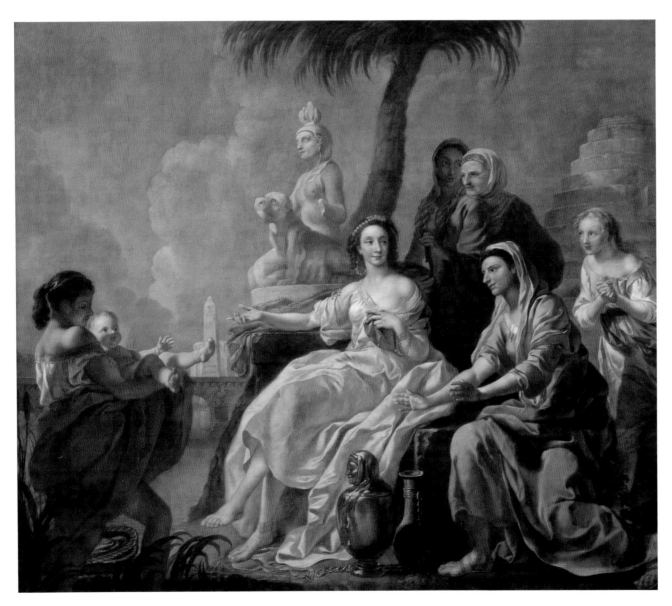

32
Francis Hayman, *The Finding of Moses in the Bulrushes*, 1746, oil on canvas, 172.7 × 203 cm, London, The Foundling Museum

(1684–1770), all of whom, like Hogarth, were elected governors of the Hospital. The Foundling Hospital artists were motivated by philanthropy, certainly, but it was philanthropy mixed with a healthy dose of self-interest. From the moment it opened, the Hospital was one of the tourist sights of London. Genteel women came there to have their hearts wrung with pity for the helpless babes who had been rescued from destitution and almost certain death on the streets of London. While they were there, their ladyships could be seen to play the part of concerned citizens by sponsoring foundlings (who would be named after their benefactors as living testimonials to the generosity of the gentry). They were also certain to admire the Hospital's art collection – and that was the payoff: in return for their generosity, the artists were given the priceless opportunity to show their work in the most propitious circumstances to a willingly captive audience of the greatest wealth and discernment.

Charitable donations were one way in which artists sought to raise their profile and improve their social standing. The artist who sought genteel status was faced with a conundrum: "For a gentleman to paint for his Pleasure without any Reward is not unworthy of him. To make a Profession of, and take Money for this Labour of the Head and Hand is the dishonourable Circumstance, this being a sort of letting himself to Hire to whosoever will pay him for his Trouble."[18] Undertakings such as the Foundling Hospital project helped put a respectable distance between the act of painting and the money to be made from it.

Trades that involved manual labour were run in a very structured way, with livery companies to supervise apprenticeships, set standards of workmanship, fix charges and arbitrate in disputes. Since the Painter-Stainers' Company had relinquished control of London's artists, however, fine art had no such professional organization to promote its interests and guarantee standards. If British artists were to shed the inferiority complex that had dogged them for over a century, they had to improve both their skills and their public image. They aspired to the kind of academic history painting that flourished in France and Italy, but lacked the necessary training. They needed the skills of composition, gesture, pose and expression that could be acquired only in the life class, drawing (though rarely painting) after the nude model; this in itself was the culmination of diligent study of their teachers' drawings and then plaster casts of Classical sculptures. To be taken seriously, and to be accorded the respect of their Continental counterparts, British artists also needed to combine forces. The problem was how to do this without losing the appearance of gentlemanly independence. The livery company model was too closely concerned with trade and manual labour to serve their purposes, and in any case was too closely associated with the City to serve the whole of London. Artists looked instead at the many academies on the Continent, which

conferred high social status upon their members while providing the kind of practical support system and opportunity for study that they required.

As a training and promotional body, an art academy would set standards, govern training, protect income and promote a collective identity. It was an appropriate response to the move from a martial and royalist culture to a civic and constitutional one in which liberal values and creative debate could flourish. Membership of an academy was also a way for an artist to raise his profile and get his work shown to the public. Thus the formation of an academy was an important element in the campaign to elevate the status of the native-born artist in line with that of Continental (especially Italian and French) artists. As Robert Campbell complained:

> Were the Lovers of Painting among our Nobility to contribute to the erecting and maintaining of Academies for Paintings, as done in other Nations, we should in a few Years boast of as eminent hands as any in Italy. For this would not only be a Nursery for Painters, but improve the National Taste and Judgement in the Art: Our Nobility would then be able to judge of a Piece by the Rules of Art, and value it according to its own intrinsic Excellence, without consulting the Name, or depending on the Judgement of Italian Picture-Mongers.[19]

Campbell, following the precedent set in France, assumed that it would be the nobility who would establish, and benefit from, an academy. In fact it was artists themselves who did so, and eventually succeeded in receiving the all-important royal charter.

As early as 1662, John Evelyn may have been the first to outline the way in which "a publick academy for the improvement of painting, sculpture and architecture" might be organized.[20] However, the first initiatives were privately run attempts to offer professional and practical training alongside the apprenticeship system. For example, in 1700 the draughtsmen John Sturt and Bernard Lens capitalized on the growing opportunities afforded by the print market by advertising evening classes for apprentices and young engravers three times a week, at a hefty subscription of five shillings a month.

The distinction of founding the first fine art academy in London belongs to Kneller.[21] From 1711, students who paid a regular one-guinea subscription could draw casts of antique sculpture and attend life classes in premises next to his house in Great Queen Street.[22] Run with a distinct hierarchy, and overseen by an appointed board of governors, the Great Queen Street academy soon dissolved into factions. In 1715, Kneller stepped down and Thornhill was elected governor: he moved the academy to his large new painting room in Covent Garden and, hoping to

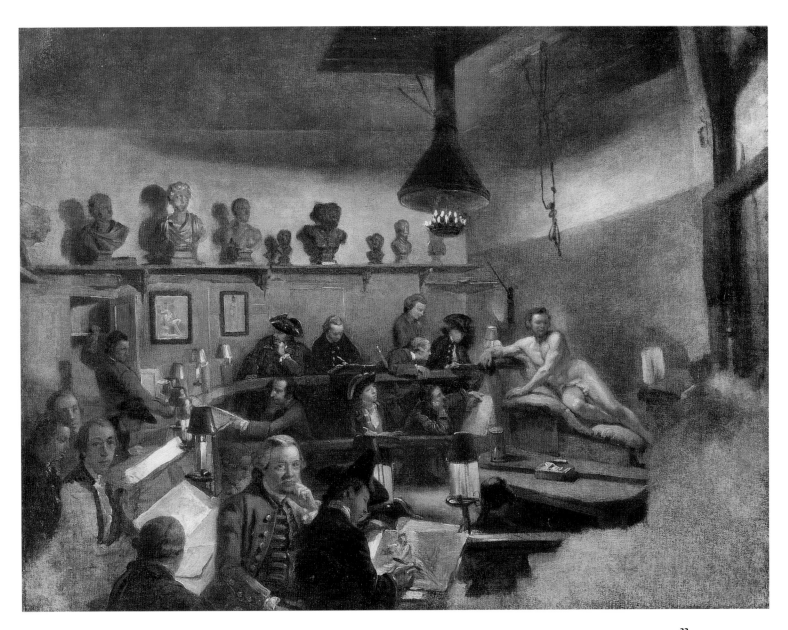

33
Anon. (possibly by Johann
Zoffany), *St Martin's Lane
Academy*, c. 1760, oil on
canvas, 48.2 × 64.7 cm,
London, Royal Academy
of Arts

34
John Vanderbank, *Drawing of the Farnese Hercules*, 1732, black chalk and white highlights on blue paper, 75 × 57 cm, London, Royal Academy of Arts

35
George Michael Moser, *Seated Male Academy Figure*, c. 1745–50, black and red chalks, 57 × 38 cm, London, Royal Academy of Arts

curry support from his network of aristocratic patrons, he abolished the subscription fee. Even so, no support was forthcoming. Thornhill's academy soon foundered and was superseded, in 1720, by one established by Louis Chéron (1655–1725) and John Vanderbank (1694–1739; fig. 34) in a disused Presbyterian chapel in Peter's Court off St Martin's Lane. This was attended by many local artists, including Hogarth, Hayman and Highmore, until bankruptcy forced its closure in 1724.[23] At Thornhill's death, in 1734, Hogarth inherited his equipment ("a proper table for the figure to stand on, a large lamp, an iron stove, and benches in a circular form")[24] and lent it to a new academy established in premises provided by Roubiliac on St Martin's Lane (fig. 33). Although Hogarth was the principal organizer, each artist who subscribed had an equal voice in how the academy should be run. This structure reflected Hogarth's democratic belief that "superior and inferior among artists should be avoided especially in this country".[25]

Over the next three decades the St Martin's Lane Academy was to become one of the most powerful influences in the professionalization of art practice. It was a powerhouse of artistic achievement that attracted a cross-section of both young and established artists. According to Vertue's notebook for 1744–45, "This winter subscribed 36 persons to draw ... some ingenious young men make good improvements amongst the best Mr. Moser the Chaser had distinguisht himself by skill in drawing ... from the life" (fig. 35).[26]

The debate about what kind of academy would best promote artists' interests rumbled on during the 1740s and 1750s: a democratic, artist-run organization such as St Martin's Lane, or a state-sponsored, hierarchical structure such as the French Académie de Peinture? Various factions were formed, pamphlets printed and meetings held to try to establish an English academy. In 1754 the Society for the Encouragement of Arts, Manufactures and Commerce was founded. The following year a committee of twenty-five artists met to consider the formation of a national academy. The result was the founding in 1759 of the Society of Artists, under Hayman's lead. The Society offered prizes for drawing, painting and engraving, and in 1760 held a free exhibition of contemporary art at its premises on the Strand. This was one of the first opportunities for the general public to view an exhibition of paintings, and the response was

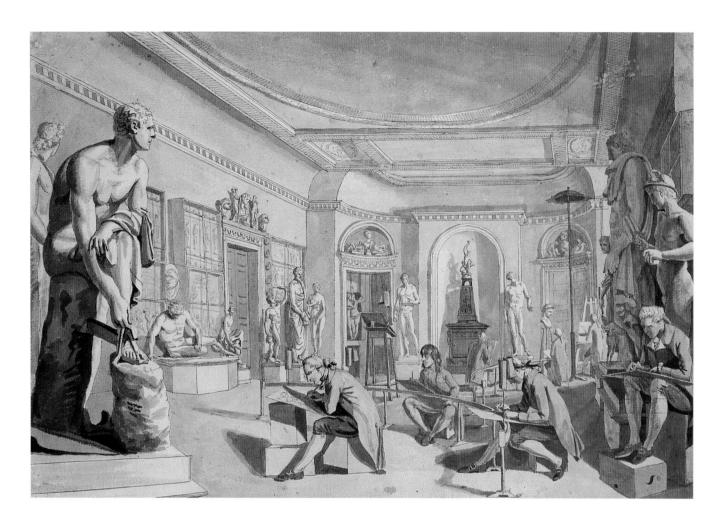

so enthusiastic that the crowds got out of hand. Some of the painters complained that potential purchasers had been put off going by the press of people; others were aggrieved to find their paintings lost in an overwhelming display of hundreds of closely hung works of indifferent quality, or ignored because "persons who were deficient in judgment"[27] concentrated their attention on the works that had been awarded premiums. Disagreements among the artists led to Hogarth setting up a breakaway group, calling itself the Society of Artists of Great Britain, which organized a rival exhibition – with an entry charge to limit numbers – at Spring Gardens, a temporary exhibition space near Charing Cross. This internecine squabbling caused great amusement in London society, but by undermining the opposition to a Continental-style academy it left the way open for the proponents of a Royal Academy to win the day.

In 1768 George III approved the founding of a Royal Academy. After a period in Pall Mall, it took up its first permanent premises in William Chambers's newly redesigned Somerset House on the Strand in 1780 (fig. 36). Where the Society of Artists was democratic, opposed to court influence, and patriotically

36
Francis Burney, *The Antique Academy at New Somerset House*, 1780, pen and coloured wash, 33.6 × 48.9 cm, London, Royal Academy of Arts

37
Pietro Antonio Martini after J.H. Ramberg, *The Exhibition of the Royal Academy*, 1787, 1787, engraving and etching, 37 × 50 cm, London, Museum of London

38
A. Charles, trade card,
c. 1790, engraving,
London, British Museum,
The Heal Collection

CHARLES, *R.A.*
Artist to his Royal Highness the Prince of Wales
No. 130 OPPOSITE THE LYCEUM, STRAND.
PAINTING
Strong Likenesses in 20 Minutes, & finished in one Day.

A most perfect resemblance of the Face taken in Miniature for Lockets, Rings &c. in a masterly manner, from One to Ten Guineas. Only one sitting, which is submitted for Public decision, whether this is not an exemplary proof of the extraordinary consequences of the Power of Practice. — The Colours will not change. ———
Mr. CHARLES has studied The Italian, Flemish, and All The great Schools, And is A ROYAL ACADEMIAN
His Profile Shades which for taste of finishing by Artists have been long allowed the Superiority, but the Public Testimony of 14,000 who have sat to him, and whose Names he can shew, is sufficient Praise, without here recapitulating the Improvements he has made on them. Time of sitting only 3 Minutes.
He Takes Them On Paper at 5.0. Elegantly Framed 7.6. On Ivory one Guinea. Whole Lengths two Guineas.
NB There is no Necessity for Persons to come with their Hair dress'd

(even xenophobically) opposed to foreign influences, the Academy was hierarchical, royalist, and included foreign artists among its founders. The Academy applied rigorous criteria to the selection of works for its exhibitions – showing only 136 in its first exhibition, as opposed to over 400 shown by the Society of Artists – and its policy of charging for admission excluded the *hoi polloi*. Many of the painters who were members of the Society of Artists were thus encouraged to secede to the Royal Academy (fig. 37), which soon gained ascendancy over all other art clubs and societies.

Although the Academy had been founded as part of the quest for recognition, it failed to 'take' in all cases, and it must be remembered that not every painter attained the heights reached by a Reynolds or a Gainsborough. Many spent their careers labouring over potboiling portraits of the anonymous middle classes, and earned no lasting fame. Remembered only by his trade card in the British Museum, for example, is one A. Charles (fig. 38), who, around 1790, offered "Painting Strong Likenesses in 20 minutes and finished in One Day" at his premises in the Strand, opposite the Lyceum. The busy City dealer requiring a portrait need only find a small window in his hectic schedule for a three-minute sitting: "NB There is no necessity for Persons to come with their Hair dress'd". Charles claimed that more than 14,000 people had sat to him (and perhaps it was true, given the advertised speed of his sittings), but the rather off-puttingly insistent tone of his advertisement suggests leaden proficiency rather than inspired genius.

Some of the output of now-forgotten London painters has great charm and freshness. When John Middleton, the proprietor of an artists' supplies shop at 80–81 St Martin's Lane, had himself and his household portrayed by an anonymous artist in the 1790s (fig. 39), they posed in their London drawing-room 'over the

shop' and surrounded by clues to their sophisticated urban tastes: a wine glass, a gilt-framed landscape, musical instruments and books. Middleton clearly made a good living from retailing art supplies despite stiff competition, and it is tempting to speculate that this picture was painted by an impoverished artist to settle his account with the colourman.

The tension between art and commerce can be discerned in John Boydell's Shakespeare Gallery (fig. 40). Boydell (1719–1804), an engraver who had spent the 1750s profitably as an importer, wholesaler and retailer of prints in Cheapside, in 1763 branched into exporting prints of Old Master paintings in English collections. This proved so successful that by 1773 he was issuing prints of works by contemporary artists, including Reynolds, Richard Wilson and George Lambert (1700–1765).[28] Through his pursuit of profit, Boydell had become one of the leading champions of British art. In 1786, he launched his most ambitious project, commissioning a large number of paintings illustrating scenes from Shakespeare. These he intended to exhibit in Pall Mall, an area that was fast becoming London's exhibition centre. He planned to commission one hundred paintings that, as they illustrated passages from Shakespeare, would satisfy artists' desire to be perceived as history painters. By buying the paintings and their copyright, Boydell could then commission luxury engravings that he would sell to subscribers. Boydell calculated that patriotic customers would queue to buy the prints, but he overestimated the market. The prints were of uneven quality, and he lost two-thirds of his subscribers. The old tensions, and perhaps also the conflicts of interest between the trade instincts of the City of London and the artistic aspirations of the West End, were not to be so easily resolved.

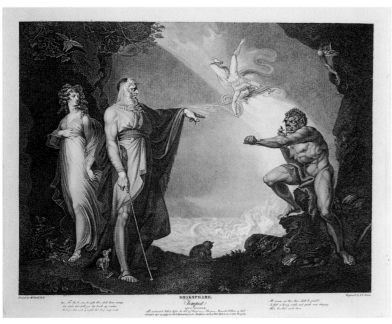

39
Anon., *Portrait of John Middleton and his Family*, c. 1796–97, oil on canvas, 88.3 × 110.5 cm, London, Museum of London

40
I.P. Simon after Johan Heinrich Fuseli, *The Tempest*, 1797, stipple engraving, 54.5 × 68 cm, London, Museum of London

Hampstead 1800–1835

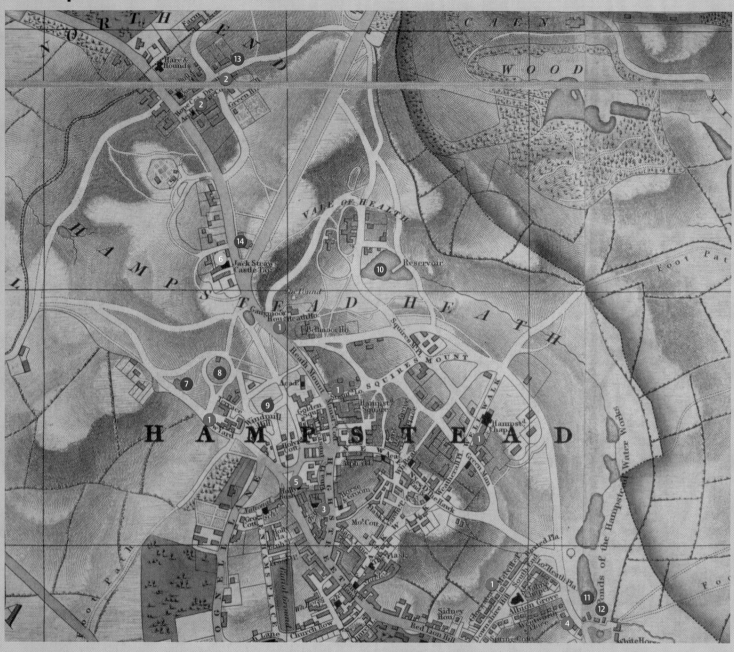

Studios & homes
1. John Constable
Albion Cottage, Whitestone Pond, 1819
2 Lower Terrace, Judges Walk, 1821–22
Stamford Lodge, near West Heath, 1823
Langham Place, 25/26 Downshire Hill, 1826–27
40 Well Walk, 1827–37
2. John Linnell
Hope Cottage, North End, 1822
Collins's Farm, North End, 1823–28
3. Frederick Waters Watts
High Street, 1821–30
4. William Collins
Pond Street, 1828–36
5. George Romney
6 The Mount, Holly Bush Hill, 1796–99

Meeting-places
6. Jack Straw's Castle

Inspiring sites & architecture
7. Branch Hill Pond
8. Judges Walk
9. Admiral's House
10. Vale of Health reservoir
11. Lower Pond
12. Lower Heath
13. North End
14. Littleworth Common

George Crutchley
New Plan of London
1836

1800–1835

Rural Retreats: Hampstead, Twickenham and Richmond

1800–1835
Rural Retreats: Hampstead, Twickenham and Richmond

An address in the centre of town enabled the successful eighteenth-century artist in London to play an active part in polite society and to maintain a high profile among potential patrons and dealers. To live, work and socialize where there were lots of artists to offer mutual support was particularly important during a period when the common goal was the foundation of organizations that would represent artists and foster the arts. However, if the city represented wealth, culture, fashion and intellectual stimulation, it was also a place of noisome squalor, pollution and crime. Those who could afford to escape to the country from time to time did so, and in the eighteenth century – as now – to have a little place in the country for weekends was a coveted status symbol, evidence that one had earned the leisure to develop one's refined sensibilities in a rural environment.

Villas and villages west of London
From the mid-eighteenth century artists particularly favoured locations to the west of London such as Richmond, Chiswick and Twickenham, which were all accessible by river and were on the well-travelled road to the fashionable spa resort of Bath. These places also had long-established associations with royalty, celebrities, architects, designers and intellectuals, which increased their appeal to artists seeking Nature's inspiration and congenial neighbours.

The discovery of mineral wells at Richmond in 1696 initiated a building boom as houses were erected for the gentry who visited to take the waters. Maids of Honour Row, overlooking Richmond Green, was built in 1724 to house the gentlewomen of the Princess of Wales when the Princess was in residence at Richmond Lodge. The following year, Lord Burlington started building his country villa at Chiswick. At only a few hours' journey from London, Chiswick Villa housed some of the choicest spoils of Burlington's Grand Tours and was the wellspring of Palladian design in England. Further upriver, artistic and literary London began colonizing Twickenham in the 1730s, when the Countess of Suffolk, a mistress of George II, entertained a small, informal circle of artistic and cultured friends at Marble Hill, her mansion on the bank of the Thames.

The most famous member of the Marble Hill circle was the poet Alexander Pope, who had lived in Twickenham since 1718 (fig. 41). Here he became an expert in landscape gardening and transformed the tunnel under the Teddington Road (now Cross Deep), which linked his house and garden, into a grotto that became a local curiosity. Building mania, whether for grottoes, Gothick cottages or classical villas, could be indulged on rural riverside sites at "sweet Twitnum".[1] Kneller had begun his house in Twickenham in 1709, and enjoyed thirteen summers there before renting it out. Hudson built two houses in Twickenham. The first was a Classical villa, to which he retired – his career threatened by the rising talent of his pupil Reynolds – in 1755. Then, on the neighbouring plot, he built a Gothick house perhaps inspired by Horace Walpole's nearby Strawberry Hill. In 1758, after forty years of living and working at the heart of the artists' quarter in Covent Garden, Samuel Scott also took a house at Twickenham. His *View of Pope's Villa*, painted *c.* 1760, has a serenity that contrasts with the inner-city Thames-side scenes, all bustling wharves and forested masts, that were his stock-in-trade.

It is not surprising that many of the St Martin's Lane artists gravitated westwards: they were merely accompanying their patrons, among whom David Garrick was pre-eminent. In 1762 Garrick bought Johann Zoffany out of his bond to Benjamin Wilson, for whom he painted drapery, and Zoffany thanked him with four pictures of the Garrick family enjoying their country retreat at Hampton (fig. 42).[2] The relationship between artist and patron was mutually beneficial: Zoffany's theatrical portraits of Garrick helped forge the public image of the celebrated actor while they contributed to Zoffany's reputation as an artist. Even portraits that purported to show Garrick 'as himself', such as *David Garrick and his Wife by the Temple of Shakespeare at Hampton* (1762), contributed to the image. The glamorous pair pose in a setting that symbolizes their success, as media-savvy as the present-day celebrities who invite *Hello!* magazine into their lovely homes.

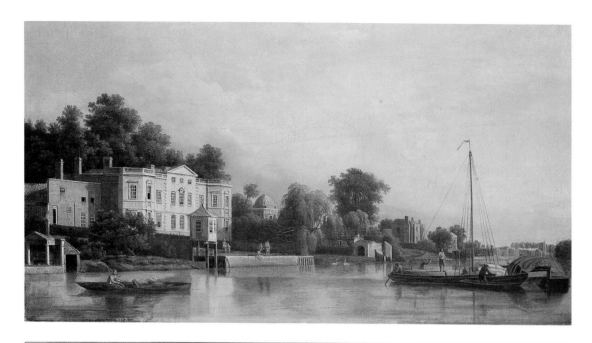

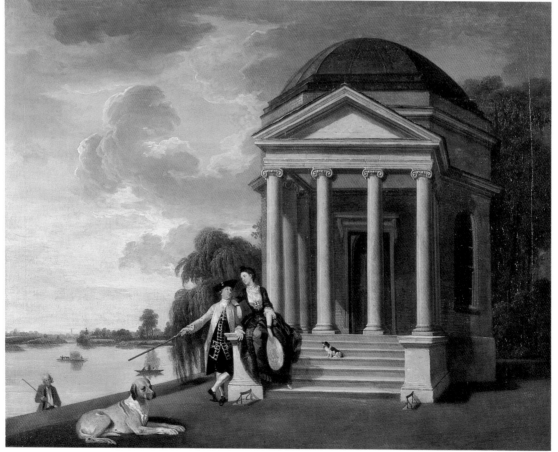

41
Samuel Scott, *View of Pope's Villa*, *c.* 1760, oil on canvas, 18.9 × 36 cm, London Borough of Richmond upon Thames, Orleans House

42
Johann Zoffany, *David Garrick and his Wife by the Temple of Shakespeare at Hampton*, 1762, oil on canvas, 102.2 × 134.6 cm, New Haven CT, Yale Center for British Art, Paul Mellon Collection

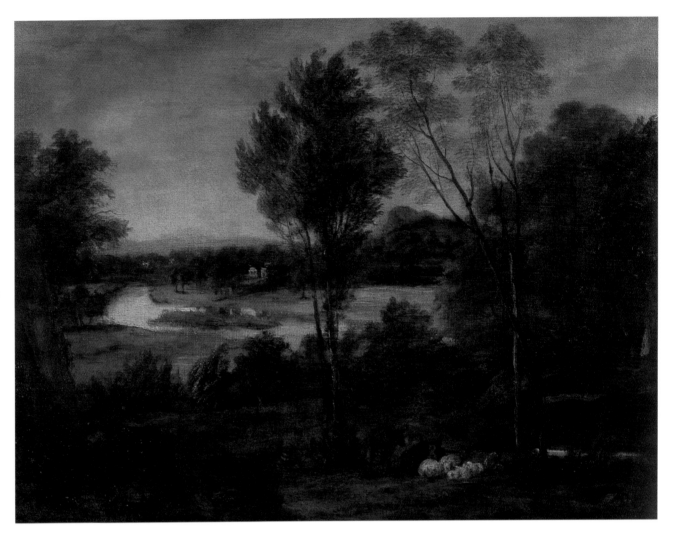

43

Sir Joshua Reynolds, *View from Sir Joshua Reynolds's House, Richmond Hill*, 1788, oil on canvas, 69.5 × 90.8 cm, London, Tate

It should not be imagined that artists embraced the simple life when they went to their country estates. Keeping up appearances remained important, and the manners of the gentry were aped just as assiduously in Twickenham or Hampton as in Covent Garden or Leicester Square. Kneller knew what was required of him: "with glorys & Honours heap'd on him he livd in splendour gathering Riches keeps a noble house & equipage built himself a fine Palace at his Country seat at Whitton about 8 mile from London. where he has purchast an Estate & lives in the sommer visited & courted by all People of Honour & distinction."[3] Half a century later, less ostentation was expected of the pathologically unpretentious Hogarth, who bought his house in the "pleasant village" of Chiswick in 1749.[4] Even so, Hogarth kept up a social round of tavern visits and congenial suppers with London friends who had country retreats near by.

Retirement to the country was in no sense retirement from professional life as a painter. Even though his portrait practice dwindled, Hudson retained his house in Great Queen Street,

and subsequently rooms in King Street, until the end of his life. Scott used a studio, and perhaps continued to live, in Bedford Street, Covent Garden, between taking his house in Twickenham and his retirement in 1765. Artists neglected London at their peril: Zoffany worked abroad between 1772 and 1779 and returned to find his style of portraiture no longer admired. He recouped his fortunes by a seven-year sojourn in Bengal, where he painted the nabobs of the East India Company, expatriates who could still be impressed with fashions that London had discarded. When he returned in 1790, he was sufficiently prosperous to live out his days at Strand-on-the-Green, near Chiswick, in some style, attended by liveried servants.

Unless they specialized in landscape, artists do not seem to have viewed the country as a source of ideas and inspiration for their art. The river at Hampton is mere background to Zoffany's portraits; Scott's view of Pope's villa is not typical of his œuvre, and only one view of Richmond is known to have been painted by Reynolds, although his house on Richmond Hill

commanded a wide view of one of the most attractive stretches of the Thames (fig. 43). With the notable exception of Joseph Mallord William Turner (1775–1851), who bought land in Isleworth in 1805, the riverside to the west of London was purely a leisure ground for sophisticated urban artists following the routes of middle-class gentrification. By the beginning of the nineteenth century, the social standing and aesthetic output of an artist who moved west was quite distinct from that of Reynolds and his contemporaries. The career of John Varley (1778–1842), who had a summer house at Twickenham from 1804, reflects the transition. Varley was not a fashionable society figure with an ostentatious villa: he was at the forefront of a new, more intimate and domestic style of landscape painting, and used the local landscape as a teaching aid and source of personal inspiration.

Hampstead horizons

Towards the end of the eighteenth century, Hampstead began to rival the villages to the west of London as an artists' retreat. Like Richmond, it had mineral springs that had attracted Londoners since the late seventeenth century, and was first 'discovered' as a spa town. The gentry taking the waters also enjoyed the opportunity of taking the air on the heath. A topographical print made for this tourist market by J.B. Chatelain (1710–1758), *The Long Room at Hampstead from the Heath* (1745; fig. 44), shows fashionably dressed visitors straying – but not too far – on to the heath, with the Long Room dominating the village of Hampstead (at this date a mere cluster of buildings) on the horizon.[5]

It was not until the craze for the Picturesque in the last quarter of the eighteenth century that Hampstead really came into its own as a source of notable views and artistic inspiration that was easily accessible from London. The Picturesque was a way of categorizing views that seemed naturally composed in the 'foreground, middle distance and distance' format

established by the landscape painters of the seventeenth century. The perfect landscape was neither 'Sublime' (overwhelming, terrifying, craggy and untamed) nor 'Beautiful' (restful and undulating) but something in between: 'Picturesque'. On a day trip to Hampstead in the 1780s, Gainsborough supposedly raved to Reynolds at the thrill of finding a Picturesque vista on the "untouched" heath: "this picture composes well – yes! Beautifully! Intersected as it is!!! ... Thirteen degrees of distance have I counted – all distinct ... Tis like viewing nature through the medium of a lens."[6]

As nature was rarely so obliging as to provide ready-made views that lent themselves to this style of representation, artists had to adjust what they saw to produce the desired effect. The "lens" Gainsborough refers to might be a Claude glass, one of several contrivances for helping artists, amateurs and lovers of landscape to compose views in the approved manner. Named after the undisputed master of the Classical landscape tradition Claude Lorraine (1600–1682), this was a portable convex mirror with a tinted surface "in which the prospect could be condensed into a tiny framed picture, with the authentic Claudian glow".[7]

From the high ground at Hampstead and Highgate views could be obtained north towards Harrow or south towards London. The differences between London and the surrounding country were becoming more marked as the city grew in size and density and the air pollution became more noticeable: less Claudian glow than industrial smog. Writing about "London in a picturesque point of view" in 1802, James Peller Malcolm described the smoke with a mixture of dismay – "Smoke, so great an enemy to all prospects, is the everlasting companion of this great city" – and pride in the technological and manufacturing supremacy that it represented: "Yet is the smoke of London emblematic of its magnificence ... It is pleasing to observe the black streams which issue from the different manufactories".[8]

Moreover, the smoke created atmospheric effects that artists might enjoy: "At times, when the wind, changing from the West to the East, rolls the vast volumes of sulphur towards each other, columns ascend to a great height, in some parts bearing a blue tinge, in others a pale flame colour, and in a third, accumulated and dense, they darken portions of the city till the back rooms require candles". Malcolm's technicolour prose is suggestive of the new ways of seeing that arose at the end of the eighteenth century. Improved optical instruments enabled views to be seen up close or manipulated – as with a Claude glass – while innovative technology was exploited for popular urban entertainments such as Philippe de Loutherbourg's Eidophusikon, or "Various Imitations of Natural phenomena represented by Moving Pictures", and Robert Barker's 360° walk-in spectacle known as the Panorama, which opened in central London in 1781 and 1793 respectively.

44

J.B. Chatelain, *The Long Room at Hampstead from the Heath*, 1745, etching, 18 × 25 cm, London, Guildhall Library

45
J.T. Smith, *Near Jack Straw's Castle*, 1797, etching, 17.5 × 17 cm, London, Museum of London

46
Charles Robert Leslie, *Londoners Gypsying*, 1820, oil on canvas, 83 × 100 cm, London, Geffrye Museum

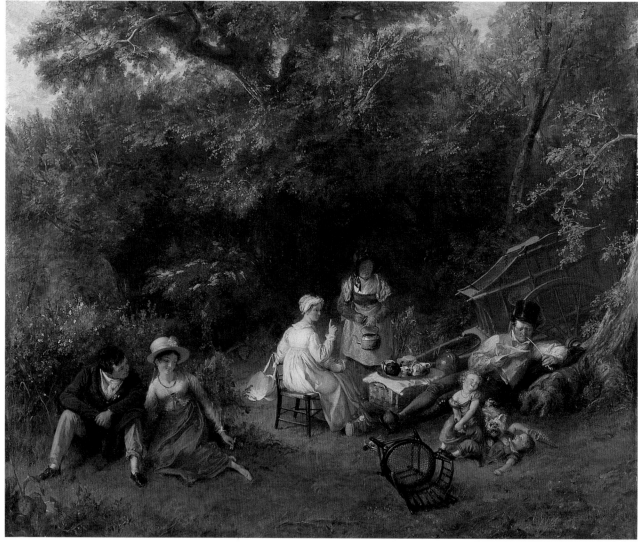

In order fully to appreciate the Picturesque, the public had to be educated to look at landscape in the correct way and in the right frame of mind. People had to be taught how to look anew at nature. As Malcolm explained, "A resident in London cannot form an idea of the grand and gloomy scene: it must be viewed from the environs". Vantage points were rated according to their Picturesque potential. The views from Greenwich Observatory, Putney Common, Harrow, Richmond Hill and Camberwell were praised, those from Primrose Hill and Greenwich judged only partially successful, but the view from Highgate was unreservedly admired. This echoed Thomas West's *A Guide to the Lakes*, published in numerous editions between 1778 and 1821, which contained a list of "stations" where the tourist might stand to see the landscape naturally compose itself according to Picturesque principles.[9] Thus Malcolm appropriated for the environs of London some of the Picturesque associations of the Lake District, and his commentary is a late example of the didactic literature that promoted the Picturesque sensibility.

Hampstead offered other contrasts that piqued the Picturesque imagination. Not only was it the start of 'proper' countryside beyond the urban and suburban sprawl: it also attracted people from opposite ends of the social scale. Enclosure – dividing the landscape up into the now-familiar patchwork of fields with walls and hedges – improved agricultural efficiency but deprived thousands of cottagers and farm labourers of their livelihoods, and its progress towards London was inexorable. Hampstead Heath was one of a shrinking number of commons where the displaced and impoverished rural population could build hovels and supplement casual jobs with a little livestock grazing, rabbiting and pilfering. An infamous shanty settlement at the very top of the heath was, somewhat indicatively, named 'Littleworth'.

As a style, the Picturesque delighted in the textures and shapes of "rough ruins" and "ragged children"[10] (when they

were found in rural settings; paupers in city slums, on the other hand, were associated with the threat of crime and disease). Successful artists naturally adopted the attitudes and prejudices of the prosperous entrepreneurial class and had no special sympathy with the plight of the rural poor, but they found that squatters and gypsies lent interest to the landscape: "'Gipsies – where?' exclaimed Gainsborough, jumping up and seizing the telescope, 'My Heaven, how precious! I'll be among you! – Yes! This is worth a day's march. What a delectable group!'"[11] The Picturesque aspects of poverty are exploited in *Near Jack Straw's Castle, Hampstead Heath* (1797; fig. 45), John Thomas Smith's delicately drawn etching of a pitiful Hampstead hovel at the top of the heath.

The Picturesque sensibility, which had been the preserve of intellectuals and aesthetes in the eighteenth century, was popularized and eventually debased into mere tourism. *Londoners Gypsying*, painted in 1820 by Charles Robert Leslie (1794–1859), shows – perhaps with a grain of satire – the urban bourgeoisie enjoying the romantic associations, and none of the discomforts, of the gypsy life in Epping Forest (fig. 46).

One of the first fashionable artists recorded as not merely visiting but actually going to live in Hampstead was the portrait painter George Romney (1734–1802). Romney first rented lodgings in Hampstead in April 1788, and spent that summer commuting to his house and studio in Cavendish Square on foot. A few years later, he was considering setting up his own academy and gallery, and had taken delivery of a large number of casts of antique statuary specially chosen for this purpose and despatched from Rome by his friend the sculptor John Flaxman (1755–1826). Romney was about to sign a building lease on a large plot on the Edgware Road, a plan that would certainly have bankrupted him, when his son John (no doubt with an eye on his eventual inheritance) persuaded him instead to move permanently to a "good ... and convenient house" in Hampstead that

47, 48
Romney's house, Hampstead, London

could be extended with a gallery and studio "at small expense" (figs. 47 and 48).[12]

Hampstead suited Romney's determination to achieve "pastoral felicity" by escaping the city, where bustle and pollution had an "unpleasant effect upon [his] senses". To John's relief he purchased The Mount, on Holly Bush Hill, for £700. However, he soon became obsessed with opening a gallery on the site, and began building almost immediately. While his "whimsical structure" was being raised, Romney continued to walk to and from central London as necessary.

where those that were not stolen rotted in the damp. John can be forgiven the grim accuracy with which he recorded his father's extravagance: the new building cost £2733 and eventually sold for £357. Romney left Hampstead for ever in 1799, and spent the last three years of his life in his native north of England.[13]

Capturing the countryside

The artist who retreated to the country could not do so permanently, for fear of losing his carefully nurtured clientele and professional contacts. Maintaining career momentum also meant

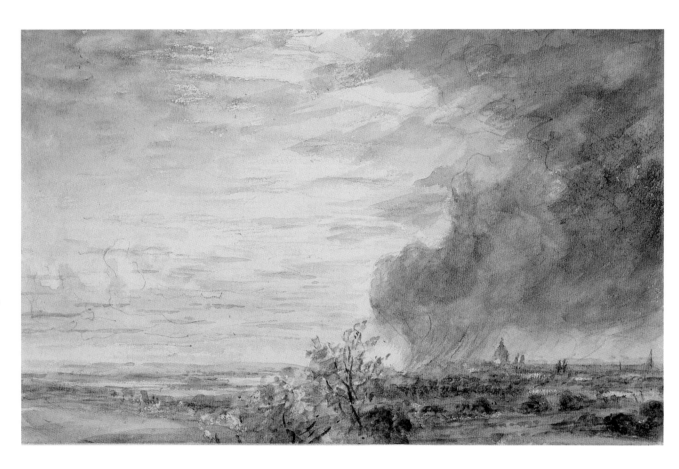

49
John Constable, *View Towards London from Well Walk*, 1830, pencil and watercolour, 11.2 × 17.8 cm, London, British Museum

He moved in at Christmas 1797, while the plaster was still wet, eager to set up his cast gallery of Classical sculpture. Ignoring the wonderful views over the metropolis that Prospect House afforded, Romney hoped to attract visitors by creating a little Rome in London's own Campagna. He expected to fill his academy with young trainee artists, but only Isaac Pocock (1782–1835) was prepared to make the round trip from London regularly. This professional isolation left Romney struggling. Disordered heaps of unfinished portraits bore witness to his lost motivation and declining health. There was not enough space to accommodate his collection, so paintings had to be stored in outbuildings,

keeping a studio going in central London, a practice followed by most London artists who divided their time between town and country, until the fashion for building studio houses in the suburbs took hold in the 1860s and 1870s.

Hampstead is within easy reach of central London, and as early as 1740 there were two daily coaches into town, one to Holborn, the other to Covent Garden. This convenience, paired with a determination to get out of the polluted city, was the principal reason why John Constable (1776–1837) moved there. He and his family spent part of every summer from 1819 to 1826 in various rented lodgings in Hampstead (fig. 50).[14]

The annual effort of moving house eventually became too much, especially as Constable's wife Maria had tuberculosis, and by 1826 the painter was looking for a permanent home in Hampstead to "prevent if possible the sad rambling life which my married life has been, flying from London to seek health in the country".[15] They moved permanently to no. 6 (now no. 40) Well Walk in 1827 (fig. 49). The annual rent was £52, a slightly better bargain than the four guineas a week they had paid for unfurnished accommodation in Lower Terrace, Hampstead, during 1821. Constable was delighted: "three miles from door

carry out studies direct from nature. In two years alone, 1821–22, he painted more than fifty sky studies. The heath was the ideal spot from which to observe a wide range of weather effects, and he sketched the skies methodically, noting the date, time of day, wind direction and temperature. One such annotation reads, "September 21, 1822, looking south Brisk wind to East, warm and fresh 3 o'cl afternoon"; another, "Afternoon 17 April 1834/ Hampstead/ and Evening look S.E./ 5 O'Clock Wind East" (fig. 51).

'Skying' was an established practice among landscape artists. Wright of Derby, Turner, Cornelius Varley (1781–1873)

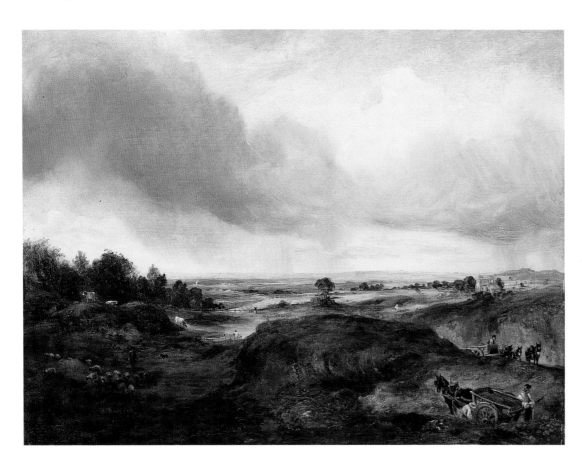

50
John Constable, *Hampstead Heath*, c. 1825, oil on canvas, 44.5 × 60.9 cm, Greater Manchester, Bury Art Gallery and Museum, Thomas Wrigley Collection

to door – can have a message in an hour – & I can get always away from idle callers – and above all see nature – & unite a town & country life".[16] Although the looked-for improvement in Maria's health never happened – she died in 1828 shortly after they moved in, following the birth of their seventh child – Constable kept the house at Well Walk until his death. Nevertheless, he maintained the lease of his London base, 76 Charlotte Street, and thought of himself as a London artist. Hampstead was not a place of labour, but a place for leisure, refreshment and contact with nature.

From his first visits to Hampstead, Constable was able to

and William Mulready (1786–1863), among Constable's contemporaries, produced studies of cloud formations and weather effects;[17] Constable merely did so with more dedication and method than most. The question that he asked in a lecture towards the end of his life, "may not landscape painting be considered as a branch of natural philosophy, of which pictures are but the experiments?",[18] helps to explain the almost scientific rigour with which he studied the sky. His Hampstead cloud studies are the visual equivalent of the written records of natural phenomena kept by scientists and amateurs such as Gilbert White, whose *Natural History of*

51
John Constable, *Cloud Study*, 1822, watercolour, 30.5 × 49 cm, London, Courtauld Institute of Art, Witt Collection

52
Frederick Waters Watts,
Branch Hill Pond,
c. 1820, oil on canvas,
94 × 109 cm, London,
Hildegard Fritz-Denneville
Fine Arts Ltd

Selborne had been a bestseller since its first publication in 1788–89. Constable's 'skying' was complemented by his formal knowledge of meteorology, gleaned from works such as Luke Howard's *On the Modifications of Clouds* (1803) and his *The Climate of London: Deduced from Meteorological Observations* (1818–20), both of which he owned.[19] While he may have been fascinated by the meteorological explanations for rainbows and cloud formations, his interest in science never blinded him to beauty or dulled his emotional reaction to the landscape: "The last day of Octr was indeed lovely so much so that I could not paint for looking – my wife was walking with me all the middle of the day on the beautifull heath".[20]

Professionally something of a loner, Constable joined in the local community life of Hampstead more than most painters, but socialized proportionately less with other artists who were there – even managing to alienate his Hampstead neighbour John Linnell (1792–1882) in a squabble about elections to the Royal Academy.[21] He did, however, inspire one local follower. Little is known of Frederick Waters Watts (1800–1862), who was living on the High Street in 1821 (at the same time as Constable) and who copied Constable's celebrated style (fig. 52). The older man was certainly aware of Watts's tendency to imitate him by 1833, when he remarked on the confusion caused when both had works hanging in the same exhibition.[22]

The tradition of landscape painting in oils in the seventeenth and eighteenth centuries required the artist to make studies out of doors that would be taken back to the studio to be adapted to fit the accepted rules of art and used as notes for finished oil paintings. The sketches were merely aids to the painter, and not valued as works of art in their own right; hence Constable's claim that "I do not consider myself at work without I am before a six foot canvas".[23] In the nineteenth century, however, some English painters began to seek a freer rendition of landscape through painting directly from nature in the open air. The results might stand as pictures in their own right; and artists endeavoured to keep the same freshness in their studio pictures, rather than recomposing and overworking them in the stately seventeenth-century manner.

At the same time, watercolour was becoming more important. Hitherto used for tinting topographical views and maps, and viewed as the poor relation to oil painting, watercolour now came into its own as a medium for finished paintings – particularly landscapes – that were destined for public exhibition. Unlike oil paint, watercolour does not permit overpainting and reworking: each brushstroke must stand on the paper as it comes from the painter's hand. It requires confidence and encourages freedom and spontaneity, and thus is ideally suited to on-the-spot renditions of landscape like those that Constable and others produced during their Hampstead sojourns.

53
George Scharf, *Interior Showing Visitors to the New Society of Painters in Water Colours*, 1834, watercolour, 29.6 × 36.9 cm, London, Victoria and Albert Museum

Early watercolour paints were lumpy and had to be grated and soaked before they could be used. John Middleton of St Martin's Lane was the first to produce watercolour paints in cake form, but the more astute William Reeves (1739–1803) perfected the process and made it commercially viable, for which he was awarded the "great silver pallet" of the Society of Arts in 1781.[24] The new watercolour cakes were easy to use out of doors and, neatly packaged in portable boxes, were less cumbersome on outings. Hampstead artists had to stock up on paints before leaving town, as the colourmen continued to trade at their traditional central London locations in and around St Martin's Lane.

In 1804 sixteen artists founded the Society of Painters in Water Colours, in an attempt to put themselves on an equal footing with oil painters and to obtain exhibition space alongside similar types of painting, where they would not be overshadowed by blockbuster oils as they were at the Royal Academy.[25] They were eager to educate a wider public to appreciate watercolour paintings as art objects in their own right, something that was not possible while watercolours were relegated to the small back rooms at the Academy, alongside inferior oil paintings. The Society organized a selling exhibition, the first such exhibition devoted entirely to watercolours, which opened in April 1805 at 20 Lower Brook Street.

A similar organization, the Associated Artists in Water Colours, lasted only four years after its founding in 1808, but reformed in 1832 as the New Society of Painters in Water Colours. Scharf's watercolour of their third exhibition, held in Old Bond Street in 1834, shows pictures in a wide range of subjects and styles, all framed in the same kind of heavy gilt frames as those that were used for oil paintings (fig. 53). Scharf was an active member of the New Society, but resigned in 1836, confiding to

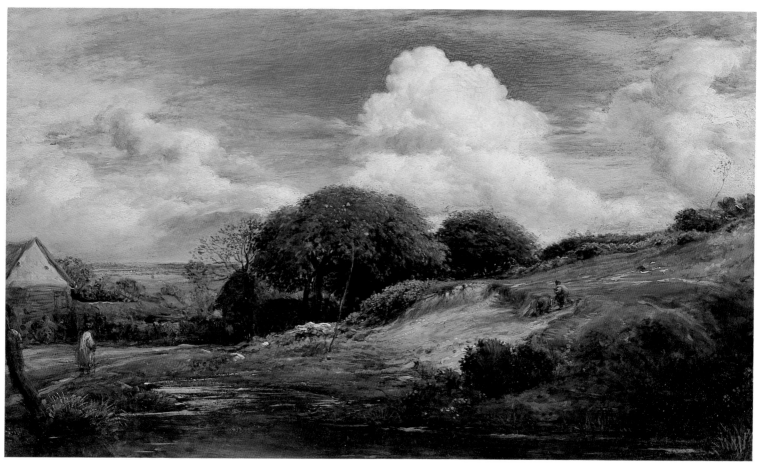

54

John Linnell, *Collins's Farm*,
1830–34, oil on canvas,
15.4 x 37.5 cm, London,
Museum of London

55

John Varley, *Frognal,
Hampstead*, 1826,
watercolour, 26 × 39 cm,
London, Victoria and Albert
Museum

his diary that it was "in consequence of my being unable to continue paying the subscription of 6 shillings per month and felt it very hard to have to pay a fine of 5 shillings each time when I was a month behind paying it".[26] Watercolourists accepted these rather high subscription rates in exchange for recognition and status that they could not otherwise obtain, and for the opportunity to exhibit their work to the public in a sympathetic setting.

John Varley was one of the many artists who benefited from the new interest in watercolour (fig. 56). Coming from an impoverished London family, Varley had grown up in Carnaby Market and had been apprenticed to a portrait painter in Holborn in 1793 or 1794, but in his limited leisure time he enjoyed sketching and would disappear to Hampstead "in search of the picturesque".[27] While his style developed along more naturalistic lines, his early training honed his ability to "cook" nature for more commercial ends. Another way of bolstering his income was to take on pupils. At first these were well-born ladies, but soon he became renowned as the best watercolour teacher in London, and by 1805–06 the "whole of the rising generation of watercolour artists were his pupils".[28] Among those paying £100 per year, and living at Varley's house in Golden Square in 1805, were the thirteen-year-old John Linnell

and William Holman Hunt (1827–1910), then aged fifteen. Despite Varley's commitment to careful composition and meticulous finish, his pupils were encouraged to draw from nature and in the open air when they accompanied their teacher to his summer house in Twickenham. Varley's own watercolour of Frognal (1826; fig. 55) is carefully inscribed "painted on the spot" to identify it as an open-air and not a studio production.

John's brother, Cornelius (1781–1873) practised as a painter for a short while. He too was a founder-member of the Old Water Colour Society, but made little impact – perhaps because he was so committed to working *en plein air*, direct from nature. Following the early death of their father, he was fostered by his uncle Samuel Varley, a scientific-instrument maker, and made his greatest mark on the London art world with his Patent Graphic Telescope (1811). This product of the convergence of art, science and technology allowed "any person, who can make a good outline, [to] draw, correctly, all kinds of objects".[29] It was on sale at Varley's own premises, 228 Tottenham Court Road, and other art-supplies shops, including Rudolf Ackerman's Repository of the Arts at 101 Strand. Curiously, given that his profession demanded precision above all things, and that his Telescope was designed for objective and exact renderings of buildings and topographical outlines, Cornelius painted with a much freer and more spontaneous style than his brother.

Collins's Farm

The Varleys were at the centre of a group of painters that included Mulready, John's former pupil Linnell (1792–1882) and Linnell's good friend, William Blake (1757–1827). On 27 May 1821 Blake went with Linnell to Hampstead, which seems to have been Linnell's first visit. The following summer Linnell established his family in lodgings at Hope Cottage, North End, Hampstead. He did not stay with them but spent the week working in his studio in London, joining them only on Sundays. The following year they rented Collins's Farm at North End for the summer, and in 1824 they moved there permanently (fig. 54). Linnell kept his studio at 6 Cirencester Place (the street no longer exists, but was near Newman Street and off Fitzroy Square) and commuted between home and work by coach.[30] He came increasingly to rely on portraiture for his income during the 1820s, and it was essential for him to keep a studio in central London in order to be close to his clients. Linnell also maintained close links with the London art-publishing trade, and eventually published Blake's *Book of Job* (fig. 58) from his Cirencester Place address.

Linnell's drawing of William Blake in conversation with John Varley (1821; fig. 59), done in Cirencester Place, conveys the informal friendship that existed between the artists associated with Collins's Farm. Artists from three generations, including Blake, the Varleys, Mulready, George Richmond (1809–1896) and Samuel

56
John Linnell, *Portrait of John Varley*, c. 1808–15, watercolour, 11.9 × 9.1 cm, London, Victoria and Albert Museum

57
John Linnell, *William Blake on Hampstead Heath*, 1825, pencil, 17 × 11 cm, Cambridge, Fitzwilliam Museum

58
William Blake, *The Lord Answering Job out of the Whirlwind*, 1826, engraving, 22 × 17 cm, Cambridge, Fitzwilliam Museum

59
John Linnell, *Blake and Varley in Conversation at Cirencester Place*, 1821, pencil, 11.3 × 17.6 cm, Cambridge, Fitzwilliam Museum

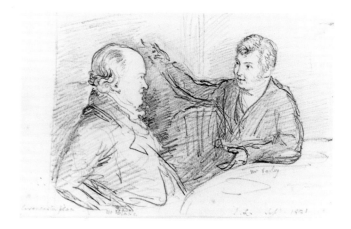

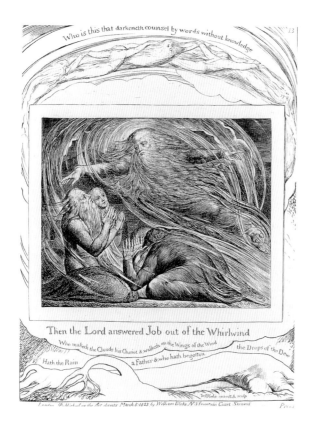

Palmer (1805–1881), shared ideas, inspiration and observations on the walk from the West End to Hampstead. Of this group, Linnell and Blake were particularly close. Though of different generations, both had been educated at the Royal Academy schools; both rejected religious conformity (although their principles took them in markedly different directions, Linnell sampling several nonconformist sects before evolving his own natural philosophy and Blake becoming committed to his own visionary path); both were outspoken and tenacious, and neither was a respecter of persons. Their friendship was enhanced by Blake's fondness for Linnell's large and loving family whom he would visit most Sundays at Collins's Farm. The children would look out for Blake's approach across the heath, recognize his special wave, and troop out to meet him. Once home, they would sit on his knee while he told them stories. Hannah Linnell remembered "cold winter nights when Blake was wrapped up in an old shawl by Mrs Linnell, and sent on his homeward way, with the servant, lantern in hand, lighting him across the heath to the main road".[31] Blake lived with his wife in two rooms, one of which was his shop and workroom, in Fountain Court, off the Strand, trapped by poverty in a part of London that was no longer the centre of artistic fashion that it had been in his youth.

Although Blake professed an aversion to Hampstead, during his visits to Collins's Farm he "would often stand at the door, gazing in tranquil reverie across the garden towards the

gorse-clad hill".[32] Linnell captured that contemplative mood in a pencil drawing of Blake "on the hill before our cottage at Hampstead", of about 1825 (fig. 57).[33] Their friendship lasted until Blake's death. Linnell, moreover, was a tactful patron: he commissioned Blake to engrave his earlier ink designs for the *Book of Job*, and arranged for him to be paid a retainer to work on Dante's *Inferno*, eventually publishing them as a way of providing for the impoverished older man without making him appear dependent on charity.

In 1828 Linnell moved to a new house in Porchester Terrace, Bayswater, ending his connection with Hampstead. This change of address seems to mark the change in the direction of his art as he reached his mid-thirties, and also the break-up of the first notable artistic community in Hampstead. The younger generation of 'Ancients', led by Palmer and Richmond, had moved away to the 'real' countryside, Palmer having decamped to Shoreham in Kent in 1826. Driven by the need to provide for a large family and by the vivid memory of his own father's bankruptcy, Linnell concentrated on portraiture and formulaic landscape oils that betrayed the artistic promise of his youthful watercolours but which were guaranteed to sell. He eventually retired to Redhill in Surrey, where he lived out a prosperous old age. A few years later, when George Sidney Shepherd (1784–1862) painted a watercolour of Hampstead Heath in 1833, the inscription he added – "Finished on the spot" – was a conventional acknowledgement of *plein-air* orthodoxy. It depicts the heath, the duck pond and the trees, and in the background the newly built terraced housing on Downshire Hill. Hampstead, no longer a rural retreat, was on the point of being absorbed into London proper (fig. 60).

60
G.S. Shepherd, *Hampstead Heath*, 1833, watercolour, 31 × 47 cm, London, Victoria and Albert Museum

Marylebone 1770–1850

Studios & homes

1. Benjamin West
14 Newman Street, 1774–1820
2. John Bacon
17 Newman Street, 1774–99
3. John Partridge
7 London Street, 1815
21 Wigmore Street, 1817–25
21 Brook Street, 1828–72
4. Thomas Stothard
28 Newman Street, 1794–1834
5. John Flaxman
7 Buckingham Street, 1796–1826
6. John Russell
21 Newman Street, 1790–1806
7. Thomas Brooks
22 Charlotte Street, 1848
8. Augustus Egg
6 University Street, 1838
9. William Powell Frith
31 Charlotte Street, 1840s
10. Henry Nelson O'Neil
68 Newman Street, 1840s
11. John Phillip
71 Newman Street, 1840s

12. Edward Matthew Ward
67 Berners Street, 1840s
13. John Linnell
6 Cirencester Place, 1818–27
14. John Constable
35 Charlotte Street, 1822–37
Keppel Street, 1816–22

Meeting places
**15. Mrs Mathew's Literary
& Artistic Salon**
27 Rathbone Place, 1779–84

Supporting trades & organisations
16. G. Rowney & Co.
51 Rathbone Place
17. Winsor & Newton
39 Rathbone Place, 1841–1938
18. S. & J. Fuller
34 Rathbone Place, 1810s–30s
19. Sherborn & Tillyer
321 Oxford Street, c. 1810–20

Art schools & academies
**20. Leigh's Art School, 1848–60
Heatherley's Art School, 1860–87**
79 Newman Street

Exhibition spaces & dealers
21. Gambart & Co.
print dealer
25 Berners Street, 1844–68
22. Lord Grosvenor's Gallery
Gloucester House, Park Lane, 1826

Inspiring sites & architecture
23. British Museum
Great Russell Street

Unnumbered coloured spots indicate
lesser-known artistic locations

Richard Horwood
*Plan of the Cities of London and
Westminster*
1792–99

1770–1850
'Artists' Street' in Marylebone

1770–1850
'Artists' Street' in Marylebone

Throughout the eighteenth century fashionable society in London moved westwards into the new, ever smarter housing that was springing up to the west of Soho. The development of St James's and Mayfair had begun in the 1660s, and over the next century these areas filled up with aristocratic and middle-class housing. Although the laying-out of Cavendish Square in the 1720s gave an impetus to the development of Marylebone, Oxford Street formed a kind of unofficial northern boundary to the central London area of Covent Garden, Leicester Square and Soho for another twenty years. But once William Berners began in 1738 to build streets of houses on fields he owned north of Soho, at the eastern end of Oxford Street, development continued unabated for the rest of the century. Berners Street, Rathbone Place and Newman Street were built in the 1740s, Charlotte Street was begun in 1787, and Fitzroy Square was laid out (although not completed) in the 1790s. Three ink-and-wash drawings of c. 1771–72 in the Museum of London's collection show built-up town abruptly meeting open country at the top of Newman Street before the building of Norfolk Street (now Cleveland Street) in 1774, and how stretches of Tottenham Court Road were dotted with cottages, timber yards and agricultural buildings, with boundaries defined by hedges and ditches (fig. 61).

Artists followed the general move westward, sticking as closely to polite society as their means would allow. The more established painters tended to live at the smartest addresses west of Oxford Circus. Portrait painters still needed to be in the centre of fashion so Ramsay was at 67 Harley Street between 1767 and 1784, Romney at 32 Cavendish Square between 1775 and 1797, and John Singleton Copley (1738–1815) in George Street off Hanover Square. These were very desirable residences: the diarist Joseph Farington noted how, when Romney was planning his move to Hampstead he "did mean to part with his House in Cavendish Square, but was so struck with his own description of it when He drew up an advertisement, that He resolved to continue in it".[1] When Romney did eventually sell, it was to the young Martin Archer Shee (1769–1850), a future president of the Royal Academy, and part of the bargain was that Romney would sit to Shee for his portrait. No doubt the younger painter sought to strengthen his association with someone who was already an established 'name' in the London art world.

Stratford Place, on the north side of Oxford Street halfway between Oxford Circus and Marble Arch, was certainly smart enough for the superfashionable Richard Cosway (1742–1821) and his wife Maria (1760–1838). The Cosways were artist-celebrities in the 1770s and 1780s. Richard in particular adored smart society and aspired to be a part of it. He naturally chose to live alongside the aristocrats and courtiers who sat for his exquisite miniature portraits, first at 4 Berkeley Street in Mayfair, and then in St James's, at Schomberg House on Pall Mall (fig. 62). He moved to 22 Stratford Place in 1791, and lived there amid his fabulous collection of pictures, furniture, tapestries, clocks, sculpture, armour and porcelain until just before his death in 1821.

Artists of lesser fame – or with fewer pretensions – began to colonize the area north-east of Oxford Circus, around Newman Street in the acute angle between Tottenham Court Road and Oxford Street. Home to innumerable painters and sculptors from the 1770s until the middle of the nineteenth century, this area made Marylebone famous as 'the artists' parish'.[2]

These streets were packed with classic London terraced houses on narrow plots. At first glance, the living quarters do seem rather mean: the American painter and president of the Royal Academy Benjamin West (1738–1820), for instance, occupied a house only two rooms deep, and each of those barely 5.2 m (17 feet) wide (fig. 63). But such a view does not take into account the adaptability of these houses and their extended gardens. As Andrew Saint has pointed out, "Every kind of activity might be carried on within them. Crafts-industry, storage, shops, museums, schools, pubs, coffee houses, smart hotels, fetid lodging-houses, brothels, banks and offices all operated within the same basic framework of front rooms and back rooms on different levels off a simple set of stairs.

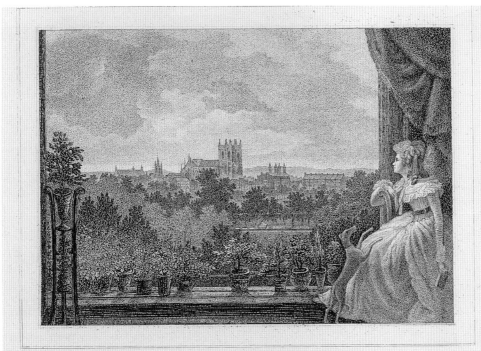

61
Samuel Hieronymous Grimm, *Newman Street Behind Middlesex Hospital*, c. 1771–72, pen, ink and wash, 16 × 23 cm, London, Museum of London

62
William Birch after William Hodges and Richard Cosway, *A View from Mr Cosway's Breakfast-Room, Pall Mall*, 1789, stipple engraving, 18 × 22 cm, London, Museum of London

The London terrace house was most commonly built with the middle-class family in mind. But over the centuries it had been honed down to an instrument of infinite flexibility."[3]

West was one of the first artist-settlers who found Newman Street attractive and its modest housing perfectly adequate; he bought no. 14 in 1774 and stayed there until his death in 1820. He painted mainly historical, biblical, literary, military and patriotic subjects – high-minded themes that, owing to the patronage of George III, earned him enormous prestige and wealth. His election as president of the Royal Academy in succession to Reynolds in 1792 confirmed the bias of the Academy towards high-status, large-scale history painting. The respect accorded to West during his lifetime says a great deal about the status that the Royal Academy had attained within its first thirty years, and also the degree to which artists had managed to create interest in, and a market for, history painting during that time.

Annually published lists of "Eminent Painters ... Whose galleries and works may be viewed at proper times, by a fee to the servant" indicate just how many artists encouraged visitors to their studios and private galleries.[4] Attempting to satisfy and influence London's new enthusiasm for art exhibitions, artists set up their own displays so that they could control the setting and the manner in which their work would be seen. They could also ensure that the paintings were hung and lit to their best advantage, and that their importance was properly explained to an audience who were willing to develop an understanding of art. This was how the Yorkshire traveller Dorothy Richardson recorded her visit to West's gallery in 1785:

> From the British Museum, we proceeded to Mr West's in Newman Street Oxford Road and were conducted down a long Gallery furnish'd with drawings into a large square Room lighted from the Roof & fill'd with paintings ... The Door into an inner Room being left a little open, Mr Webber who was with Mr West, heard our voices, came to us, & introduc'd us into Mr West's Painting Room. Here we saw a very large Landscape with a view of Windsor Forest, in the Foreground a hut, & a woodcutters Family with Pigs &c, 2d distance the King hunting ... Mr West was painting a very large Picture for the Kings Chapel there, the subject St Peter preaching ... a harsh featur'd man was sat by the fire almost smother'd with woollen drapery from whom Mr West was painting one of the figures ...[5]

Between 1808 and 1809 West produced a family portrait that also shows the alterations he had made to his house in order to display his works to their best advantage (fig. 64).

63
George Robins, *Plan of Benjamin West's House*, 1829, engraving and coloured wash, London, Westminster Archives Centre

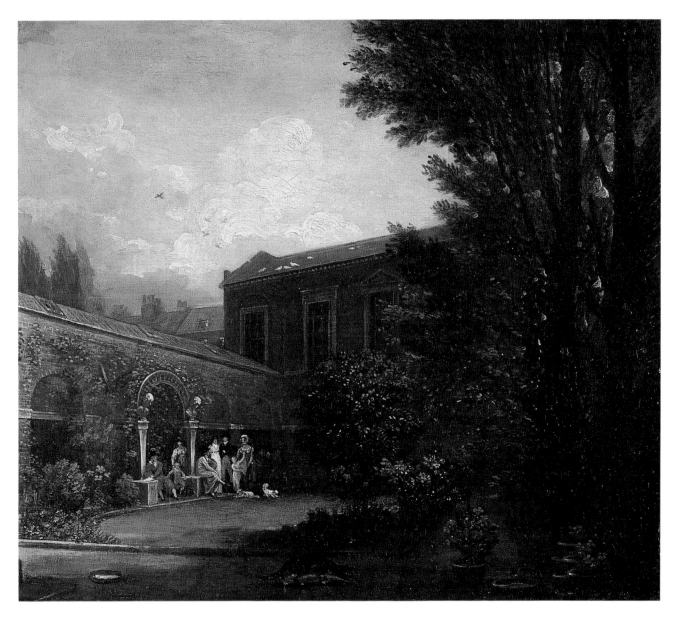

64
Benjamin West, *Portrait of the Artist and his Family in their Back Garden*, 1808–09, oil on canvas, 33 × 40.5 cm, Washington, DC, Smithsonian Institution, National Portrait Gallery

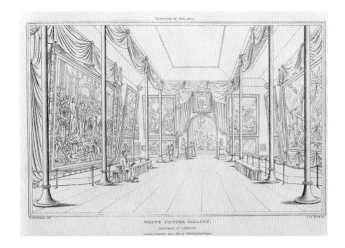

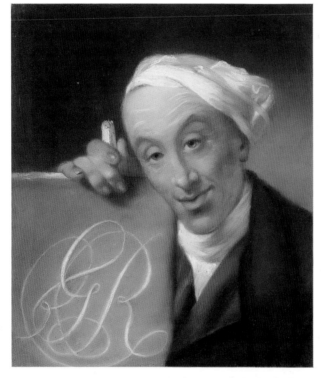

65
John Le Keux after George
Cattermole, *West's Historic
Gallery*, 1821, engraving,
23 × 29 cm, London,
British Museum

66
John Russell, *The Sign
Writer*, c. 1790s, pastel,
48.7 × 42.5 cm, London,
Courtauld Institute of Art

67
Anon., Sherborn and Tillyer
trade signs, c. 1800–20,
oil on panel, London,
Museum of London

Leigh Hunt described these in his autobiography as "a gallery at the back of [the house], terminating in a couple of lofty rooms. The gallery was a continuation of the house-passage, and, together with one of those rooms and the parlour, formed three sides of a garden, very small but elegant, with a grass-plot in the middle and busts upon stands under an arcade."[6] This pleasant prospect was lost in 1821, the year after the painter's death, when his sons built a "noble and splendid gallery" on the garden "at an expence of nearly £4,000" in order to open a permanent exhibition of over a hundred of their father's works.[7] Such was the initial popularity of "West's Gallery" that it was the subject of a painting by John Pasmore and an engraving after John Le Keux that shows West's two most famous works, *Christ Rejected* (1811) and *Death on a Pale Horse* (1817), hanging in the foreground (fig. 65). Despite changing the pictures after a six-month interval to maximize exposure and repeat visits at one shilling a time, the gallery went bankrupt in 1828. The family auctioned their collection of West's paintings and sold his Newman Street premises to a lithographic printing business.[8] This descent from the Olympian heights of history painting to mere commercial reproduction was not the final indignity: the Great Room where West's pictures had hung was a public meeting-hall by 1872, and was eventually demolished.

West was the nucleus around which other Academicians clustered. In one year, 1810, there were no fewer than six Royal Academicians in Newman Street alone.[9] One of the most prolific was John Russell (1745–1806; fig. 66), who produced portraits and commercially pleasing genre and subject paintings of the eroticized infant and pet variety. He first exhibited his work at the Society of Artists in 1758 but swapped allegiance to the Royal Academy, where he exhibited 332 works over the years. Russell's diaries show that he made about £600 in 1786, but after he became an RA in 1788 his earnings increased to about £1000 per year. In 1790 he was charging £150 for a group portrait and £80.15s. for a half-length (Reynolds at this point was charging £70). Smaller portraits cost between £33 and £52.10s. After his marriage he moved to 7 Mortimer Street, near Cavendish Square. Like many educated men at this time, Russell was interested in science, particularly astronomy. He constructed a mechanical model of the moon from studies he made with a telescope borrowed from his neighbour John Bacon (1740–1799). Together they were in good company: science and natural philosophy were hot topics within the artists' community, especially among those such as Stothard, Blake and Flaxman, who attended Mrs Matthew's literary and artistic salon at 27 Rathbone Place (c. 1779–84).[10]

In 1794 Thomas Stothard (1755–1834) bought the freehold of 28 Newman Street for "the modest sum of £1000".[11] A painting by an unknown artist shows Stothard – a dandy in

tasselled boots and with collar-length wavy hair – in his front-room studio, in what would have been the main, first-floor reception room (fig. 68). Far from being an idealized studio view of the eighteenth century, this is possibly one of the first depictions of an English artist in a realistic studio. On show is the paraphernalia of a working studio: pictures crowd the walls, a portfolio and studio props – a military jacket with epaulettes, a sword – appear in the foreground; on a table under the window lie brushes, a palette and oil flask, and in the corner is a magnifying mirror, to increase reflected light from a candle or lamp and make it easier for the painter to see his work at night. The equipment and processes, even the technology, used to produce works of art were now beginning to be celebrated along with the "sanctum sanctorum" in which this work was created.[12]

It was easy for Stothard to buy his materials locally, for as in Covent Garden in the eighteenth century, the presence of so many artists in one place attracted other, related trades into the Newman Street area. Among the businesses in Newman Street that could supply artists' materials, *Johnstone's Directory* for 1817 lists an oil warehouse and a carver and gilder, while those who might buy artists' designs included a firm of printers, a bookbinder, a stained-glass manufacturer and several jewellers. Near by were other suppliers, such as the colourmen Sherborn & Tillyer, at the sign of St Luke, at 321 Oxford Street (fig. 67).

Sculptors, who needed space, as well as good transport routes to move their heavy materials around, also found this area convenient and well connected. There is a continuous presence of sculptors in the vicinity at different times and with considerable overlaps: Thomas Banks (1735–1805) at 5 Newman Street between 1779 and 1805; Joseph Nollekens (1737–1823) at 9 Mortimer Street; John Flaxman (1755–1826) at 7 Buckingham Street off Fitzroy Square (now Green Street); and Peter Turnerelli (1774–1839) at 67 Newman Street. One of the more prolific sculptors in the area was John Bacon, who had moved to Wardour Street after realizing that his "small studio in the city" was in an "unfavourable situation".[13] After winning an important royal commission, he moved to 17 Newman Street – his final destination (fig. 69).[14] His large output of statues, monuments, chimney pieces and other architectural work required a team of between fifteen and twenty carvers. The narrow street frontage of his house belied the eventual size of the complex of modelling room, workshops, furnace and statuary yard behind. When business was brisk and artistic inspiration failed him, the pragmatic Bacon would sigh that he supposed he would have to fall back on "our old friend the Pellican"[15] – a reference to a symbol of Christian piety that he used with "remorseless frequency".[16] At his death in 1799 he left £17,000 in his will and several properties in and around London.[17] The youngest son of Bacon's first marriage, also a

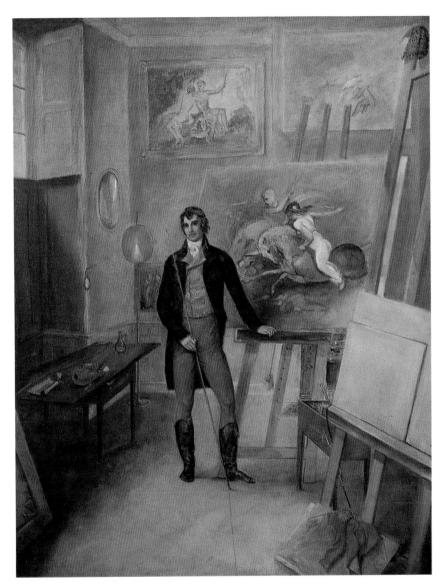

68
Anon., *Portrait of Thomas Stothard*, c. 1800, oil on canvas, 89 × 68.5 cm, Oxfordshire, Roy Davids Ltd

69
Plan of John Bacon's Premises at 17 Newman Street, 1769, London, London Metropolitan Archives

sculptor, inherited his father's "models, books, drawings, prints, marble and the remaining money not yet paid on the several works [still in the yard upon Bacon's death]". The property suffered a similar fate to that of West, becoming subdivided and used for less prestigious branches of art. Part of the yard was leased to a "glass enameller" (*i.e.* a stained-glass maker), and eventually the property was taken over by another firm of lithographic printers.

One of the great attractions in this part of London was the British Museum. For fifty years after its founding in 1753,

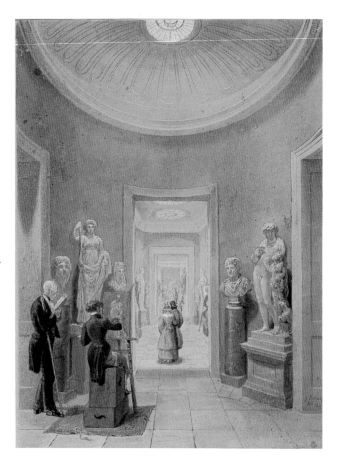

70
George Scharf, *Sculpture Gallery at the Old British Museum, Montagu House*, 1827, watercolour, 24 × 17.8 cm, London, British Museum

71
John Flaxman, *Monument to Anne Fortescue*, 1817–19, plaster maquette, 48.6 × 25.7 cm, London, University of London, College Art Collections

the museum was housed in Montagu House, Bloomsbury (demolished in the 1840s to make room for the front of the present building), and until 1879 the general public were not freely admitted, but students who could show that they were serious artists could obtain a ticket to study and draw the collections (fig. 70). Copying antique sculpture was the basis of all figure drawing, and interest in this aspect of art training was intensified by the arrival of the Elgin Marbles in 1816. The opportunity to view the frieze of the Parthenon at close quarters gave a boost to the Greek Revival strand of Neo-classical design, and

increased the status of Classical sculpture generally. George Frederick Watts (1817–1904), who entered the RA Schools in 1835, later proclaimed that his only true teacher had been the Elgin Marbles.

The great Neo-classical sculptor and illustrator John Flaxman moved to Buckingham Street, off Fitzroy Square, in 1794. Flaxman was the son of a model-maker who had been employed by Roubiliac, and had taught himself to draw and model by copying work in the family shop in Wardour Street. He studied at the Royal Academy, where he formed lasting friendships with William Blake and Thomas Stothard, but made his reputation, particularly as an illustrator, during a seven-year stay in Rome.

A visitor recalled the Buckingham Street house in Flaxman's old age: "We entered a small, simple house, but nice and well

kept like all English dwellings, and were shown into the 'drawing room' on the ground floor which was decorated with some witty oil sketches of Fuseli and Stothard".[18] Flaxman's modest lifestyle there was remarked upon: "He kept neither coach nor servants in livery and considered himself more the companion than the master of his men, treated them to a jaunt in the country and a dinner twice a year".[19] The fact that this was considered noteworthy by the Academy's Professor of Sculpture indicates that other Academicians were living in grander style.[20]

Flaxman followed the common practice of making a clay model that was then cast in plaster for his workmen to copy in marble; his assistants used the Improved Pointing Machine invented by Bacon to transfer the three-dimensional design to the block of stone.[21] The plaster cast (1817–19) of the monument

to Anne Fortescue is a typical example of one of Flaxman's Neo-classical memorials (fig. 71). The tablet below the figures is left blank so that an individual inscription can be inserted.

The career of the sculptor William Behnes (1795–1864) began and ended in the Newman Street area. Behnes got off to a promising start: he came to live in Newman Street in 1818, and the following year the Society of Arts awarded him a gold medal for his invention of a pointing machine. As commissions began to pour in, he made the expensive mistake of buying a house in Dean Street, Soho, that was completely unsuitable for making sculpture. It cost him so much to adapt this house and add a modelling room big enough for large-scale statues that he was never free of debt thereafter. A harrowing bankruptcy in 1861 forced him to take mean lodgings in Charlotte Street, just around the corner from where he had started out with such high hopes forty years earlier.

The Sketching Society

London's social life no longer revolved around the coffee-house or the tavern, but was becoming increasingly domestic. Artists met at each other's houses for sketching parties. In contrast to the commercial academies or the various societies that had fought for dominance in the campaign to establish the Royal Academy, sketching clubs were non-profit-making, apolitical get-togethers at which young artists could work and socialize in a carefree and relaxed atmosphere. As long ago as 1753 the brothers Paul (1725–1809) and Thomas Sandby (1721–1798), both topographical draughtsmen, were inviting friends to come to their house in Poultney Street (now Great Pulteney Street), Soho, "To Sit or Sketch a figure here/ We'll study hard from Six till Nine/ and then attack cold Beef and Wine" (fig. 72).[22]

Though it met in a different artist's house every week, the Chalon Sketching Society was rather more formally constituted. It had its roots in a sketching club founded in 1799 under the leadership first of Thomas Girtin (1775–1802) and later John Sell Cotman (1782–1842). In 1808 this inspired a spin-off society formed by the Chalon brothers, John James (1778–1854) and Alfred Edward (1780–1860). The official title, The Society for the Study of Epic and Pastoral Design, was later converted to the more prosaic Bread and Cheese Society; it was eventually known as the Chalon Sketching Society.[23] They met every Wednesday evening from November to May, and during the summer made occasional excursions to such places as Hampton Court, Windsor and Richmond. Having shrunk to just four members, the society was reconstituted in 1829 with an injection of fresh talent: Thomas Uwins (1782–1857), W. Clarkson Stanfield (1793–1867), Charles Robert Leslie (1794–1859) and John Partridge (1790–1872).

Partridge's study for *The Critical Moment* (fig. 73) depicts the end of a meeting at his house in Brook Street in about

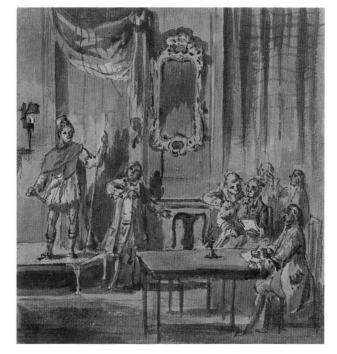

72
Paul and Thomas Sandby, *Invitation to a Sketching Club*, 1753, watercolour, 9.5 × 9 cm, London, Museum of London

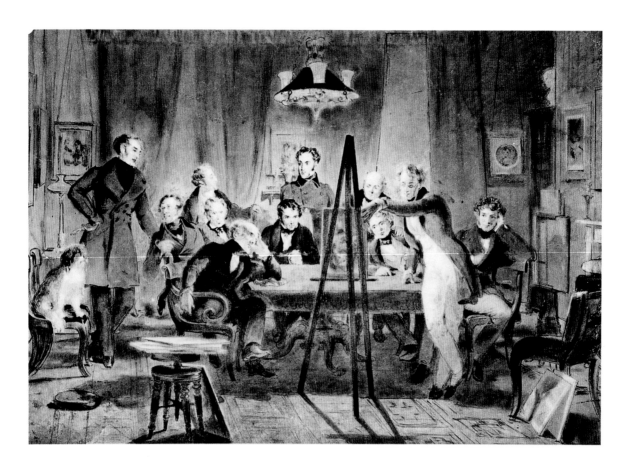

73

John Partridge, *The Critical Moment, c.* 1835, pen, ink and wash, 45 × 60 cm, London, British Museum

1832.[24] He shows himself, as host and president for the evening, in the act of placing a drawing on an easel so that the assembled artists can discuss it.[25] The chief critic for the evening was C.R. Leslie, shown in the centre of those sitting at the table. It was his job to judge how well each member had interpreted the theme (*e.g.* 'A Fall' or 'Expectation') set by the president that evening. The Sketching Society was a social club; the work produced at each meeting belonged to the host and could not be sold,[26] but the members cannot have had too low an opinion of their work, as (besides sitting to Partridge for their portraits) they invited the engravers Colnaghi to publish eight lithographs after their drawings under the title *Evening Sketches* in 1840. The promotional purpose of the book is underlined by its dedication to the President of the Royal Academy, Sir Martin Archer Shee.

John Partridge: a career outside the Royal Academy

When he first came to London from his native Glasgow, Partridge lived at 7 London Street (now Maple Street), Fitzroy Square, but by 1817 he had moved west to Wigmore Street. He married in 1821, went to Rome and by 1828 was installed in a new house at no. 21 (now no. 60) Brook Street, just off Grosvenor Square. His escape from Marylebone and into Mayfair signalled the thirty-eight-year-old painter's determination to operate as a successful

portraitist at the very heart of high society. His attempt to distinguish himself is suggested by the fact that he left "that great mart of Art & Artists"[27] long before any of his friends from the sketching society. It is also indicated by his portrait of himself and his family, where he deploys the setting of his smartly furnished drawing room and the supporting cast of well-dressed relatives to emphasize his own refinement and success in a blatant advertisement to potential sitters (fig. 74).

Partridge's portrait career was enormously successful and culminated in his being appointed Portrait Painter Extraordinary to Queen Victoria and Prince Albert in 1843. However, he was never elected to the Royal Academy, a slight he blamed on a whispering campaign against him and that left him smarting under a sense of injustice until the end of his life. In 1846, having exhibited at the Academy nearly every year since 1815, he started to send his work to the British Institution instead.[28] His resentment is understandable, for the magic letters 'RA' after his name would have increased his prestige and enabled him to charge more for his work; even so, his estate was worth £20,000 at his death.

Partridge – or someone very like him – appears in a satirical 'character sketch' by William Makepeace Thackeray as "the superb Sepio, in a light-blue satin cravat, and a light brown coat, and yellow kids, tripping daintily from Grosvenor-Square to

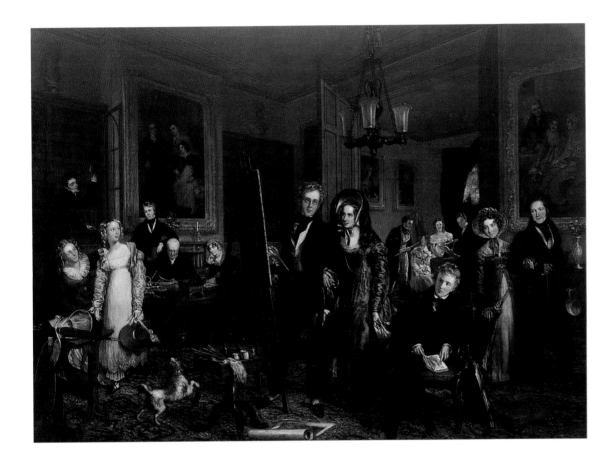

Gloucester-place, a small sugar-loaf boy following, who carries his morocco portfolio. Sepio scents his handkerchief, curls his hair, and wears on a great coarse fist, a large emerald ring that one of his pupils gave him ... At the houses where he teaches, he has a faint hope that he is received as an equal, and propitiates scornful footmen by absurd donations of sovereigns. The rogue has plenty of them." This sly portrait of a successful Mayfair artist is set against one of "poor Rubbery, the school drawing-master" who is trapped by failure "in a third floor in Howland-street".[29]

'Artists' Street' in decline[30]

The death of Benjamin West in 1820 marked the end of the glory days of Newman Street as the domestic headquarters of the Royal Academy. The instinct that made Partridge move on soon after this was a sound commercial one: by 1840 the district was in deep decline: "Look at Newman-street. Has earth, in any dismal corner of her great round face, a spot more desperately gloomy? The windows are spotted with wafers, holding up ghastly bills, that tell you the house is 'To Let' ... The ground floors of the houses where painters live are mostly make-believe shops, black empty warehouses ...".[31] The Swiss animal painter Jacques-Laurent Agasse (1767–1849), who had

fallen on hard times, ended his days in a very different Newman Street from the one he had first moved to in 1810. By 1843 he was living in a furnished room over the shop of the colourman Robert Davy, at no. 83.[32] But the area was still central to the artistic life of the capital. No longer the final destination for successful artists, it entered a new phase as a nursery for many of the best-known artists of the mid-century, including Augustus Egg (1816–1863), who lived in University Street in 1838; Ford Madox Brown (1821–1893), who made his studio in a rented and rat-infested Clipstone Street carpenter's workshop into a studio in the late 1840s;[33] and Edward Burne-Jones (1833–1898), who shared rooms with William Morris (1834–1896) at no. 1 Upper Gordon Street in Bloomsbury between 1856 and 1859. The young John Everett Millais (1829–1896) lived with his parents, just around the corner at no. 87 (now no. 7) Gower Street in the 1840s.

The reasons why Newman Street had attracted artists in the first place remained valid. It was a central location, and the fact that the area was becoming cheaper made it all the more attractive to young artists just starting out. They benefited from the presence of the many small businessmen trading in the subdivided buildings (Brown's studio was cheek by jowl with a sofa manufacturer, a furniture japanner, a piano maker and a

74
John Partridge, *The Artist and his Family, in his Drawing Room at 21 Brook Street, Grosvenor Square*, c. 1828–35, oil on canvas, 110 x 151 cm, London, Museum of London

carver and gilder), who might require designs for engravings, decorative paintwork or trade cards. Even after the first rank of painters had moved on to more fashionable addresses, they left behind a certain glamour that cast its glow on the students and aspiring artists who succeeded them.

Various forms of art training were easily available to artists just starting out in London. The British Museum was an indispensable resource. The Royal Academy's Antique school and life classes, held at the new National Gallery building in Trafalgar Square (completed 1838), were also free. They were, however, open only to students who could present a strong portfolio of work. Those who had not yet reached that stage had to pay for private tuition, either individually from an established master, or at a private art academy. Partridge studied painting with Thomas Phillips (1770–1845) and in turn advised the parents of William Powell Frith (1819–1899)[34] to send their son to Sass's, an art school in Charlotte Street. Another fee-paying academy was Leigh's, at 79 Newman Street, which had been set up by James Matthews Leigh (1808–1860) in 1848. Thackeray owed his intimate knowledge of Newman Street and its characters to the time he spent as a pupil at Leigh's. The school was taken over in 1860 by Thomas Heatherley, who ran it until he retired in 1887. Samuel Butler's (1835–1902) painting *Mr Heatherley's Holiday: An Incident in Studio Life* (1874; fig. 75) shows Heatherley repairing one of his vital studio props, the skeleton, which "was always getting knocked about and no wonder, the students used to dress it up and dance with it".[35] Among the artists who trained at Heatherley's were Dante Gabriel Rossetti (1828–1882), Burne-Jones, Morris, Arthur Hughes (1832–1915), Edward Poynter (1836–1919), and the sculptors Joseph Boehm (1834–1890) and Alfred Gilbert (1854–1934). The young Kate Greenaway (1846–1901) also attended the school; its life classes were the only ones in London at this time where women were permitted to draw from the nude model.

The Pre-Raphaelite Brotherhood grew out of discussions between William Holman Hunt (1827–1910) and John Everett Millais at the latter's family home in Gower Street in 1848. The intriguing 'PRB' device was first used to sign a painting by Rossetti the following year. Shortly after 1850 the original brotherhood – which, despite its huge influence, had never had a properly developed intellectual basis – dissolved. Ford Madox Brown, although not one of the original Pre-Raphaelites, was heavily influenced by them, especially in his use of white ground colour and the minute rendering of detail. In 1852 Brown moved from Newman Street, where he had a studio, to 33 High Street, Hampstead. *An English Autumn Afternoon, Hampstead* (1853; fig. 76) was painted over the next couple of years from a back bedroom window in this house. Brown called it "a literal transcript of the scenery around London, as looked at from

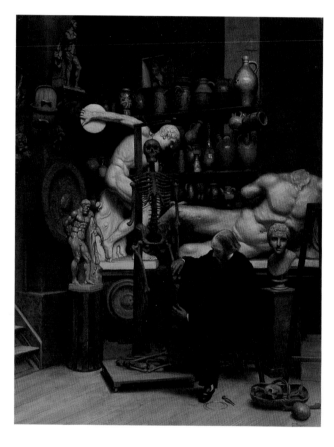

75
Samuel Butler, *Mr Heatherley's Holiday: An Incident in Studio Life*, 1874, oil on canvas, 92.1 × 70.8 cm, London, Tate

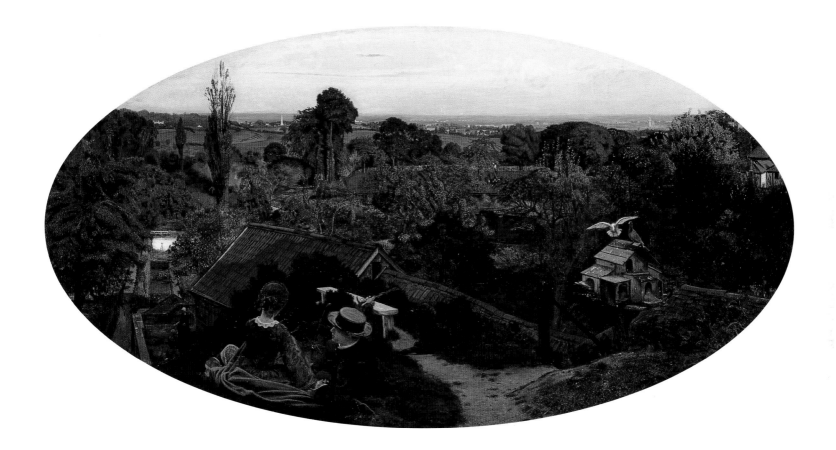

76
Ford Madox Brown, *An English Autumn Afternoon, Hampstead*, 1853, oil on canvas, 71.2 × 134.8 cm, Birmingham, Birmingham City Art Gallery

Luton Sixth Form College
Learning Resources Centre

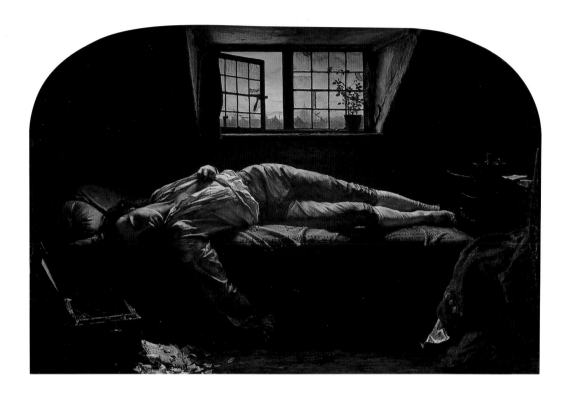

77
Henry Wallis, *The Death of Chatterton*, 1856, oil on canvas, 62.2 × 93.3 cm, London, Tate

Hampstead. The smoke of London is seen rising half way above the fantastic shaped, small distant cumuli, which accompany particularly fine weather ... the grey mist of autumn only rising a certain height. The time is 3PM., when late in October the shadows already lie long, and the sun's rays (coming from behind us in this work) are preternaturally glowing"[36] – a description that connects this work directly to the observations and sketches of Linnell and Constable in Hampstead thirty years earlier.

Memories of the Clique
Many of the artists who earned sufficient reputation and money to leave Newman Street and join the westward exodus to St John's Wood, Bayswater or Kensington looked back at their early years in Marylebone with affectionate nostalgia.[37] The Clique was a sketching club of close contemporaries who met and painted together between about 1837 and 1842: Frith, Egg, Edward Matthew Ward (1816–1879), Henry Nelson O'Neil (1817–1880), John Phillip (1817–1867), Thomas Brooks (1818–1891) and Richard Dadd (1819–1886).[38] Frith introduced Patrick Allan, another aspiring painter, to the group in the late 1830s. Allan did not prosper in London and within a few years had returned to Scotland, married an heiress, changed his name to Allan-Fraser, given up painting professionally and set about amassing a collection of modern paintings.[39]

He commissioned each member of the Clique to contribute a painting to commemorate their youthful friendship, with the stipulation that each painting should contain a self-portrait. In 1858 Augustus Egg supplied his self-portrait in the character of the unsuccessful poet David Fallen (fig. 78). The painting is a meditation on the theme of young genius left to starve in a garret, having failed to 'make it' in London. The immediate inspiration is a scene from the play *Not So Bad As We Seem* (1851), written by Edward Bulwer-Lytton as a fund-raiser for the Guild of Literature and Arts, a charitable insurance scheme for artists who were struggling to earn a living. The picture also has an earlier antecedent with a London setting: two years previously Henry Wallis (1830–1916) had exhibited his romantic vision of *The Death of Chatterton* (fig. 77) to great acclaim, thereby reviving the touching story of the suicide of a misunderstood young writer.

Alone of the Clique painters who contributed to Allan-Fraser's project, Egg chose to refer, albeit indirectly, to the struggles (real or nostalgically exaggerated) of the young artist in London. His self-portrait is a tribute to the powerful formative influence of Newman Street, and there is no reason to think that the middle-aged Egg noticed or intended any irony when he despatched the finished work from his house, 'The Elms', in the comfortable heart of bourgeois Kensington.

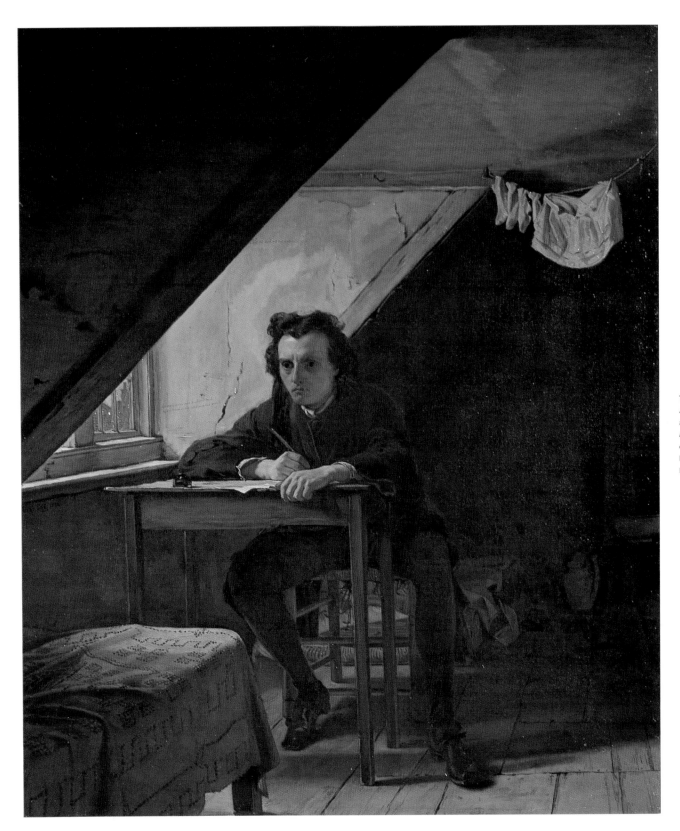

78
Augustus Egg, *Portrait of
the Artist in the Character of
David Fallen*, 1858, oil on
canvas, 76.5 × 65 cm,
Patrick Allan-Fraser of
Hospitalfield Trust

Chelsea 1860–1900

Studios & homes

1. James Abbott McNeill Whistler
Lived at seven different addresses, 1863–90

2. John Birnie Philip (died 1875)
Merton Villa, Manresa Road
(Manresa Villa Studios est. 1876)

3. Trafalgar Studios & Wentworth Studios, Manresa Road, 1878–1905
Phillip Wilson Steer, William Holman Hunt, Louise Jopling, G.P. Jacomb-Hood and others

4. William Holman Hunt
60 Cheyne Walk, Prospect Place, 1850–54

5. Dante Gabriel Rossetti
16 Cheyne Walk, Tudor House, 1862–70

6. Walter Greaves
104 Cheyne Walk, 1855–97

7. Mortimer Menpes
25 Cadogan Gardens, 1892–97

8. J.M.W. Turner
119 Cheyne Walk, 1846–51

9. john Everett Millais
2 Palace Gate, 1873–96

10. Carlo Marochetti
1 Onslow Square, c. 1848–67

11. Frederic Leighton
2 Holland Park Road, 1866–96

12. Mary Lowndes
Park Walk Studios, 1897–1906
The Glasshouse, 11/12 Lettice Street, est. 1906

13. William de Morgan
30 Cheyne Walk, 1871
125/127 Old Church Street
1 The Vale, 1887

Meeting-places

14. Chelsea Arts Club
181 King's Road, founded 1891
148 Old Church Street, 1900–

Art schools & academies

15. Chelsea Arts School
4/5 Rossetti Studios, Flood Street, 1903–06

16. Louise Jopling's Art School
27 Clareville Grove, 1889–92

Exhibition spaces & dealers

17. Grosvenor Gallery
135/137 New Bond Street, 1877–90

18. Fine Arts Society
148 New Bond Street, est. 1876

19. The Royal Academy
Burlington House, Piccadilly, 1868–

Inspiring sites & architecture

20. Cremorne Pleasure Gardens
1832–77

21. Battersea Bridge

Unnumbered coloured spots indicate
lesser-known artistic locations

G.W. Bacon
New Shilling Map of London (west)
1896

1860–1900
Alternative Paths to Kensington and Chelsea

1860–1900
Alternative Paths to Kensington and Chelsea

In the late nineteenth century the consensus that the mark of an artist's success was his ability to 'pass' as a gentleman began to break down. A host of social and economic factors, including the growth of public interest in art, led to an increase in the opportunities for art education and display. The ensuing number of artists in London could not all be welcomed into the top ranks of society, and throughout the second half of the nineteenth century various alternative models of the artist's life were played out. To infiltrate polite (or even aristocratic) society was still the aim of many artists; and owning and vaunting a mansion in a desirable area of London was as essential to that ambition as cultivating duchesses.[1] By the 1860s, however, there were other options. An artist might signal his success by building a 'palace of Art' in Kensington and demand that society travel to meet him on his home ground; he might rub shoulders with the *demi-monde* in St John's Wood; or he could choose to move to Chelsea, which attracted both the aesthete and the cosmopolitan into its unpretentious society.

Sir John Everett Millais had an almost eighteenth-century love of high society and dedication to climbing as high as he could within it. From humble lodgings near Newman Street he moved to Palace Gate in Knightsbridge, where he crowned his ambition with an enormous mansion in Italian Renaissance style (fig. 79). Designed by leading Neo-classical architect P.C. Hardwick and executed by Thomas Cubitt, Prince Albert's favourite builder, Millais's house, with its marble interiors and separate two-storey studio wing, could hardly have been more stodgily conventional yet more perfectly suited to an artist who had risen from boy-wonder to pillar of the Establishment.

Conservative Kensington

If the grandeur of Palace Gate was overwhelming but predictable, Kensington offered more scope for individuality and flair. In 1865 Burne-Jones moved to 41 Kensington Square, even though his wife Georgiana needed to be convinced that their friends would not find the "distance too far".[2] Despite the wrench from Bloomsbury, Burne-Jones had perhaps been attracted to Kensington because his famously hospitable friends the Prinseps lived near by in Holland Park. The Prinseps had developed a circle of artistic acquaintances in the 1850s, when the painter George Frederic Watts arranged for them to rent the dower house on Lady Holland's Kensington estate. They more than repaid the favour when Watts became their permanent guest. As Mrs Prinsep said, apparently without rancour, "He came for three days; he stayed thirty years."[3] Conscious of the superstar status Royal Academicians were beginning to attain, Lady Holland enjoyed parading Watts and his friends at her salons, which were attended by London's literary luminaries (fig. 80). Reflecting the changing status of London's artists by the 1870s, no society party was complete without an artist among the company. The relationship between artist and hostess was reciprocal: in the 1860s and 1870s Watts painted portraits of many of the people he had met at Lady Holland's gatherings, and when she decided to sell of some of her land there was a stream of artists wanting building plots on which to erect studio houses. First in line was the Prinseps' painter son, Val (1838–1904), who commissioned a house from the architect Philip Webb in 1864. No. 14 Holland Park Road, described as "the first artist's house of its kind erected in London",[4] set the pattern for the artists' houses of this quarter: built of exposed red brick (rather than the stucco that was conventional for equivalent houses at this date), with an explicit division between the studio workspace and the private areas of the house (signalled by the large studio windows and separate staircase for models), it was extravagantly decorated in avant-garde taste, with tapestries, blue-and-white porcelain and exotic plants. The plot next door to Val Prinsep's house was taken by Frederic Leighton (1830–1896), for whom G.H. Aitchison built a simple red-brick building in 1865. Criticized at the time for being too austere and bleak in outline, the box-like exterior gives little hint of the treasures within. Lined with tiles, woodwork and stained glass from Cairo, Constantinople and Damascus, the interior is "in the true spirit of Arab magnificence" (fig. 81).[5] The house was crucial to Leighton's artistic and social ambitions: in 1879, when all his

NEW HOUSE AND STUDIO FOR MR. J. E. MILLAIS, R.A., PALACE GATE, KENSINGTON.
MR. HARDWICK, ARCHITECT.

79

New House and Studio for Mr J.E. Millais, Palace Gate, Kensington, 1876, photolithograph, *The Builder,* p. 565

80

James Jacques Joseph Tissot, *Portrait of Frederic Leighton,* 1872, watercolour, 30.5 × 19 cm, London, Museum of London

81
Arab Hall, Leighton House,
London, 1876–79

Fildes declared, "It is a long way the most superior house of the lot. I consider it knocks Stone's to fits".[8] Decorating the studios was an equally competitive activity: oriental carpets, tapestries, inlaid furniture, priceless antiques and worthless studio props were 'thrown together' to stunning effect.

Popular interest in these houses was immense. In 1883 Maurice B. Adams, editor of the *Building News*, produced *Artists' Homes*, a survey of twenty-five studio houses (including eight in Holland Park), with plans and drawings, intended for a specialist architectural readership. The following year F.G. Stephens published *Artists at Home*, with photogravures by J.J. Mayall. The interiors of these houses were dissected in the specialist and popular press and in the new literature on home decoration, such as *Beautiful Houses* by Mrs Haweis (1882). But art lovers could also experience the real thing, when local artists threw open their studios for 'Show Sundays'. In the late 1880s Mrs Fildes regarded as a flop any Show Sunday that failed to attract at least 1000 visitors to her husband's studio.[9] This was the heyday of artistic Kensington. As the high prices commanded by leading painters in the 1850s, 1860s and 1870s began to tumble, it became harder to sustain such magnificence. Fildes could not accept the presidency of the Royal Academy on the death of Millais in 1896, because he could not spare time from his work to carry out the duties of the office: he had school fees to pay.[10]

alterations and additions were complete, there were six major public areas for entertaining, but only one small and sparsely furnished bedroom. The house was both a showcase for the painter's art and a work of art in itself.

The reason for this rash of high-profile 'palaces of Art' in London is twofold. First, painters were becoming more determined to work in natural light, and the glass was available to provide the dramatic north-facing windows they needed. Secondly, some artists could now afford customized housing because they had made fortunes, particularly from selling the reproduction rights of their paintings.[6] Frith's career illustrates the kind of prosperity the successful late nineteenth-century artist could enjoy. *Derby Day* (1858; fig. 82) was painted to commission for £1500, but Frith made as much again by selling the engraving rights to the dealer Ernest Gambart, and he charged Gambart a further £750 for the right to exhibit the picture in his gallery in Rathbone Place for a brief period after the Royal Academy show.[7] The total, £3750, was one of the highest amounts ever paid to a British artist for a single work.

Wealth brought with it the confidence to commission different, or 'original' housing. The luxurious houses in Melbury Road that Marcus Stone (1840–1921) and Luke Fildes (1843–1927) commissioned from Richard Norman Shaw (in 1875 and 1876 respectively) show how the new breed of rich and socially ambitious painters invested their wealth. Close proximity made it easier to network, but it could also engender rivalry among their brotherhood: shortly after his house was completed, Luke

Society in St John's Wood

A more discreet urbanity characterized St John's Wood. Sir Edwin Landseer (1802–1873) was one of the first artists to settle here, having thoroughly exploited everything that Hampstead and Bloomsbury had to offer the art student. His father "set young Edwin, from his very earliest age, to study direct from nature, sending him to Hampstead-heath and other picturesque suburbs to make studies of donkeys, sheep and goats".[11] The family home was at 33 Foley Street, just north of Newman Street, and Landseer made full use of all the contacts and opportunities there. He also followed Flaxman's advice to draw from the Elgin Marbles. At twenty-four (the youngest age at which he could be admitted as an associate) he became an ARA and bought a "cottage" in St John's Wood Road. This he "gradually converted into a handsome and artistic residence, always maintaining a certain seclusion there, though mixing freely in the courtly and fashionable society, in which he was always a great favourite".[12]

Landseer had to surrender that seclusion when, in 1859, he accepted the commission to model the lions for the base of Nelson's Column in Trafalgar Square. This, his one venture into large-scale public sculpture, exposed him to several uncongenial aspects of the complex London art world. His first problem was to secure the use of a large modelling room, and for this he turned to another recipient of Queen Victoria's patronage, the

sculptor Carlo Marochetti (1805–1867), who had a house in Onslow Square, South Kensington. Marochetti could easily extend his hospitality to a fellow artist. He had ample space as over the years he had extended his premises by taking over a group of underused workshops in the mews behind; when Queen Victoria visited in 1853, she recorded nearly twenty assistants at work.[13] Even so, the favour became something of a trial to all concerned. Marochetti's brother sculptors were outraged that the commission had gone to a painter; the ageing and increasingly tetchy Landseer occupied the borrowed studio for eight years; and there was an outcry at the cost (£17,183, against an original estimate of £3000 in 1840), and in particular against the £11,000 paid to Marochetti for obtaining the bronze and supervising the casting.

The lions episode brought further embarrassment. A young Scottish painter, John Ballantyne (1815–1897), had arranged to paint Landseer at work in Marochetti's studio (fig. 83). Ballantyne was a member of the Smashers Club, an Edinburgh-based sketching group of young artists. By 1862 three of the more ambitious 'Smashers', James Archer (1823–1904), John Faed (1820–1902) and his brother Thomas (1826–1900), had felt the need to move to London, to be "in the centre of things, fighting with the very best men of the profession".[14] The following year Ballantyne decided to join them, and moved with his wife and family to a house in The Mall, Kensington. Ballantyne's strategy was to infiltrate the London art scene with an ambitious proposal to paint a series of portraits of artists in their studios, on which he would then sell reproduction rights. The project was designed to exploit public interest in fashionable artists, and to get Ballantyne's name associated with the established names of the London art world. Not only was it meant to raise money, but it might also be a short-cut to the heart of the art establishment.

Frith and several other leading painters readily agreed,[15] but Landseer had to be persuaded to support Ballantyne's project, as he suspected that the younger painter was acting more in his own interests than in those of art. In the end, he was prepared to supply only photographs and he stipulated that the design for the lions be kept secret until the official unveiling, but as Landseer's modelling dragged on for so long Ballantyne was ready to exhibit his pictures before the lions were finished. The portrait, which inevitably revealed the lions, was to be the centrepiece of Ballantyne's exhibition, held at the printseller Henry Graves & Co. in Pall Mall in November 1865. On the eve of the exhibition, when the show – and particularly his portrait – had already received a great deal of publicity, a furious Landseer demanded the withdrawal of the picture. Puzzled and humiliated, Ballantyne had no choice but to accede to the older painter's wishes, for fear of offending the very Establishment he aspired to join.

With his mental and physical health deteriorating, Landseer spent his last years as a virtual recluse in his half-furnished mansion. Notwithstanding the brooding presence of the great Victorian animal painter, St John's Wood had by now

82
After W.P. Frith, *Derby Day*, 1858, engraving, 72 × 131 cm, London, Museum of London

83
John Ballantyne, *Sir Edwin Landseer Modelling the Lions for Trafalgar Square*, *c.* 1864, oil on canvas, 80 × 113 cm, London, National Portrait Gallery

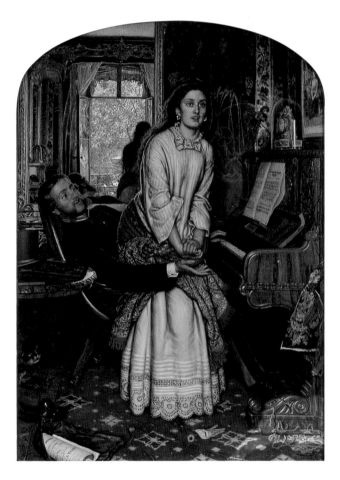

84
William Holman Hunt,
The Awakening Conscience,
1853, oil on canvas,
76.2 × 55.9 cm, London,
Tate

gained a frivolous, not to say louche reputation. At first glance it was a picturesque, semi-rural enclave of widely spaced semi-detached and detached villas in generous gardens, where successful professional men could raise their families in quiet suburban domesticity. Landseer's house, as rebuilt in the late 1840s by Cubitt, represented this genteel respectability to perfection. But that same green seclusion was equally attractive to "divorced wives, not married to anyone in particular, mysterious widows whose husbands have never been seen, married women whose better halves were engaged in the City"[16] – and to the men who kept them. Holman Hunt set his dramatic condemnation of this elegant prostitution, *The Awakening Conscience* (1853; fig. 84), in a villa in St John's Wood, a context that gave every detail in the picture a special moral resonance. Some thirty years later a more sympathetic and sophisticated view of such relationships was provided in the delicately allusive paintings and etchings of the Frenchman James Tissot (1836–1902), who bought no. 17 (now no. 44) Grove End Road in 1873, and lived there with his mistress, Kathleen Newton, until her death in 1882. Newton appears in *Hide and Seek* (c. 1877; fig. 85), painted in Tissot's studio, and in many views of his large garden. The house was subsequently occupied by Sir Lawrence Alma-Tadema, whose respectability was beyond question, and who extended it into one of the most extravagant artist's houses ever seen in London.

Although not all of the artist's houses in St John's Wood were as lavish as this, a painter had either to attain a degree of success or have private means before he could consider moving there. The 'St John's Wood Clique' certainly attracted some of the brightest young talents of the period. It was instigated in 1862 by David Wilkie Wynfield (1837–1887), a historical genre painter and pioneer photographer, and its leading light was Philip Hermogenes Calderon (1833–1898). The membership, all of whom lived in or near St John's Wood, included John Evan Hodgson (1831–1895), George Dunlop Leslie (1835–1921), Henry Stacy Marks (1829–1898), George Adolphus Storey (1834–1919) and William Frederick Yeames (1835–1918). They had sound commercial instincts and a gift for eye-catching narrative painting with a romantic, historical or dramatic theme. Hodgson's *Margaret Roper in Holbein's Studio* (1860) and Yeames's *And When Did You Last See Your Father?* (1878) were typical of the St John's Wood Clique's crowd-pleasing output.[17] They met each Saturday to draw an agreed subject and would then assess the results, in the manner of the Sketching Society. The meetings of these upwardly mobile young men were jolly occasions, marked by practical jokes and dressing-up, and commemorated in photographs and caricatures.

Chelsea riverside

Though St John's Wood is more north than west, the general movement of fashionable London continued claiming western

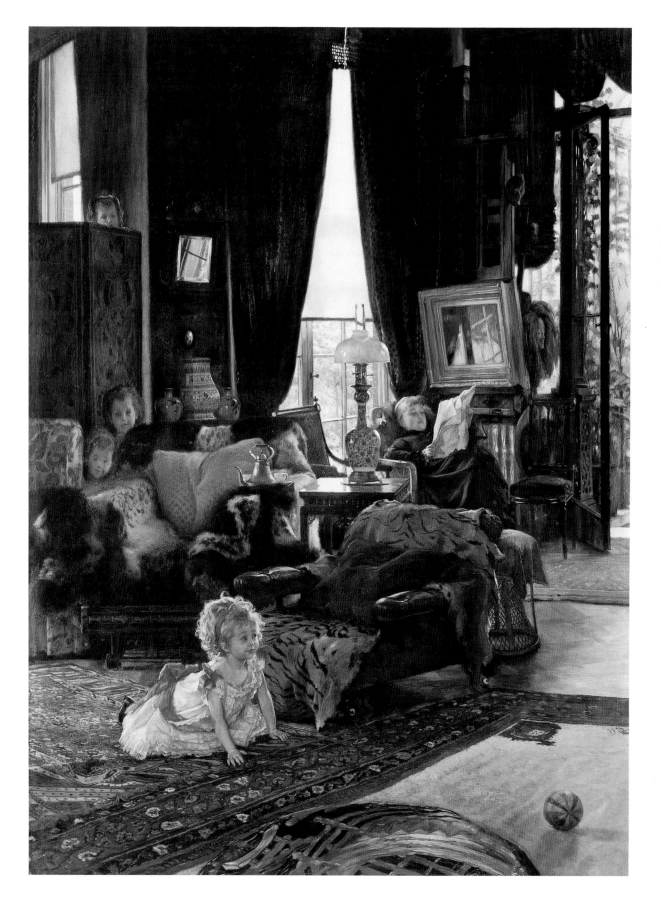

85
James Jacques Joseph
Tissot, *Hide and Seek*,
c. 1877, oil on canvas,
75.9 × 60.3 cm,
Washington, DC, National
Gallery of Art

regions, as it had since the early eighteenth century. Young painters who had still to make their mark, who rejected social climbing as a route to recognition, or who simply could not afford to live closer to the centre of London, found that Chelsea was convenient, congenial and, above all, affordable. It was a step in the right direction, but one that could be made on one's own terms. Compared with the ostentation of Kensington or the decadence of St John's Wood, Chelsea seemed vigorous and unpretentious – and besides, there was an established tradition of artists settling in this part of London.

After selling his Twickenham residence in 1827, Turner had moved around England and the Continent. In the last decade of his life he was particularly keen to preserve his privacy and keep a fair distance between himself and the art world. Part of the reason for this secrecy was his relationship with the widow Mrs Booth.[18] It was to Chelsea that they came in 1846, to settle in a waterfront cottage – no. 6 Davis Place, Cremorne New Road (now no. 119 Cheyne Walk). He used this house as a retreat, maintaining his Marylebone studio, in Queen Anne Street, for the little painting he now did and all official engagements. Chelsea at this time was little more than a fishing village on the river bank. Before the building of the Chelsea Embankment (which was not opened until 1874) it offered fresh air, river views and the opportunity for amusement on the water and at the pleasure gardens at Cremorne. Here Turner could escape the tyranny of his workload and avoid public attention by living quietly and anonymously, known only to the local villagers as "Admiral Booth".

Ostensibly Turner did not go to Chelsea to paint and he does not appear to have made it the subject of any of his late works. The play of moonlight on the water, however, did evoke an enthusiastic response from John Martin (1789–1854), the painter and engraver of visionary apocalyptic landscapes, who was another early settler in Chelsea. Martin lived in Lindsey House (also known as Lindsey Row, this comprises 95–100 Cheyne Walk; Martin's house was no. 98) for the last fifteen years of his life. Unlike Turner, who was at pains to conceal his professional identity in Chelsea, Martin overtly relished the river as a subject for painting. The boatman Charles Greaves, who served both Turner and Martin from his yard at the end of Cheyne Walk, had instructions to ring Martin's doorbell "if there [were] any good clouds and a good moon",[19] whereupon the painter would come out on to his balcony to sketch the night sky over the water.

Thus the area probably had a small reputation for welcoming eccentrics who kept odd hours by the time that Holman Hunt, working by night when the moon was full, produced his sketch *View across the Thames, Twilight, Chelsea* (fig. 86). It was painted in 1853, at the same time as Ford Madox Brown's *An English Autumn Afternoon, Hampstead*. Brown painted his picture

looking out from an upper floor of his lodgings on Hampstead High Street; Hunt's view was taken from a window at 5 Prospect Place, Cheyne Walk. Both pictures are non-narrative responses to "what lay out of a window", as Brown snapped when Ruskin asked what had made him paint "such a very unattractive subject",[20] but the Thames at Chelsea elicits from Hunt an atmospheric evocation of light and mist over the water that anticipates the Impressionists' views of the Seine and, more precisely, Whistler's *Nocturnes*, by nearly twenty years. Its sober colouring and lack of detail is in marked contrast to the other works Hunt was painting at this time, and it is startling to realize that this suggestive sketch is by the same man who went to Chelsea to work on the flora and lighting in his relentlessly detailed *The Light of the World* (1851–53).

Decadent Chelsea: Rossetti and Whistler

If riverside life could encourage an obsessive like Hunt to expand and relax, it had an even greater loosening-up effect on his fellow Pre-Raphaelite Dante Gabriel Rossetti (1828–1882). The charismatic half-Italian painter-poet moved from Marylebone to Chelsea in 1862, some months after the death of his wife, Lizzie Siddall. In his Georgian house at 16 Cheyne Walk Rossetti self-consciously cultivated the exotic: in animals – his menagerie included peacocks, a wombat, a racoon and an armadillo; in people – the sadomasochistic, alcoholic poet, Algernon Swinburne, and the novelist and poet of the fantastic, George Meredith, were among his acolytes; and in interior decoration.

The exotic interiors Rossetti assembled were recorded in paintings by his studio assistant, Henry Treffry Dunn (1838–1899). *Rossetti's Sitting Room, Cheyne Walk* (1882; fig. 87) shows how Rossetti mixed eighteenth-century furniture with oriental furnishings in an early, and influential, essay in Aesthetic taste. This eclecticism was something new in domestic decoration and made a great impression on visitors. Describing Rossetti's bedroom, Dunn recalled how:

> Thick curtains heavy with crewel work in designs of print and foliage hung closely drawn round an antiquated four-post bedstead. This he had bought out of an old furniture shop somewhere in the slums of Lambeth ... A massive panelled oak mantelpiece reached from the floor to the ceiling, fitted up with numerous shelves and cupboard-like recesses, all filled with a medley assortment of brass repoussé dishes, blue china vases filled with peacocks' feathers, oddly fashioned early English and foreign candlesticks, Chinese monstrosities in bronze and various other curiosities, the whole surmounted by an ebony and ivory crucifix. The only modern thing I could see anywhere was a Bryant and May's box of safety matches.[21]

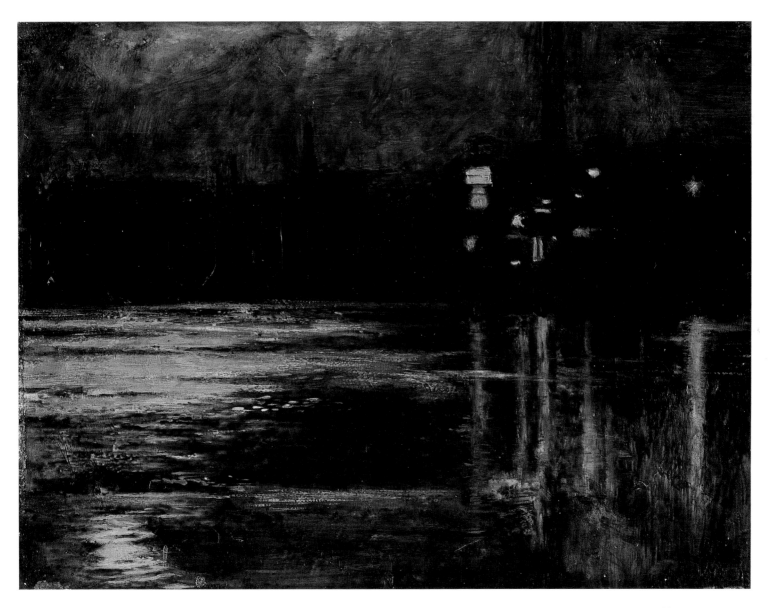

86
William Holman Hunt,
*View across the Thames,
Twilight, Chelsea,* 1853, oil
on panel, 25.1 × 29.9 cm,
Cambridge, Fitzwilliam
Museum

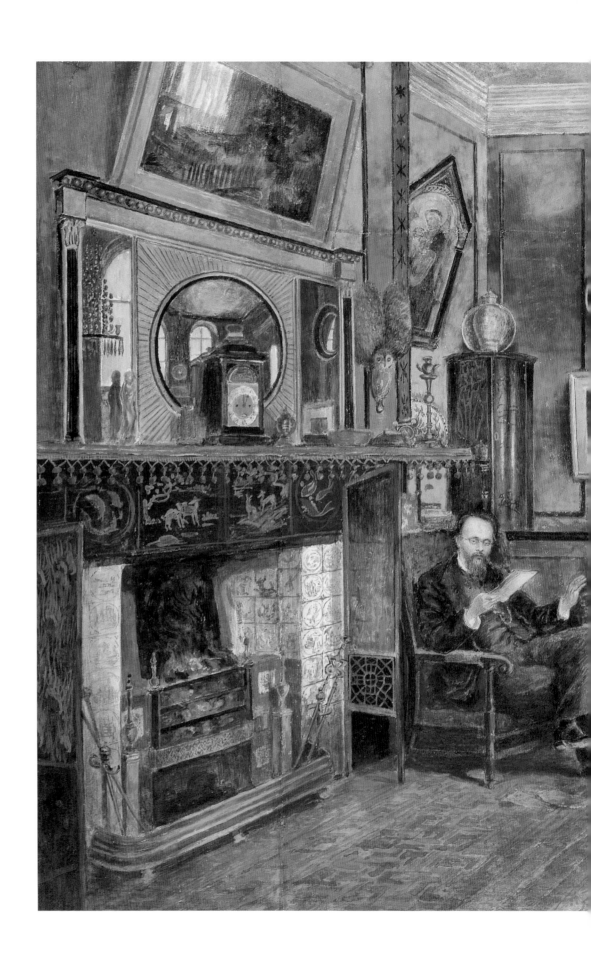

87
Henry Treffry Dunn,
*Rossetti's Sitting Room,
Cheyne Walk*, 1882,
watercolour, 54 × 81.9 cm,
London, National Portrait
Gallery

88
Dante Gabriel Rossetti and
Henry Treffry Dunn, *The
Loving Cup*, 1867,
watercolour on board,
54 × 36.7 cm, London
Borough of Waltham
Forest, William Morris
Gallery

It was not a restful environment, but the 'look' was more important than mere physical repose. As William Morris snapped, "If you want to be comfortable, go to bed".[22] But Rossetti's desire for bric-a-brac was not just focused on domestic decoration. Dunn's *Recollections* include numerous references to going "junking" in the "slums of Lambeth" or Hammersmith in search of suitable props; the jewellery around the neck of the model in *The Loving Cup* (fig. 88), for example, was found on such a trip.[23] Judging from Dunn's descriptions, this artist's house was one great dressing-up box.

Morris and Burne-Jones were among Rossetti's keenest disciples, and their visits to the older man at Chelsea introduced them to the riverside environs of London, which were a revelation to Morris after the confined atmosphere of Soho and Bloomsbury. It was not until 1879 that Morris bought Kelmscott House, overlooking the Thames on The Mall at Hammersmith. He moved there partly because it offered more workspace (his hand-knotted "Hammersmith" carpets were made in the coach house and stables). And while his interiors at Kelmscott may have been filled with complementary organic patterns, none was incidental and all were carefully designed and beautifully crafted by his own decorating firm, Morris & Co.

Rossetti's house and his lifestyle contributed to a new and enduring image of the artist as intellectual, cosmopolitan, open to outside influences and at odds with the Establishment. No matter that Rossetti himself, after a few years of intense work at Cheyne Walk, slid into a drug- and alcohol-fuelled torpor: his style and notoriety were integral to Chelsea's artistic allure – as was the fluctuating circle of innovative friends and derivative admirers who surrounded him. This circle for a time included the American painter James McNeill Whistler (1834–1903), whose numerous Chelsea addresses were a barometer of his varying fortunes.

Within eighteen months of meeting Rossetti and Swinburne in 1862, Whistler had moved from Newman Street to lodgings that were more to his liking in Lindsey Row, Cheyne Walk (fig. 89). The relationship between Whistler and Rossetti was complex. They were friends but also rivals, particularly in their competitive collecting of blue-and-white porcelain. Rossetti would also, no doubt, have liked to consider himself Whistler's mentor, in the art of living if not in art itself, but the younger man had other ideas. Whistler distilled the essence of Rossetti's style: he discarded the squalor, the drug addiction, the indolence and the eccentricity for eccentricity's sake, and

89
James McNeill Whistler, *Battersea Reach from Lindsey House*, 1864–71, oil on canvas, 51.3 × 76.5 cm, Glasgow, University of Glasgow, Hunterian Art Gallery, Birnie Phillip Bequest

90
Mortimer Menpes, *Whistler in White Ducks*, c. 1880, etching, 25 × 23 cm, London, British Museum

91
Walter Greaves, *Battersea Bridge – Misty Moonlight*, 1875–80, oil on canvas, 73 × 51 cm, London, Museum of London

intensified the glamour, the idiosyncrasy and the disregard of convention. He applied his own New Englander's exactitude to Rossetti's aesthetic credo, achieving a kind of fastidious decadence, and lost little time in usurping his mentor's role as the King of Chelsea, surrounding himself with submissive, admiring courtiers. One of these courtiers, Mortimer Menpes (1855–1938), produced an etching of Whistler (fig. 90), elegant in a white suit with his distinctive white forelock, and sporting a monocle and slender cane, which clearly succumbs to Whistler's particular brand of *chic* self-promotion. But as occasional photographs of Whistler, off-guard, show, there was an another side to him: serious, committed and hard-working (fig. 94).

Whistler's impact on his disciples could be devastating. Charles Greaves, the Chelsea boatman who had served Turner and Martin in the 1840s, had two sons, Henry (1844–1904) and Walter (1846-1930), who, after meeting Whistler in 1863, were quickly enamoured of an artistic life. Walter was more deeply bitten and, as Whistler's student and unpaid assistant, absorbed what art instruction he could, with mixed results. Greaves had his own, albeit naïve, style of detailed topography, but Whistler belittled this and advised him to create harmonic "arrangements" by memorizing the sensations, shapes and colours of the landscape. Greaves's attempts to emulate his master can be seen in *Battersea Bridge – Misty Moonlight* (1875–80; fig. 91), a poor relation to Whistler's *Nocturne: Blue and Gold – Old Battersea Bridge* (1871). Whistler's glamour and worldliness were intoxicating to the naïve

and insecure Greaves, who began to copy not only his master's painting, but also his dress and mannerisms – but without the money, the social assurance or the sheer style of the original. On one heartbreaking occasion he gatecrashed a party in Whistler's honour at the Chelsea Arts Club and, in his long overcoat, straight-brimmed hat and white gloves, was mistaken for the master himself. When the real Whistler came face-to-face with his shabby doppelgänger he "put up his monocle and said nothing, and Greaves faded away" under his icily contemptuous gaze.[24]

Greaves shared (or imitated) Whistler's fascination with the public entertainments at Cremorne Gardens, which stood on the river bank next to Battersea Bridge. The site had first opened as a sporting club but had been recast as a pleasure garden in the 1840s. It catered to a lower class of customer than Vauxhall or Ranelagh Gardens: the presence of prostitutes and other forms of licence led the local Baptist minister to condemn it as a "nursery of every kind of vice".[25] Greaves recalled the nightly firework displays as the most notable feature of the entertainment on offer at Cremorne. Whistler responded to one such display in *Nocturne in Black and Gold: The Falling Rocket* (c. 1874; fig. 92), a painting that the leading art critic John Ruskin likened to a pot of paint thrown in the face of the public. The jibe provoked Whistler to sue for libel; the trial that ensued remains unparalleled among the eternally entertaining efforts of the British legal system to come to terms with artistic innovation.

Those outside Whistler's charmed circle he labelled

92
James McNeill Whistler,
Nocturne in Black and Gold:
The Falling Rocket,
c. 1874, oil on canvas,
60.2 × 46.6 cm, Detroit,
The Detroit Institute of
Arts, Gift of Dexter M.
Ferry, Jr.

"Philistines". Ruskin was certainly a Philistine, and so were the artists he championed. But Whistler's contempt was mixed with envy of the phenomenal wealth and influence that could be achieved by pandering to the British taste for sentimental genre, narrative or Academy-approved Grecian or Oriental scenes. He sneered at Leighton's success – "paints, too, don't he, among his other accomplishments?"[26] – but could not ignore the challenge posed by Leighton's house. In 1877 he took a building lease on a plot in Tite Street, and commissioned the architect E.W. Godwin to build him a studio house. Godwin's daring, stripped-down, overtly Japanese design was a chaste riposte to the Philistines' overblown Queen Anne detailing.[27] Named "The White House", it was one of London's few artists' houses truly to reflect something of its owner's personal style (fig. 93).

Bankrupted by building costs and by the disastrous outcome of his case against Ruskin,[28] Whistler enjoyed his exquisite house for less than a year. He moved there in June 1878 and the bailiffs took possession in May 1879. Whistler decamped to Venice, but by 1881 was back in Chelsea. Never short of nerve, he moved into a flat and studio at no. 13 (now no. 33) Tite Street, next door to the White House, for three years, before making a series of moves to various houses and studios in Chelsea and fetching up at 21 Cheyne Walk in 1890. Despite these disruptions Whistler could easily re-create his working environment, as his studio was "always severely simple and bare, and in no sense a 'show Studio' – an uncarpeted floor, a few large canvases turned to the wall; and on one side a great printing press for printing his etched plates ...".[29]

Communal life

Thanks to Whistler and Godwin, Tite Street became, if not Chelsea's answer to Melbury Road, then at least the next step on the property ladder for artists who had begun their careers in one of the area's many *ad hoc* or communal studios. The large-scale migration of artists westwards to Chelsea had begun by 1867, when the watercolourist Henry Riviere wrote to his friend "Jenkins", in Upper Charlotte Street: "So you are alone in all your glory; all the Boys having left the Clipstone Street neighbourhood must make it somewhat melancholy".[30] And certainly by 1870 Chelsea had completely eclipsed Marylebone as London's creative quarter. The initial settlers had sought its isolation and scenery; the next generation of artists were drawn there by their predecessors' celebrity and success, not to mention the *laissez-faire* lifestyle, the sense of community and the low rents.

The east side of Manresa Road was lined with workshops that immediately lent themselves to use as painters' or sculptors' studios, but "any old loft or warehouse could be converted and £40 per year was though to be a big rent".[31] One of the first people to see the possibility of converting an existing property

93
E.W. Godwin, *The White House – second design*, c. 1876, pen and ink, 42.3 × 57.5 cm, London, Victoria and Albert Museum

94
Anon., *Whistler in his Fulham Road Studio*, n.d., albumen photograph, Glasgow, Glasgow University Library, Special Collections

into communal studios was the widow of the sculptor John Birnie Philip (1824–1875). Following his death she turned his Merton Villa into Merton Villa Studios, providing accommodation for two or more artists. Frances Philip's studio conversion scheme may have been encouraged by her son-in-law, Godwin. His intimacy with Whistler introduced him to the community of young followers and hangers-on, who flocked to Chelsea to get near to the American. Over the next twenty-five years, in Chelsea alone, nearly thirty group studios were erected in Glebe Place, Manresa Road, Cheyne Walk and the King's Road itself. Their long corridors of small, single rooms were a far cry from the grand style of living of the Holland Park artists. In fact, few of these young men could afford other places to sleep, so a basic studio room was home and workplace to many. Their consequent sense of being on the margins of respectability was probably inevitable but was not necessarily desirable. Nevertheless, poverty and proximity encouraged artists to club together, support each other and socialize. It is not surprising that so many mature artists, who had eventually attained the honours of the Establishment, came to publish nostalgic 'reminiscences' of youthful evenings spent smoking in each other's studios, discussing painterly techniques and the progress of the Impressionists in France.[32] It is in this nostalgic literature that the concept of 'Bohemia' took on full force, as old men remembered the carefree (if impoverished) days of their youth in Chelsea. In truth, many artists struggled to afford these units so as to prove they were above "the suspicion of amateurism in the mind of the buying public",[33] and no serious artist ever relished the indolent or nomadic lifestyle that got in the way of getting on.[34]

The nostalgia for youthful japes and impoverished intimacy underpins one of the fullest accounts of this area, which appears in the memoirs of the painter, illustrator and sculptor George Percy Jacomb-Hood (1857–1929).[35] For him, the tenancy of a studio in Manresa Road automatically conferred membership of an exclusively artistic community – albeit a fluid one, which changed as studios were given up, swapped, shared or subdivided. Jacomb-Hood's neighbours included, at different times, the painters Solomon J. Solomon (1860–1927), William Ayerst Ingram (1855–1913), James Jebusa Shannon (1862–1923), Henry Herbert La Thangue (1859–1929), Frank Short (1857–1945), Frank Brangwyn (1867–1956), Nelson Dawson (1859–1941) and the sculptors Fred Pomeroy (1857–1924) and Thomas Stirling Lee (1856–1916). Many of these artists had spent some time studying in one or another Parisian fee-paying *atelier* and wanted to re-create the informality and camaraderie of that environment.[36] Despite youthful ambitions to *épater les bourgeois*, all of them, reminisced the elderly Jacomb-Hood, "have since won much distinction and the terminal letters of RA to their names, in addition to three knighthoods. Not bad for one little Chelsea covert!"[37]

The communal studio life certainly created a hotbed of artistic and social activity. Jacomb-Hood's first studio in Manresa Road was in Carlyle Studios, a former stable block; he then moved to a larger space at 3 Wentworth Studios. This, the largest studio in a block of eight, was a social asset. It enabled Jacomb-Hood to entertain his friends and neighbours, to host informal life classes when several artists clubbed together to hire a model, and to claim the honour of accommodating the first meetings of the New English Art Club (NEAC) in 1886 simply because his was the biggest space available.

The collective principles upon which the NEAC was founded had their roots in these artists' common experience in the French *atelier* system. Indeed, the influence of France on these young Chelsea painters cannot be overstated. In the last decades of the nineteenth century, British painters who had trained in the Parisian studios of Bonnat, Bastien-Lepage and Bouguereau had been able to indulge not only in a more liberal attitude to sketching from the nude and an emphasis placed on draughtsmanship and technical mastery, but also in the convivial Bohemianism of a carefree artist's existence. They had shared studios, frequented the same cafés and made sketching expeditions together. They had been exposed to Impressionism and witnessed artists who refused to toe the Academy line, setting up their own exhibitions in alternative venues such as the Salon des Indépendants (1884) and the Salon d'Automne (1903). They returned to Britain, as Anna Robins has said, "full of ideas about painterly values, atmospheric light and the importance of painting naturalistic subjects in the open air".[38]

After Paris, it seemed incredible that any serious artist would require a lavish mansion like Leighton's house, when for a very cheap rent he could enjoy the communal life of somewhere like the Bolton Studios on Redcliffe Road, or the many multiple studios on Manresa Road. But life was not all frivolity, and these studio complexes were the perfect environment in which to nurture a sense of independent worth and launch co-operative action. Having been exposed to new teaching methods and new aesthetic sensibilities, young British artists were not prepared to compromise. Waging a war of words, in 1888 George Clausen (1852–1944) railed against the stodgy conservatism of artists and critics who held that talent was forged in the "laborious and persistent study of the nude"[39] – in short, the Royal Academy, from which "younger painters, almost en masse, were convinced of the need to separate themselves".[40]

The NEAC was a collective undertaking that grew out of the shared desire of several young Chelsea-based artists to exhibit outside the Royal Academy, where they were consistently unsuccessful in getting their works accepted (fig. 95). The club's first objective was to set up a self-funded exhibition.

95
Sir William Orpen, *Group Associated with the New English Art Club* [Alphonse Legros; Auguste Rodin; Philip Wilson Steer; Henry Tonks; Frederick Brown; Sir William Rothenstein; Augustus John; Charles Conder; probably Dugald Sutherland MacColl], 1909, pencil, pen and ink, water-colour and wash, 21.6 × 40.6 cm, London, National Portrait Gallery

Each founding member was entitled to invite two more to join. By approaching friends and neighbours from the Chelsea studios they immediately achieved a membership of fifty, of whom forty-three showed work in the first exhibition, in the Marlborough Gallery in Pall Mall.[41] The artists' fraternity was based upon shared needs, not upon similarity of artistic view-point or output. The exhibition was thus very varied, and received good reviews, George Bernard Shaw describing it as "one of the most interesting and least fatiguing now accessible in London".[42]

The NEAC's exhibiting policy admitted new subjects, including nudes in modern settings, which were not acceptable to the Royal Academy (where the nude was only permissible in mythological or Classical scenes). But a painting need not contain a nude in order to shock. In the exhibition of 1888, pride of place was given to *Gatti's Hungerford Palace of Varieties: Second Turn of Miss Katie Lawrence* by Walter Sickert (1860–1942).[43] This depicted a singer at one of the most notorious music-halls in London. Among the audience in the foreground, a woman in a large red hat was readily identified by contemp-orary critics as a prostitute. A contemporary critic's description of the picture as "the lowest degradation of which the art of painting is capable"[44] indicates how problematic such realist subjects remained at this time.

Even within the NEAC, the exhibiting policy provoked dissent. Stanhope Forbes (1857–1947) found Sickert's picture "tawdry" and "vulgar", and was not the only member to be dismayed by it: living in an artists' quarter did not eliminate factions: indeed, artistic brotherhoods often gave rise to family squabbles. It was inevitable, perhaps, that the more conserva-tive members should eventually be seduced into the ranks of the Royal Academy, where reputation and good income were comparatively certain. As Jacomb-Hood wrote – in careful self-justification some years after abandoning his youthful ideals – "of the original revolutionists, La Thangue, Clausen, Stanhope Forbes, and finally Mark Fisher, were elected as Associates of the Academy, and few members had the strength of mind to keep their works for the 'New English'. Hence it was kept alive by the

little 'clique' who exhibited no other where, and became rather more exclusive and bigoted than any other artistic body. Then I, among others, gave it up."[45]

Although there was not always intellectual agreement, all the artists felt that the social life of the Chelsea studios was too fragmentary. There was no venue big enough for meetings, and although "the artists used to feed and talk at the Six Bells Tavern, the public-house in the King's Road",[46] this was not a particularly congenial place in which to dine and talk painting. Hence the founding of the Chelsea Arts Club in 1891, which started off in the house of a Scottish painter, James Christie (1847–1914), on the King's Road. The Club provided a frame-work for, and to some extent formalized the socialising of, such artists as Philip Wilson Steer (1860–1942) and Thomas Stirling Lee (fig. 96). It also provided some domestic infrastructure that answered a need shared by many young, single and impover-ished artists: besides cameraderie, the Arts Club offered meals and heating. It was a great success. Only ten years after its founding, the Club announced in the *Westminster Gazette* that the membership was to be increased to 200, "and seeing that Chelsea now accommodates nearly 2,000 devotees of the brush and mallet, this anticipation should be easily realised".[47]

One of the reasons for this strikingly large figure was that there were more opportunities for art training, and, for the first time, large numbers of women had access to art education. Louise Jopling (1843–1933) attended Leigh's School of Art in Newman Street, the only art school in London where women could study on the same terms as men – that is, they could draw from the nude (though modesty was protected by care-fully arranged drapery). She specialized in portraits and genre pictures of women (fig. 98), and exhibited at the Royal Academy from 1870 and in the Grosvenor Gallery from 1877. Declaring that "It is not a shock to a girl to study from life",[48] she set up an art school in Clareville Grove, on the border of Chelsea with South Kensington, in 1887, to train women as professional artists.

Women were slowly breaking down the barriers that prevented them from practising as professional artists, but propriety still had to be observed – and be seen to be observed. An advertisement of the 1890s for the Glebe Place Studio for Ladies at no. 55 Glebe Place, Chelsea, "Open daily from 10 a.m. till 4 p.m. for the study of the Life only", emphasized that a Miss Agnes Walker was "always present during class hours".

Once they had tasted Chelsea life, women artists wanted to participate fully. After training at the Slade, recently founded in 1871, the stained-glass artist Mary Lowndes (1857–1929) set up a collective studio in Park Walk, Chelsea, on socialist princi-ples of shared spaces for common productivity (fig. 97). Although the studio units were independent, there was one shared workshop with heavy machinery where tenants could

96
Philip Wilson Steer, *Portrait of Thomas Stirling Lee*, 1887, oil on board, 60 × 74 cm, London, private collection

97
Mary Lowndes, *The Supper at Emmaus* [stained-glass design for Sutton Coldfield Church], *c.* 1910, water-colour, London Borough of Waltham Forest, William Morris Gallery

98
Louise Jopling, *Blue and White*, oil on canvas, *c.* 1896, 123.5 × 84 cm, Merseyside, Port Sunlight, Lady Lever Art Gallery

make their stained glass. This later moved to Fulham and continued as a studio favoured by stained-glass designers until the 1970s.

Purpose-built studios were the building industry's response to the new phenomenon of a distinct population of artists with specific housing requirements. It is striking that speculative builders, who operated on a knife-edge of profitability and were therefore extremely reluctant to innovate and slow to exploit new markets, felt that there would be sufficient demand for communal studio developments to justify investing in them. The *ad hoc* development of workshops into studios in Manresa Road was soon supplanted by purpose-built multiple studios. One of the first was instigated in 1878 by John H. Brass, a local builder (fig. 99). He found his fifteen-unit Trafalgar Studios (1878–79) such a successful venture that in 1886 he erected Wentworth Studios, which converted his own villa on Manresa Road into a further fifteen studios. Developments such as St Paul's Studios, Talgarth Road, West Kensington (fig. 100), designed by the architect Frederick Wheeler in 1890, sought to replicate the same creative atmosphere in the suburbs further west. The most spectacular development of this kind was Bedford Park, built between 1875 and 1881 specifically to attract artists, writers and designers; but while some of its residents did earn a living, and some modest fame, from art, most of the houses were sold to middle-class commuters.

It is debatable whether in fact the special atmosphere of Chelsea in the 1870s and 80s could be re-created once the studio lifestyle was identified by estate agents as a marketing tool. In 1896 a set of purpose-built studios in Glebe Place, equipped with "electric light and perfect sanitation", were advertised as being located "in the heart of this Artistic and accessible district".[49] The word "artistic", already a cliché, was becoming a liability. Nevertheless, the significance of the artists' houses of Chelsea was realized as early as 1920, when a campaign was waged to preserve the Manresa Road studios from demolition: "It is time that London, like all European cities, should have its artists' quarter, and Chelsea, with its already existing studios ... is evidently the place for it".[50] As ever, by the time the preservationists had arrived on the scene, the practitioners had moved on. The next generation of artistic innovators had already made their return to central London and Camden Town.

99
E.T. Lingwood, *Manresa Road*, *c.* 1880, gouache, 12 × 16 cm, London, Museum of London

100
St Paul's Studios, Talgarth Road, 1891, lithograph, *Building News*

101
Advertisement for studios in Glebe Place, Chelsea, *c.* 1896, London, Chelsea Public Reference Library

Camden Town 1905–1920

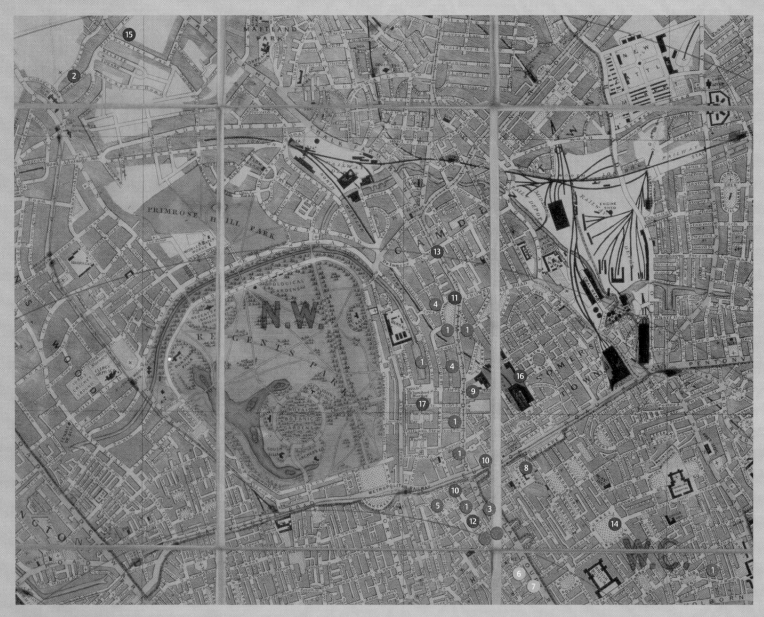

Studios & homes
1. Walter Sickert
6 Mornington Crescent, 1905
8 Fitzroy Street, 1905–07
247 Hampstead Road, 1908
31 Augustus Road, 1909
209 Hampstead Road, 1909
Harrington Square, 1911–12
24 Red Lion Square, 1914
2. Robert Bevan &
Stanislawa de Karlowska
14 Adamson Road
3. Harold Gilman
14 Maple Street, 1908–12
4. Spencer Frederick Gore
31 Mornington Crescent, 1909–12
2 Houghton Place 1912–14
5. Omega Workshop
33 Fitzroy Square, 1913–19

Meeting-places
6. Fitzroy Tavern
16 Charlotte Street
7. La Tour Eiffel
12 Percy Street

Art schools & academies
8. The Slade School
University College, Gower Street,
1871–
9. Rowlandson House
Sickert's art school
140 Hampstead Road, 1910–14
10. Euston Road School
12 Fitzroy Street, 1937–38
314/316 Euston Road, 1938–39

Inspiring sites & architecture
11. Mornington Crescent
12. Fitzroy Street
13. Bedford Music-Hall
Camden High Street
14. Russell Square
15. Belsize Park
16. Euston Station
17. Cumberland Market

Unnumbered coloured spots indicate
lesser-known artistic locations

Collins
Standard Map of London
c. 1900s

1905–1920
Art Movements: Camden Town, Bloomsbury and Fitzrovia

1905–1920
Art Movements: Camden Town, Bloomsbury and Fitzrovia

By 1911 the population of Greater London exceeded 6.5 million, many of them housed in the newly built outer suburbs. The increase in population went hand in hand with house building, led by speculative builders who threw up rows of new terraces and detached villas along the suburban railway and Underground routes. Overall, the population of the new suburbs east, north and south-west of the centre grew by 45.5% during 1901–14.[1] Within the Inner London area there were still pockets of overcrowding and slum housing, and areas such as Lambeth, Shoreditch and Camden were doubly blighted by the arrival of the railways (which, by demolishing existing buildings, exacerbated overcrowding) and by the middle-class exodus from the inner city.

The growth and dispersal of the general population was reflected in microcosm by the artist population of London. The proliferation of art schools in the suburbs in the late nineteenth century had greatly increased the number of artists in Greater London, at the same time spreading them out over a wider area. Moreover, with the advances made in communications and transport, the need for artists to live in close quarters was no longer as great as it had been in earlier periods. As a result there was no one centre of artistic activity in early twentieth-century London comparable to St Martin's Lane in the eighteenth century or Newman Street in the nineteenth.

It is therefore paradoxical that the most significant development in British art of the early twentieth century should have

been named after one small area of London: Camden Town. But as Wendy Baron has pointed out, "Camden Town ... gave its name both to a style of painting and to a society of sixteen artists".[2] In this context 'Camden Town' denotes not merely a neighbourhood where artists lived side by side, but also a state of mind, a shared artistic sensibility. Although this community of artists paid more attention than many others to their immediate surroundings, they might easily have executed the same artistic experiments in another area of London. In reality only a few 'Camden Town' painters lived and worked in Camden. Lucien Pissarro (1863–1944) lived in Hammersmith; William Ratcliffe (1870–1955) in Hampstead Garden Suburb and Robert Polhill Bevan (1865–1925) in Swiss Cottage. While many of these artists had studied at the Slade School, which had opened at nearby University College in 1871, only those artists most closely associated with Camden Town painting – Walter Sickert and Spencer Frederick Gore (1878–1914) – kept studios and homes variously in Fitzrovia, Holborn and Tufnell Park but most consistently in Camden Town.

Camden Town was developed in the early nineteenth century broadly following a scheme of the architect John Nash, "who envisaged this area as a service background for his elegant terraced residences facing Regent's Park".[3] The area was made up of a "criss-cross network of little streets lined wth well-proportioned but relatively modest houses".

Almost as soon as the area was built, it was irrevocably changed by the arrival of the railways (Euston Station was opened in 1838, King's Cross in 1852 and St Pancras in 1870). The railway lines swallowed up large tracts of residential land; houses built as middle-class homes were divided into temporary lodgings for a working-class population; and property in neighbouring streets fast declined in value (fig. 102).[4] The result was that by the time Sickert moved to nearby South Hampstead in 1885, Camden Town was a tatty, incoherent, working-class area with the kind of seedy character that had appealed to the painter since his early Chelsea days. As Sir William Rothenstein (1872–1945) recalled: "I had known many poor studios in Paris, but Walter Sickert's genius for discovering the dreariest house and the most forbidding rooms in which to work was a source of wonder and amusement to me. He himself was so fastidious in his person, in his manners, in the choice of his clothes; was he affecting a kind of dandyism 'à rebours'?" (fig. 103)[5] Whatever his motives, Sickert was clearly content with his unfashionable address close to the railway tracks – and to his old haunt, the Bedford Music-Hall in Camden High Street, which he had painted a number of times before leaving for France in 1898.

Coming to Camden Town

Sickert had begun his London career as an assistant and pupil to Whistler, and he therefore understood the visual potential of the

102
Spencer Frederick Gore,
Nearing Euston Station,
1911, oil on canvas,
49.8 × 60 cm,
Cambridge, Fitzwilliam
Museum, Keynes
Collection

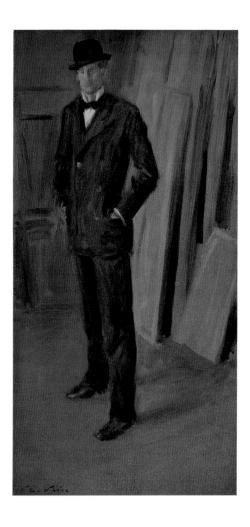

103
Philip Wilson Steer, *Walter Sickert*, 1894, oil on canvas, 59.7 × 29.8 cm, London, National Portrait Gallery

eighteen years separated the two men, they soon became firm friends and colleagues. Sickert had Gore to thank for inspiring him with stories of his fellow students – Harold Gilman (1876–1919), Wyndham Lewis (1882–1945) and Augustus John (1878–1961), who represented a new generation of British Impressionists. Along with Gore they had all graduated from the Slade School, where they had been taught the use of free and impressionistic colour by the painting tutor Philip Wilson Steer.[7] Steer may have inspired them, but he was not willing to "enter the fray on behalf of his young pupils".[8] Sickert was encouraged to return to Britain and assume the role of spokesman for the leaderless young painters of London. The role appealed to the older man's collaborative temperament, to his psychological need to teach and promote younger painters and, perhaps, to his considerable degree of vanity.

In 1905, when Sickert finally settled back in England, he was already a mature and recognized artist. On his arrival in London he returned immediately to Camden Town and Fitzrovia, as the area north of Oxford Street towards Tottenham Court Road was becoming known. Sickert was familiar with these areas, having lived close by and painted them throughout the 1890s. Although he insisted his return from Dieppe was provisional, he rented studios at 8 Fitzroy Street and 76 Charlotte Street (which had been, respectively, Whistler's and Constable's old studios); attempting to keep work and home separate he also took lodgings at 6 Mornington Crescent in Camden Town, an unfashionable address with a garden that backed on to a railway line (fig. 104).

In Mornington Crescent Sickert often shared his studio with Gore, and the two continued to feed off each other's enthusiasms. Despite Gore's youth he had much stylistic and technical insight to offer Sickert. This can be detected in Sickert's new use of pure colour and dry pigments (rather than paint heavily thinned with turpentine), his move towards greater colour and his new ability to "observe colour in the shadows".[9] Sickert's influence on Gore is seen in his willingness to tackle more challenging works depicting people, and the seedy bedrooms and parlours of Camden Town. For these settings they often used rooms in their own rented lodgings, and, during this period, Sickert returned repeatedly to paint a series of nudes lying on metal bedsteads in shabbily furnished rooms. The identical room-setting and dressing-table of Sickert's *Mornington Crescent Nude: Contre-jour* (1906) and Gore's *Behind the Blind* (1906; fig. 105) indicate their close collaboration and mutual influence at this point. It also shows the spread of Sickert's maxim of painting modern life in London to shock people into noticing the world in which they lived. Picking up the threads of his London career, Sickert announced his return by sending the NEAC another music-hall picture,

urban landscape. By 1888, when he first exhibited with the NEAC, Sickert had grown away from this master. Inspired by Manet and Degas, Sickert began to treat realist subjects in a new Impressionist style of painting. This severance was seen in his focus on the cockney equivalent of the Parisian *café-concerts* – those music-hall scenes that Sickert favoured in the 1880s after his encounter with Manet and Degas. Practically, the move was complete when Sickert moved to France, frustrated with the conservative tenor of the English art world. Not everyone was ready to accept his advice that modern artists should seek beauty in everyday urban surroundings, "strong in the belief that for those who live in the most wonderful and complex city in the world, the most fruitful course of study lies in a persistent effort to render the magic and the poetry which they daily see around them."[6] But these words do seem to have had resonance for the young Spencer Frederick Gore, who was the person responsible for enticing Sickert out of his self-imposed exile in France.

A key turning-point in the history of English art is the meeting of Gore and Sickert in Dieppe in 1904. Although

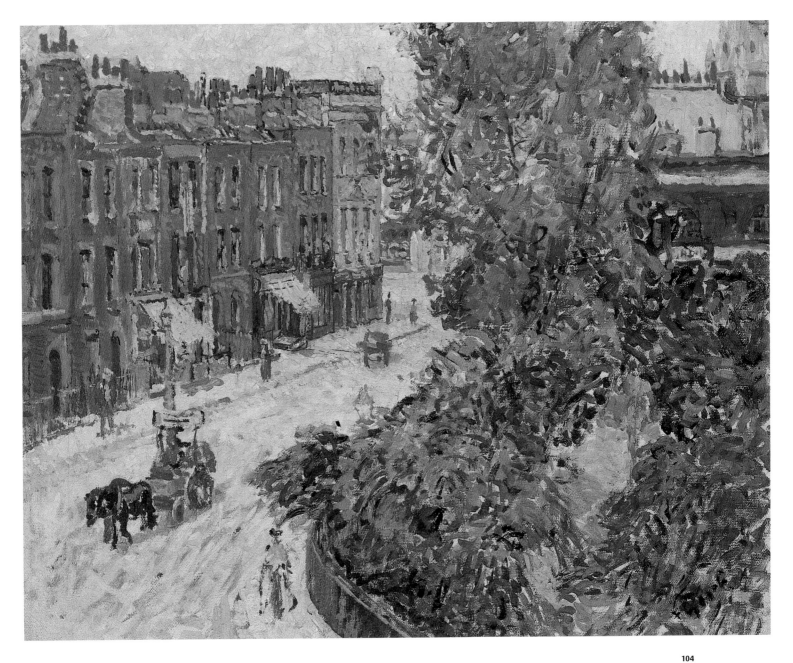

104
Spencer Frederick Gore,
Mornington Crescent, 1911,
oil on canvas,
40 × 50.8 cm, London,
Museum of London

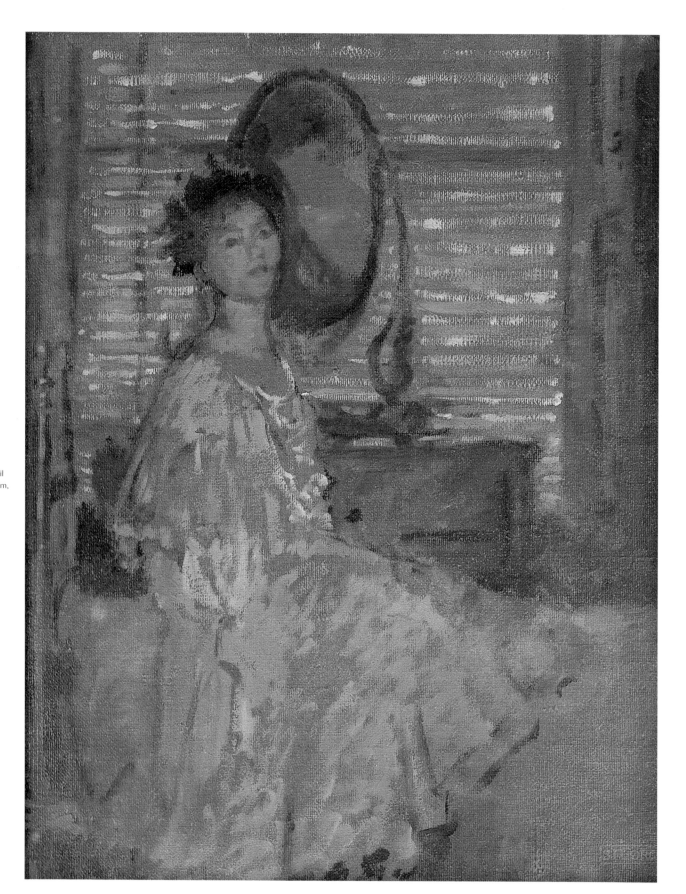

105
Spencer Frederick Gore,
Behind the Blind, 1906, oil
on canvas, 50.8 × 40.6 cm,
whereabouts unknown

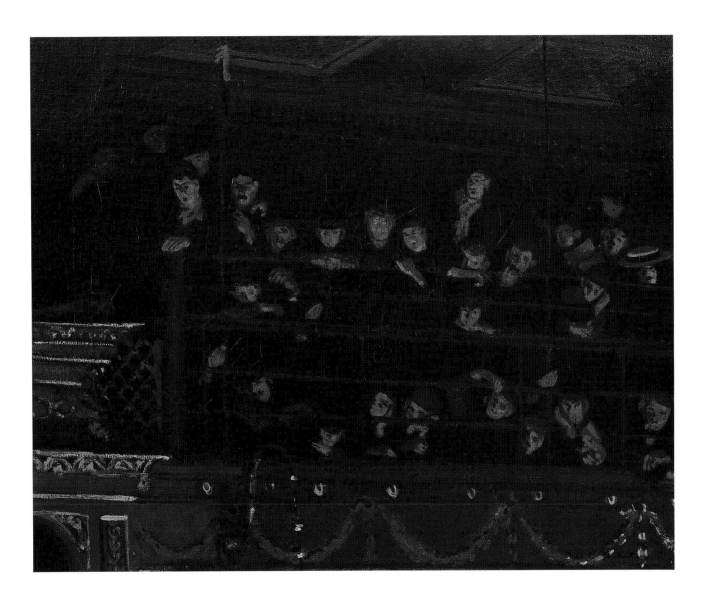

Noctes Ambrosianae, in June 1906 (fig. 106). But his innovative interest in the audience on the balconies, rather than the performance, seems to mark the influence of the French Post-Impressionists and his return to urban life.

In the spring of 1907 Sickert opened his 8 Fitzroy Street studio for weekly 'At Homes' on Saturday afternoons. This helped put him and the area on the artistic map, as people (mostly fellow artists) came to chat and see the latest offerings. This personal initiative soon gave rise to a collaborative venture. With his growing band of protégés, Sickert proposed that they club together to rent a larger space: a first-floor room with a store-room, down the road at 19 Fitzroy Street. Besides Sickert, the principal participants in this shared studio venture were Gore, Harold Gilman (1876–1919), the Rothensteins and Walter Westley Russell (1867–1949), who taught painting at the Slade. All these men were Slade graduates who exhibited at the NEAC

but were keen to find alternative opportunities for putting their work on display. Gilman trained at Hastings School of Art but he came to study at the Slade School in order to kickstart his career in London. Initially influenced by Whistler, he met Sickert in 1907 and through this meeting discovered artists such as Matisse and the possibility of sending his work to Paris, to display in the Salon des Indépendants. Like Sickert, Gilman favoured common domestic subjects and undistinguished interiors but took this one step further by concentrating on ordinary people, such as his Maple Street landlady, Mrs Mounter (fig. 107). Between 1908 and 1912 Gilman developed his own Post-Impressionistic colouring and composition, and succeeded in getting works hung at Parisian exhibitions, which must have raised the group's sense of confidence as London Impressionists. Later in 1907, Lucien Pissarro (1863–1944) also joined the Fitzroy Street Group. Having studied with his father Camille

106
Walter Sickert, *Noctes Ambrosianae*, 1906, oil on canvas, 63.5 × 76.2 cm, Nottingham, Nottingham Castle Museum

107
Harold Gilman, *Tea in a Bedsitter*, 1916, oil on canvas, 71 × 92 cm, Kirklees, Huddersfield Art Gallery

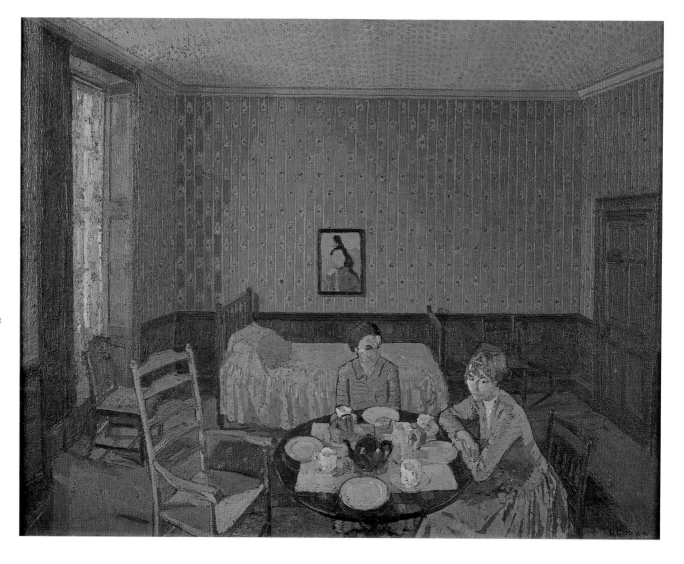

(1831–1903), Lucien brought first-hand knowledge and an intimate understanding of the French Impressionists. In 1908 Walter Drummond replaced Russell, and around 1913 he captured the essence of the Fitzroy Street Group's communal studio/gallery with his painting of three respectably dressed artists paying studious attention to one of the group's paintings (fig. 108). In the background is the rack of works waiting to be seen, and the bare floorboards in the foreground remind us that this is a business rather than a domestic space.

The birth of the informal, artist-run gallery not only put Fitzroy Street back on the artistic map of London; it also provided a central headquarters for a group of artists whose battle plan was to teach London about modern art. Sickert explained his motivation for organizing the group in a letter to Nan Hudson (1869–1957; fig. 109):

"I do it for 2 reasons. Because it is more interesting to people to see the works of 7 or 9 people than one and because I want to keep up an incessant proselytising agency to accustom people to mine and other painters' work of a modern character. Every week we would put something different on the easels. It is agreeable sometimes to show how 'lucky' you have done at once to anyone it may interest. All the painters interested could keep work there and would have keys and could show anything by appointment to any one at any time."[10]

The venture was led by Sickert but retained a certain makeshift feel. While the £50 rent was divided equally between all exhibiting artists (amounting to about "£6 or £7 per annum"), each member had to supply an easel, and the two women Nan Hudson and Ethel Sands (1873–1962) – despite being exhibitors – ended up responsible for tea-making. As Drummond's painting shows, the artists were present to explain their work to the visiting public, discuss it with other painters and, it was hoped, sell it at modest prices. Thus they hoped to widen the market for "little pictures for little patrons",[11] with Sickert pointing out that a painting cost less than a meal at the Savoy. Notwithstanding their stated aim of opening up discussion of art to everyone, when Gore's uncle – who happened to be the Bishop of Oxford – announced a visit to 19 Fitzroy Street all evidence of 'sordid' nudes was quickly hidden and there was an unseemly scramble to find less taxing subjects among the canvases stacked against the walls.

Exhibitions and societies inspired, fed off and recruited for one another, and Sickert, one of nature's actor-managers, was involved with most of them. He believed the Allied Artists' Association (AAA) offered even more freedom to exhibitors than the NEAC: there was no selecting jury, and participating artists

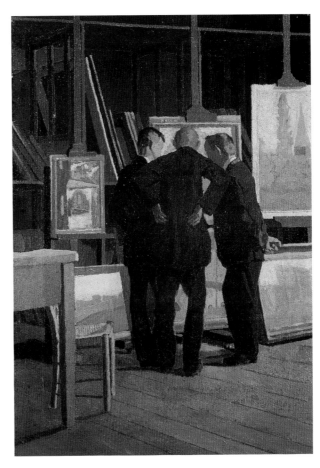

108

Malcolm Drummond, *19 Fitzroy Street*, 1913–14, oil on canvas, 71 × 50.8 cm, Newcastle upon Tyne, Laing Art Gallery

109

Walter Sickert, letter to Nan Hudson explaining layout of 19 Fitzroy Street, 1907, London, Tate Archive

bought shares that entitled them to exhibit five works apiece. Being disheartened that so many young students were being rejected from the RA, Sickert was an enthusiastic supporter of the democratic idea that "there are no good works or bad works: there are only works by shareholders".[12] He even suggested abandoning alphabetical order and holding a ballot to decide the order in which the names of the "shareholders" would appear in the catalogue. The first exhibition was held at the Albert Hall in July 1908, with an overwhelming 4000 international works on display – twice as many as at the Royal Academy Summer Show – for the same ticket price of one shilling.

The AAA exhibition included work by Bevan, Charles Ginner (1878–1952) and Walter Bayes (1869–1956), who were recruited to the Fitzroy Street studio as a result. Ginner was born in France of British parents. After early training as an architect, he switched to painting at the age of thirty and studied in Paris. He moved to London in 1910, bringing with him a passion for Van Gogh and a style of thickly applied paint that was a revelation to the other artists at Fitzroy Street. Bevan brought to the Fitzroy Street group a technique of using pure colour contained within thick outlines, which lent itself well to the depiction of the urban scene (fig. 110).

By 1910 the Fitzroy Street 'At Homes' were notable events attended by a huge circle, including, as Wendy Baron has pointed out, "every progressive artist in London".[13] Although gratifying, this defeated the object, as the artists outnumbered the buying public. To attract more potential purchasers Sickert fixed on the idea of a new exhibiting society, and in 1911, after a few meetings at the Café Royal on Regent Street, and in Soho, the Camden Town Group was founded and named after Sickert's strong connection with that address. It was resolved that there should be no more than sixteen members – most of the founders were already part of the Fitzroy Street group – and that women would be excluded (for fear that many of the men might insist that their wives be included).[14]

At this point the NEAC had been in existence for twenty-five years. Begun as an outlet for young artists whose radical work the RA could or would not accommodate, and once commended by Sickert as "the place I think for the young school of England", the NEAC had given many of the Camden Town and Fitzroy Street Group artists their first major break.[15] Despite this, several of the Fitzroy Street Group were consistently rebuffed by the NEAC, who were now rather set in their ways. One such was Gilman, who proposed that Camden Town members should sever their personal ties with the NEAC in order to promote the exclusiveness of their work. They wanted an edge, and one of the ways they developed this was in their choice of subject-matter: nudes in cluttered interiors with oppressive wallpaper and rickety, second-hand furniture; cab stands with despondent nags and tarpaulined barrows; street scenes peopled by anony-

mous figures. Sickert felt morally compelled to seek out subjects that were regarded as insignificant or, worse, vulgar: "The more our art is serious, the more will it tend to avoid the drawing-room and stick to the kitchen. The plastic arts are gross arts, dealing joyously with gross material facts ... and while they will flourish in the scullery, or on the dunghill, they fade at a breath from the drawing-room. Stay! I had forgot. We have a use for the drawing-room – to caricature it."[16]

Entirely dependent on their squalid urban surroundings and lifestyles, the Group's shocking but unpretentious subjects were handled with vibrant colour and thick paint; the style was typically characterized by a Post-Impressionist palette, impasto (thickly applied paint), contrasts of colour and texture, and complex compositional and psychological relationships of figures to each other and to their setting. The most famous and most characteristic – in subject-matter and handling – of the Camden Town Group's work is Sickert's Camden Town Murder series of images. This group of etchings, paintings and drawings, each showing a naked woman and a clothed man in a seedy interior, was completed in 1908–09. On the one hand this was a series of artistic studies in composition, form and contrast. On the other it was irrevocably intertwined with local events, popular culture and the reaction of the press.

The murder of the prostitute Emily Dimmock at 29 St Paul's Road, Camden Town, and the subsequent trial and acquittal of Robert Wood, had caused a sensation in 1907. The court case, as pruriently reported in the press, revealed a wealth of seamy details about low life in Camden Town. It struck a powerful chord with Sickert, who did not hesitate to assign titles to his works that would link them, explicitly or implicitly, with the murder. Since he regarded titles as merely "the loosest kind of labels that make it possible for us to handle [pictures], that prevent us from mislaying them, or sending them to the wrong address",[17] he was happy to play around with various formulations for maximum publicity value: L'Affaire de Camden Town for exhibition at the Salon d'Automne; the suggestive What Shall We Do for the Rent?, the ambiguous Summer's Afternoon (fig. 111) and the unequivocal The Camden Town Murder. Despite Sickert's cavalier attitude to the naming of his works, his titles certainly added to their shock value: Fred Brown, professor at the Slade and formerly a 'London Impressionist', severed his friendship with Sickert over the "sordid" nature of the Camden Town Murder paintings. Essentially, Sickert used his nude subjects to explore aesthetic problems and principles. Most critics recognized that it was this, and not narrative content, that interested him. The critic of The Sunday Times found that "The unclothed figure on the bed and the clothed figure of the man seated at the side afford a contrast which has interested painters for centuries, though Mr W. Sickert has given a novel note to a

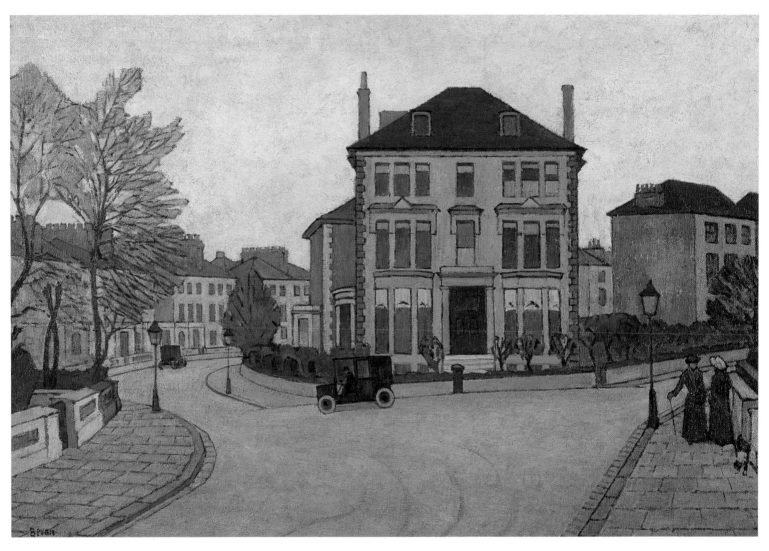

110
Robert Polhill Bevan, *A Street Scene in Belsize Park*, 1917, oil on canvas, 64 × 92 cm, London, Museum of London

111
Walter Sickert, *Summer's Afternoon*, 1908–09, oil on canvas, 64.5 × 61 cm, London, private collection

favourite theme by viewing it in dim twilight through a quivering veil of atmosphere which give just the sense of mystery and even of impending tragedy to justify the titles".[18]

The return to central London: Fitzrovia and Bloomsbury

The re-emergence of Fitzroy Street as a focus for artistic activity was part of the general cultural reinvigoration of central London during the first few decades of the twentieth century. Private commercial galleries increased in number, and art exhibitions began to form part of the social calendar for a new generation of well-off Londoners. Although members of the Camden Town Group variously drew on local subjects or views, they could not forge their reputation by being closeted away in an undesirable part of town. Accordingly, they attempted to reach a wider market at three exhibitions, held between June 1911 and December 1912, at the Carfax Gallery – a basement in Bury Street, St James's, with room for each of the sixteen members to show four works (fig. 112). At each of these they did not attempt to compromise their interest in the seamier sides of life. In the first show Sickert exhibited two "Murder" paintings, but despite these attention-seeking gambits, the exhibition was a financial disaster. By the time of the third exhibition, both the painters and their willingness to accommodate the market had matured somewhat: they showed fewer of their trademark music-halls and 'difficult' interiors, and increased the proportion of English rural scenes alongside some central London scenes by Ginner, Drummond, Ratcliffe and Bevan. Despite its name, the Camden Town Group had never lived cheek by jowl in a physical community of artists; and although they shared a common intellectual ground, a painterly point of view, they drew on a wide range of subject-matter – as far afield as Bevan's Swiss Cottage cab yards or Pissarro's Colchester views.

 The Camden Town painters had considerable social overlaps with the very different set of cosmopolitan artists who gathered around Roger Fry, the influential critic, curator and entrepreneur. Fry had organized a ground-breaking exhibition, *Manet and the Post-Impressionists*, at the Grafton Galleries in November 1910. The paintings he showed, which included works by Cézanne, Van Gogh, Gauguin, Matisse, Picasso, Dérain, Rouault and Seurat, scandalized the critics, who reacted with scorn and hostility. But to a group of English painters including Duncan Grant (1885–1978), Vanessa Bell (1876–1971) and Wyndham Lewis (1882–1957) they were a revelation. Two years later, Fry took to Paris an exhibition of contemporary English art that included works by Grant, Bell, Lewis, Gore and Ginner. Fry kept up his assault on the London art scene with the Second Post-Impressionist Exhibition, held at the Grafton Galleries in October 1912, in which French and British works were hung alongside one another.

112
Spencer Frederick Gore and Walter Sickert reading reviews of the first Camden Town Group Exhibition, in the back garden of Rowlandson House, Hampstead, London, June 1911

Fry had begun his career as an expert on Italian Renaissance painting, and he embraced Post-Impressionism with all the proselytizing fervour of the recent convert. Determined to do "something to make art possible in England",[19] he set up the Omega Workshops in Fitzroy Square as a kind of artists' co-operative, a gallery where furniture, textiles and pottery decorated according to Post-Impressionist principles could be shown alongside paintings and sculpture by avant-garde artists. The Omega artists, who included – besides Fry's 'Bloomsbury' friends – Nina Hamnett (1890–1956) and her former lover the French sculptor Henri Gaudier-Brzeska (1891–1915), were supposed to devote no more than half their time to Omega projects, and to use their share of the Omega income to support their other work. Omega's location in Fitzrovia cemented the area's reputation as London's new Bohemian quarter, a reputation that continued unabated after the First World War and the closure of the workshop in 1919.

The new approaches to art represented by Sickert and Roger Fry – both influenced by French models but the former more concerned with Impressionist subject and the latter with Post-Impressionist experiment – continued to dominate London's art scene throughout the 1920s. The year 1914 had seen the first exhibition, at the Goupil Gallery, of the London Group, an annual exhibiting society intended to be non-factional but with a preference for forward-looking work. This trend gathered strength following Fry's election to the group in 1917 and the subsequent arrival of all the Bloomsbury artists. An even more radical strand of experiment was represented by the Vorticists, led by Wyndham Lewis, who took on a new name, "Group X", on resuming their work after the disruption of war. London Group, Bloomsbury and Group X artists all rubbed shoulders in the studios of Fitzroy Street and the restaurants of Charlotte Street as the 1920s unfolded. The Vorticists' favourite restaurant, La Tour Eiffel in Percy Street, maintained its reputation as a place where creative people ate (figs. 113 and 114). Two central London drinking establishments, the Café Royal and the rather more notorious Fitzroy Tavern, also developed reputations.

You could walk into either of these establishments on any night and be surprised if there was anybody there whom you did not know. Here you could expect to find the active artists, Cedric Morris, Lett Haynes, Augustus John and countless others. Absinthe was not illegal in those days and it was a favourite tipple of the more serious drinking community at the Café Royal. Conversation was easy, lewd and loud, effectively drowning the music drummed out by the small orchestra which played every night. The atmosphere was decidedly thick and one

113
William Roberts, *The Vorticists at the Restaurant de la Tour Eiffel: Spring 1915*, 1961–62, oil on canvas, 182 × 213 cm, London, Tate

could hardly see the Toulouse-Lautrecian figure of the woman band-leader for the dense cloud of tobacco smoke. It was great fun.[20]

In the more sober climate of the 1930s, a new generation of painters turned away from fashionable experiment and rediscovered Sickert's focus on the subject. What became known as the Euston Road School was opened at 12 Fitzroy Street in 1937 by a group of four painters: Claude Rogers (1907–1979), Victor Pasmore (born 1908), William Coldstream (1908–1987) and Graham Bell (1910–1943; fig. 115). The school was in part an attempt to reassert the primacy of art's traditional main task – representing reality through painting and drawing. Coldstream developed an almost scientific method of drawing that was intended to encourage "objective representation".[21] It was also in part an attempt to provide the four artists with an income. At the time of its foundation Rogers earned a living through teaching at a school in Raynes Park, Pasmore was a clerk with the London County Council, Coldstream was a film-maker with John Grierson's famous General Post Office Film Unit, and Bell earned his keep through writing for the *New Statesman*, *The Left Review* and *The Listener*. The school was initially a success in all respects, attracting pupils and moving to larger premises at 314–16 Euston Road before being forced to close at the outbreak of war. The work associated with the institution stands in sharp contrast to the more high-minded productions of the Bloomsbury coterie: "the Euston Road was then a byword for grime, squalor, traffic jams and confusion, and the nickname seemed to suit the low toned paintings with vertical lines of 'drizzle', which emerged from its portals".[22] Nevertheless, the Euston Road painters were also part of the Fitzrovia scene (Rogers had a painting room in Goodge Street, Coldstream a studio in Charlotte Street), and several prominent Bloomsburyites, including Vanessa Bell and Roger Fry, helped the school financially during its short life.

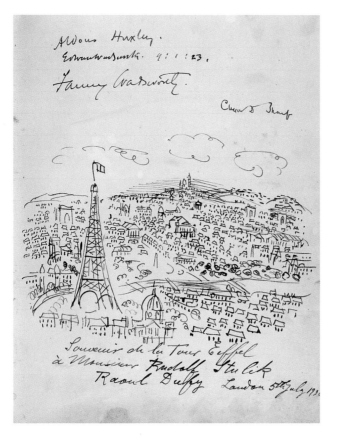

114
Raoul Dufy, *The Eiffel Tower*, 1930, pen-and-ink drawing in La Tour Eiffel's visitors' book, *c.* 1922–34, London, Museum of London

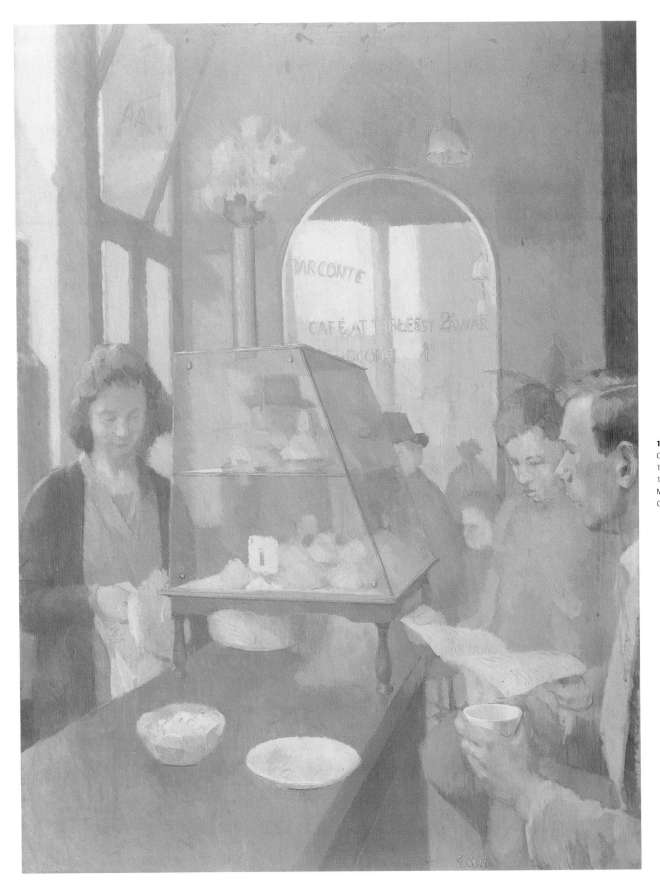

115
Graham Bell, *The Café*,
1937, oil on canvas,
120.5 × 90 cm,
Manchester, Manchester
City Art Gallery

Hampstead 1930s

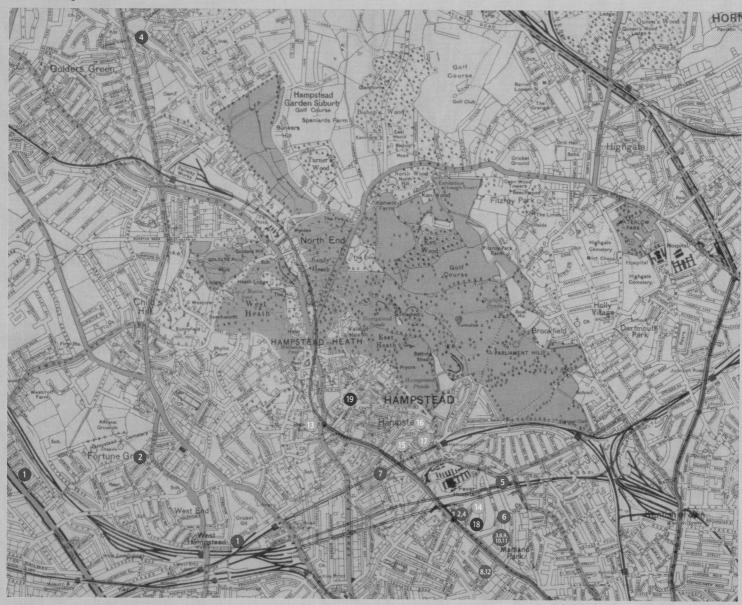

Studios & homes
1. David Bomberg
10 Fordwych Road, 1930–33
66a Lymington Road, 1937
2. Naum Gabo
Lawn Road flats, 1936–38
101 Cholmley Gardens, 1938–39
3. Barbara Hepworth
7 Mall Studios, Parkhill Road, 1928–39
4. László Moholy-Nagy
Lawn Road flats, 1935
7 Farm Walk, 1935–37
5. Piet Mondrian
60 Parkhill Road, 1937–40
6. Henry Moore
11a Parkhill Road, 1928–40
7 Mall Studios, Parkhill Road, 1940
7. Paul Nash
3 Eldon Grove, 1936–39
8. C.R.W. Nevinson
Steeles Studios, Steeles Road
9. Ben Nicholson
7 Mall Studios, Parkhill Road, 1936–39

10. Herbert Read
art critic
3 Mall Studios, Parkhill Road, 1933–37
11. Cecil Stephenson
6 Mall Studios, Parkhill Road, 1929–40
12. Eileen Agar
Steeles Studios, Steeles Road

Meeting-places
13. Everyman Cinema
1 Holly Bush Vale, est. 1933
14. The Isobar Club
Lawn Road flats, est. 1937
15. 47 Downshire Hill
Artists' Refugee Committee
Home of Fred & Diana Uhlman
16. 21 Downshire Hill
Meeting-place of British Surrealists
Home of Roland Penrose
17. Keats Grove
Meeting-place of the Hampstead branch
of the Left Book Club

Inspiring sites & architecture
18. Lawn Road flats
Landmark modernist building, est. 1934
Residents included Jack & Molly Pritchard,
Walter Gropius, Marcel Breuer & Agatha
Christie
19. 1–3 Willow Road
Modernist houses designed and lived in by
Erno Goldfinger, est. 1939

Lightning Cities and Road Map
Co. Ltd
London City and Suburban Plan
1930s

1930s and 1950s
Progressive Hampstead and Permissive Soho

1930s and 1950s
Progressive Hampstead and
Permissive Soho

Fitzroy Square, Camden Town, Euston Road, Bloomsbury: the use of London place names to describe movements in British art suggests that the relationship between artists and London had grown in significance by the middle of the twentieth century. It had certainly grown in complexity. Artists were as affected as any other profession by changes in transport, technology and communications, all of which enabled them to 'use' the city more freely. Whereas in previous centuries the need to cluster round patrons or those with common interests determined location, now social life, home and work could all be sustained simultaneously in different parts of the city. Thus the young Victor Pasmore, living with his widowed mother and family in Hammersmith, chose to rent a studio at Finsbury Park, then the northern end of the Piccadilly Line and as far away from Hammersmith as the tube network allowed.[1]

The new magnetic points on the mid-century London art map were the capital's art schools. Institutions such as the Slade, the Central School of Arts and Crafts, St Martin's School of Art and the Royal College of Art all expanded their activities and staff during this period. Together with the smaller art schools at Chelsea, St John's Wood and Camberwell, they provided professional artsts with a salary lifeline, intellectual stimulation and peer sociability. As a determinant of where artists lived and worked, the art schools took on in part the role that private patrons had fulfilled in previous centuries.

With the notable exception of society portrait painters, many of the professional artists working in mid-twentieth-century London were not well off. Few bought homes or studios: renting was the norm, and frequent moves, often triggered by personal contacts, the rule rather than the exception. Typical was the painter John Minton (1917–1957) who in 1943 began by sharing a studio in Bedford Gardens, Notting Hill, with the Scottish artists Robert Colquhoun (1914–1962) and Robert MacBryde (1915–1966). Three years later Minton moved to Hamilton Terrace, Maida Vale, to share with Keith Vaughan (1912–1972), followed in 1952 by a move to Allen Street, Kensington, and finally Apollo Place, Chelsea, which is where he took his life in 1957. Similarly peripatetic and friend-dependent were the sculptors John Skeaping (1901–1980) and Barbara Hepworth (1903–1975), who, in 1927, as young newly-weds, rented a small studio in Chalk Farm next door to that of C.R.W. Nevinson (1889–1946; fig. 116), quickly followed by a move to a more spacious basement flat with separate studio attached offered to them by the writer Leo Walmsley. In 1928, following a successful exhibition at Henry Tooth's gallery, "finding ourselves in the money for the first time, we moved to a better studio on Primrose Hill Road, close to Henry Moore".[2]

Skeaping and Hepworth were part of the "gentle nest of artists", as they were famously described by Herbert Read, who settled in Hampstead in the 1930s. But Hampstead was not London's only mid-twentieth-century artists' colony. Alternative claims could be made for Hammersmith, where Julian Trevelyan (1910–1988), Edward Bawden (1903–1989) and Eric Ravilious (1903–1942) lived in or near Weltje Road; John Piper (born 1903), Ceri Richards (1903–1971) and Raymond Coxon (1896–1997) lived in St Peter's Square and the seventy-year-old Lucien Pissarro at Stamford Brook. Pissarro's studio became a place of pilgrimage for many young artists, eager to hear him reminisce about Cézanne. In central London, the Fitzrovia/Bloomsbury district continued to loom large on the London art map, by virtue of its proximity to the major art schools and its cheap property. Fitzroy Street was a known source of studio space: Vanessa Bell (1879–1961) was at no. 8 in the 1920s, William Coldstream (1908–1987) at no. 12 in the 1930s and Adrian Heath (1920–1992) at no. 22 in the 1950s. As for living space, when in 1937 Claude Rogers (1907–1979) rented a second-floor flat at 27 Charlotte Street his neighbours were Frederick Gore (born 1913) above and Cedric Morris (1889–1982) below. The émigré-run Charlotte Street restaurants supplied hungry artists with cheap meals and its pubs provided non-genteel drinking. When Victor Pasmore returned to central London from the end of the line at Finsbury Park, he rented a studio above the White Tower restaurant in Percy Street.

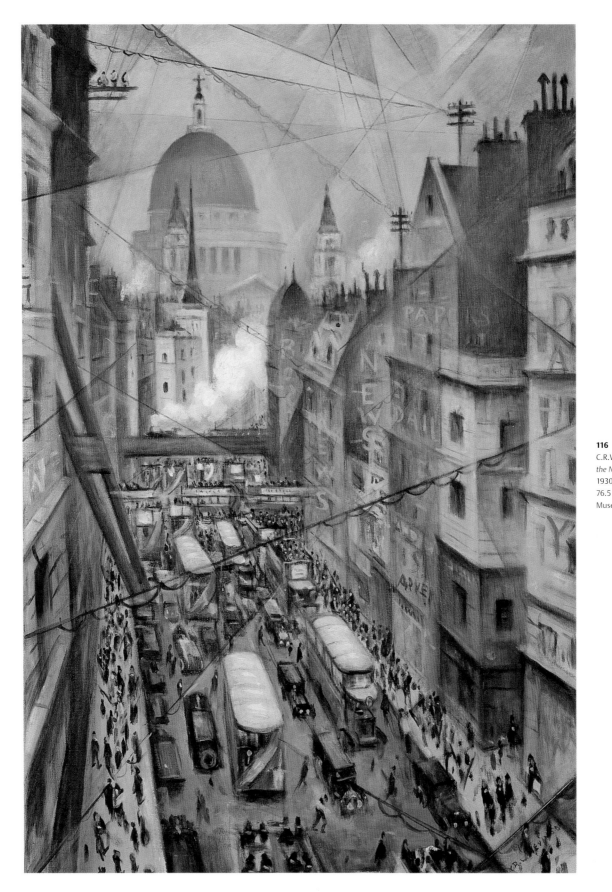

116
C.R.W. Nevinson, *Amongst the Nerves of the World*, 1930, tempera on canvas, 76.5 × 50.5 cm, London, Museum of London

But although Hammersmith and Fitzrovia can both claim some credentials, it was nevertheless Hampstead in the 1930s and Soho in the 1950s where location and artists merged most closely to produce a recognizable *genius loci*.

Hampstead in the 1930s

For the first quarter of the twentieth century Paris remained the capital of the avant garde, and contemporary British criticism had to acknowledge, however painfully, that "at any given moment the best painter in England is unlikely to be better than a first-rate man in the French second class".[3] It was not until the 1930s that the British avant garde began to meet their Continental counterparts on something more like equal terms, a development intimately connected with Hampstead. Artists were drawn to Hampstead because of its long-established artistic and literary associations, which had continued uninterrupted since the time of Constable, Blake and Linnell. In the 1880s in particular, the area had acquired a number of purpose-built artists' houses and studios, including those designed by Norman Shaw for Kate Greenaway (1846–1901), Edwin Long (1829–1891) and Frank Holl (1845–1888). These artists and their houses, mildly progressive when they were first built, now seemed quite conventional. In the new century, this comfortable conformity was overturned, giving rise to more aggressive modernist associations for Hampstead and a new London stereotype: the Hampstead artist. The francophile Ben Nicholson (1894–1982; fig. 117) was described by the *Daily Express* in 1934 as "the complete bourgeois conception of a Hampstead artist, vivid scarf, beret and all".[4]

Hampstead's artists and writers were deeply engaged with every one of the 1930s avant-garde tendencies: Surrealism, Constructivism, abstraction and Modern Movement architecture. In search of new forms of expression, many looked to Europe for new directions. In the early 1930s Barbara Hepworth and Ben Nicholson, by then Hepworth's second husband, made several trips to Paris where they visited the studios of Mondrian, Brancusi, Arp, Picasso and Braque. The painter Paul Nash (1889–1946), a Hampstead resident from 1936, was impressed by the contemporary French art – particularly that of the Surrealists – that he saw on a visit to Paris in 1930.

Nash identified two factors in the strength and success of Continental modernism that were lacking in England: cosmopolitanism and co-operation between different disciplines. Believing that "when the day comes for a more practical sympathetic alliance between architect, painter, sculptor and decorator, we may see the acceleration of an important movement [in British art]",[5] Nash wrote to *The Times* in June 1933 to announce the formation of Unit One, a group of eleven English artists and architects including himself, Nicholson, Hepworth

and the Yorkshire sculptor Henry Moore (1898–1986). Their aim was to cross-fertilize and break down traditional barriers between different disciplines, and to promote English art and design across a wide range of styles and media. True to his word, Nash himself worked in a range of media as he cast about for new forms of expression appropriate to the modern age. Unit One exhibited at the Mayor Gallery in 1934.

These attempts to further the cause of British avant-garde art were fostered by the close proximity of the leading players, all of whom were neighbours in Hampstead. The group of artists who formed the nucleus of Unit One were based in the Mall Studios in Parkhill Road: studio no. 7 in the Mall housed Hepworth and Skeaping, and subsequently Hepworth and Nicholson. Henry Moore lived over the road, in a small flat above his studio at 11a Parkhill Road but took over no. 7 when Hepworth and Nicholson moved to St Ives. Skeaping, Moore and Hepworth all explored new forms through direct carving of wood and stone, and it was in the Mall Studios in 1931 that Hepworth made her first 'holed' sculpture, which led to her exploration of negative space as an important element in sculptural form. Another Parkhill Road resident was the critic Herbert Read. In his book *Art Now* (1933), in the catalogue for the Unit One exhibition, and in his articles for *The Listener* (which alternated weekly with those of Nash), Read explained modern art to a puzzled and resistant public, and attempted to promote the best qualities of both the Surrealist and abstract tendencies, although he sometimes felt as if he was attempting to ride two horses at once.

In the late 1930s the abstract tendencies represented by Unit One were encouraged by the arrival of artist refugees fleeing the ever-darker Nazi shadow across Europe. Piet Mondrian (1872–1944) was at 60 Parkhill Road from 1937 to 1941. From her studio, Hepworth could see his geometric grids of primary colours gradually obliterating the original dreary decoration of his study. The Russian Constructivist painter Naum Gabo (1890–1977) came to England in 1935, and lived in Cholmeley Gardens, West Hampstead, between 1938 and 1946. Gabo was the figure behind the successor to Unit One, Circle, a more hardline movement that published a collection of writings by artists and architects entitled *Circle: International Survey of Constructive Art* in 1937.

In its search for new forms of expression and rejection of outworn conventions, progressive art was inseparable from progressive architecture. Modernist architecture expressed the utopian hope that rationally planned housing, built with modern, mass-produced elements (for example concrete walls and metal windows), stripped of pretentious decoration and provided with communal facilities, would be the backdrop against which could be enacted a new way of life, based on social justice and the abandonment of class distinctions. Hampstead offered interesting

opportunities for architects to put theory into practice, and in 1934 a block of flats in what would become known as the International Style was built in Lawn Road to the design of the Canadian architect Wells Coates (1895–1958; fig. 118).

With white-painted concrete walls, the Lawn Road flats offered "minimum" accommodation to people who wished to live a modern life unencumbered by possessions. The interiors were fitted with built-in plywood furniture made by Isokon, a furniture company in which Coates was a partner. Isokon employed the Bauhaus émigrés Walter Gropius (1883–1969), Marcel Breuer (1902–1981) and Lásló Moholy-Nagy (1895–1946), all of whom arrived in London in the mid-1930s, and all of whom stayed in the Lawn Road flats. Breuer's furniture designs were especially successful, and he contributed to the design of the Isobar, a club on the ground floor of the flats that became a rendezvous for progressive Hampstead.

Another European arrival was the Russian architect Berthold Lubetkin (1901–1990), whose cosmopolitan background and familiarity with Continental modernism made him welcome in the Tecton architectural partnership, for whom he designed two innovative blocks of flats in Highgate – Highpoint One (1935) and Highpoint Two (1936–38). His contemporary, the Hungarian architect Ernö Goldfinger (1902–1987), also studied in Paris before coming to London in 1934. He and his wife, the painter Ursula Blackwell (1909–1991), were among the first tenants at Highpoint before they moved into no. 2 Willow Road, the centre house in a terrace of three that Goldfinger designed and built between 1936 and 1939. These buildings were beacons signalling the arrival of International Modernism in England and proclaiming Highgate and Hampstead friendly territory – despite some well-organized local opposition to these striking new buildings – for talented immigrants.

In their new house the Goldfingers nurtured the connections and friendships they had made in Paris in the 1920s. The architect and designer Charlotte Perriand (1903–1996) was particularly struck by the "emotional experience" of staying at Willow Road, "surrounded by friendship and by objects, books and pictures which recall the spirit of that unique epoch".[6] The Goldfingers' collection, much of which remains in the house today, contained work by Robert Delaunay (1885–1941), Max Ernst (1891–1976) and Marcel Duchamp (1887–1968). They also collected the work of British artists, including Eileen Agar (1899–1990), Henry Moore (1898–1986) and Roland Penrose (1900–1984), all of whom lived in Hampstead, Agar at Steeles Studios in Steeles Road.

Penrose, an artist and collector, was the most committed of the British Surrealists, and his house at 21 Downshire Hill became a meeting-place for Surrealist artists, among them the painter and film-maker Humphrey Jennings (1907–1950; fig. 119) and the Belgian painter Edouard Mesens (1903–1971). Penrose had lived in Paris in the 1920s and early 30s, and on his return to London in 1935 "found in Hampstead a climate which had some slight resemblance to that which [he] had left in Paris".[7] Believing that Surrealism would transplant well in that climate, he organized the International Surrealist Exhibition at the New Burlington Galleries in 1936. Nearly forty years later, he recalled the excitement of planting this seed of Surrealism in England: "André Breton opened the exhibition; Paul Eluard lectured on surrealist poetry, and this was followed by the famous discourse given by Salvador Dalí from inside a diver's suit, accompanied by two elegant Afghan hounds and surrounded by paintings and sculpture by Picasso, Chirico, Ernst, Klee, Duchamp, Picabia, Man Ray, Dalí, Hayter, Magritte, Miró, Brancusi, Giacometti, Arp, from abroad, and by British artists including Moore, Nash, Burra,

117
Ben Nicholson, *Five Circles*, 1934, woodcut printed in black ink, 15.9 × 20.1 cm, London, British Museum

118
Isokon flats, Lawn Road, Hampstead, *c.* 1934, photograph, Norwich, University of East Anglia, The Pritchard Papers

119
Humphrey Jennings,
*London in the Seventeenth
Century*, 1936, oil on
board, 24.5 × 33.3 cm,
London, Museum of
London

Trevelyan, Eileen Agar, Sutherland and many others. Also we had borrowed from museums some splendid examples of tribal art and there were Surrealist objects produced by a mixed group of enthusiasts".[8] Emboldened by the success of the exhibition, Penrose and Mesens opened the London Gallery in Cork Street, where they produced bulletins and newsletters, including a Surrealist Broadsheet of 1937, which demanded, among other things, the end of the British Government's embargo on sending arms to the Republicans in Spain.

The international flavour of Hampstead in the 1930s led inevitably to a high level of political awareness and activity. The presence of artists who had been forced to flee oppression in mainland Europe lent a sense of urgency to Hampstead's passionate anti-fascist activities. Refugees were guaranteed a warm welcome from like-minded artists and intellectuals. From their home at 47 Downshire Hill, Fred and Diana Uhlman ran the Artists' Refugee Committee, which provided financial support to perhaps as many as thirty artists from Austria and Germany. Among them was John Heartfield (1891–1968), a German Dadaist and pioneer of photomontage, who lived with the Uhlmans from 1938.

Heartfield, Oskar Kokoschka (1886–1980) and Kurt Schwitters (1887–1948) were all habitués of the Free German League of Culture in Parkhill Road. Anti-fascist activities that grew out of the salons of left-wing Hampstead included the

International Association's sale of "Portraits for Spain" in support of the Republicans during the Civil War, and an "Aid to Russia" exhibition at Willow Road in 1942, at which socialites such as Nancy Cunard rubbed shoulders with socialist painters and sculptors.

The very qualities of mobility and cosmopolitanism that had allowed artistic Hampstead to flourish in the 1930s hastened its eventual unravelling. Artists who had fled Nazi Germany and broken down linguistic and cultural barriers in order to work and thrive in London thought nothing of pursuing even greater opportunities across the Atlantic. Gropius and Breuer left for the United States in 1937. Mondrian followed them in 1940, Gabo in 1946. The native-born artists, too, were dispersed. Hepworth and Nicholson moved to Cornwall in 1939, and Henry Moore to Much Hadham in 1940.

The Second World War not only broke up the Hampstead colony; it also swept away the whole basis of the intellectual discourse with which Hampstead had addressed the search for new ways of living and new forms of artistic expression appropriate to the twentieth century. Hampstead in the 1930s had made modernism respectable, but the preoccupations of artists in post-war London were very different, and they had to be pursued in a very different environment.

Soho 1950s

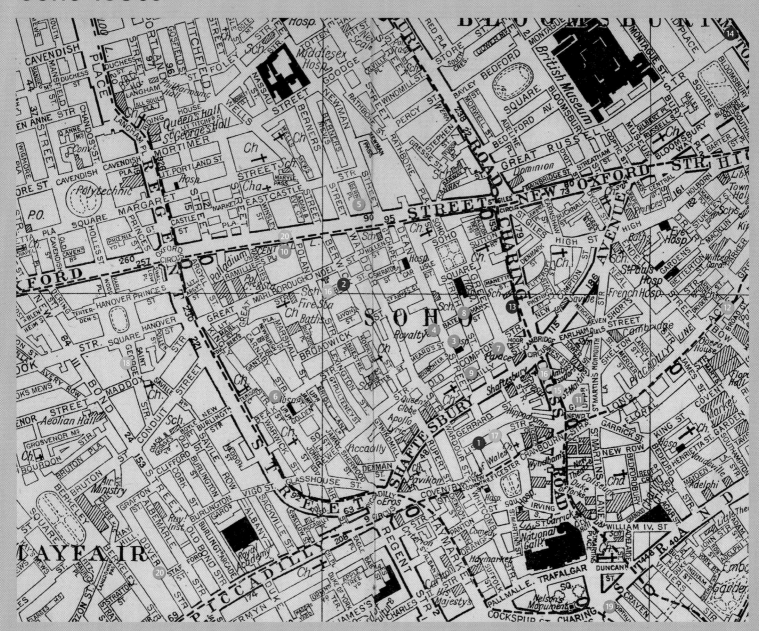

Studios & homes

1. Gillian Ayres & Henry Mundy
15 Lisle Street

2. Colin MacInnes
writer, art critic
20 D'Arblay Street, 1956

Meeting-places

3. The Colony Room club
41 Dean Street

4. The Gargoyle club
69 Dean Street

5. London Jazz Club
100 Oxford Street

6. Barcelona restaurant
17 Beak Street

7. Wheelers restaurant
19 Old Compton Street

8. The Dog and Duck pub
18 Bateman Street

9. The French House pub
49 Dean Street

10. Academy Cinema
165 Oxford Street

11. Arts Theatre
6/7 Great Newport Street

Supporting trades & organizations

12. Brodie and Middleton
79 Long Acre

Art schools & academies

13. St Martin's School of Art
109 Charing Cross Road

14. Central School of Arts and Crafts
Southampton Row

Exhibition spaces & dealers

15. Zwemmers
26 Litchfield Street

16. Gallery One
1 Litchfield Street, 1953–55
20 D'Arblay Street, 1956–61

17. Artists International Association
15 Lisle Street, 1947–71

18. Hanover Gallery
32a St George Street

19. New Vision Group exhibitions
Coffee House, Northumberland Avenue,
1953–58

20. Institute of Contemporary Arts
165 Oxford Street, 1948
17/18 Dover Street, 1950–68

Geographia Ltd
Map of London
c. 1940s

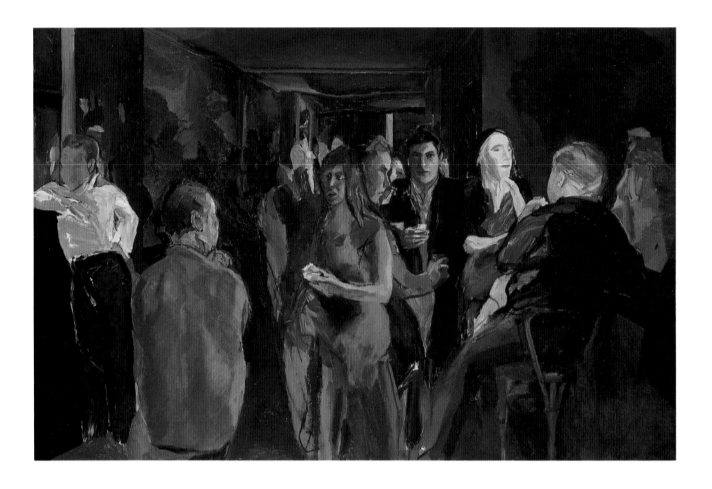

120

Michael Andrews, *The Colony Room I*, 1962, oil on canvas, 122 × 183 cm, London, Tate, on loan from the St John Wilson Trust

Soho in the 1950s

The 1950s were marked by the immense economic and political challenge of Britain's slow recovery from global war. In London alone, three-quarters of a million homes had been destroyed or severely damaged by the Blitz. In 1951, while the Festival of Britain was in full swing, the Greater London Council had 250,000 families on its housing waiting list. Some forms of rationing continued until 1954. Socially and culturally, too, the country entered a period of convulsive change that was marked by the search for a new place in the post-war world. The traditional French dominance of cultural life was undermined by the attractions of American consumer culture, as depicted in Hollywood films – which the British public watched in record numbers in the immediate post-war years. The unattainable dream of the good life depicted by Hollywood was accompanied by fear, especially of the future. The liberation of the Nazi death camps had revealed the depths of cruelty and degradation that humans could inflict upon one another. The atomic weapons used against Japan had demonstrated the terrifying possibilities of nuclear war, and the politics of the Cold War dominated official relations with Europe and America.

It was in this climate of change and uncertainty that Soho

came into its own as a centre for London artists. It had an air of decay (exacerbated or enhanced, depending on one's point of view, by bomb damage) and an un-British buzz of cosmopolitanism. Jewish, French and Italian communities were long established there, and since the end of the nineteenth century the area's émigré restaurants had fed astonishingly cheap meals in a Bohemian ambience to artists, writers and those in search of true Italian coffee. Soho's credentials as a haunt of artistic hedonism had been firmly established before the Second World War by the Café Royal and the Gargoyle Club, with its 1928 murals by Matisse, but in the 1950s the district acquired a new frisson. Its drinking clubs served alcohol outside the puritanically restrictive pub-licensing hours; its jazz clubs stayed open long after the Underground had taken the last West End theatre-goers safely back to the suburbs. It was also notorious for being the city's "sexual gymnasium",[9] its shifting community of prostitutes, sailors and ex-servicemen offering opportunities for both hetero- and homosexual adventures.

All this was alien to mainstream British society, and the metaphors used to describe Soho in the immediate post-war period emphasize this sense of difference. Most frequently Soho is an island, a haunt of oddballs and outsiders: "Soho was the

perfect place for the misfit. There nobody fitted, that was the point".[10] Artists who were engaged in an intense search for meaning and self-expression, which could not take place in establishment settings or cosy suburbs, found in Soho a place where their mission could be pursued.

On the whole the artists who foregathered in Soho were not 'joiners', unless membership of drinking clubs counted. The underworld appeal of readily available alcohol and (homo)sexuality was exemplified by the success of the Colony Room. This members-only drinking den run by the formidable Muriel Belcher was "the nearest thing to a Paris café this bleak and private city could offer",[11] but was more Montmartre than Montparnasse. Whereas the Isobar Club had served nourishing food in a purpose-designed interior where the state of the world could be discussed in the carefully inflected English of the educated émigré, the Colony Room was an *ad hoc* adaptation of the upper floors of an inner-city house, in which booze, fags and raucous laughter accompanied the hedonistic pursuit of personal gratification, and where a few choice expletives might serve to analyse the state of one's hangover. Belcher's gift for insult was legendary. She could be ruthless in excluding hangers-on and would-be Bohemians, but her aggressive manner concealed a kind heart and fierce loyalty to her artist friends.[12] The unsettlingly louche atmosphere of the club was captured by Michael Andrews (1928–1995) when, in 1962, he painted Belcher in the Colony Room with a cluster of her favourites (fig. 120): Francis Bacon (1909–1992; figs. 121 and 122) and his model Henrietta Moraes, the photographer John Deakin (1912–1972), Bruce Bernard (1928–2000) and Lucian Freud (born 1922).

In keeping with their individualistic attitudes, the artists identified as belonging to the "School of London"[13] were never a formally organized group, and Soho was not their only stamping ground. Their studios and homes were scattered across London: Bacon (after many moves) in South Kensington; Frank Auerbach (born 1931) in Camden Town; Freud in St John's Wood followed by Maida Vale. The two Roberts, MacBryde and Colquhoun, shared a studio in Notting Hill where it was said that "The Old Swan Pub ... was popular on Sundays when bus and tube trains were too infrequent to carry the artists into Fitzrovia and Soho for their drink and social life".[14] Homosexuality was a strong bonding force for some of these artists, as it was for other 'misfits', such as John Minton (fig. 123) and the writer Colin MacInnes (1914–1976), both 'outsiders' whose sexual orientation placed them on the wrong side of British law and who found a highly charged camaraderie in the bars and clubs of Soho.

Not all Soho's artistic activity was focused on hedonism. The district was home to the Artists International Association and several small contemporary art galleries, two of which, Zwemmer's and Gallery One, were beacons for the next genera-

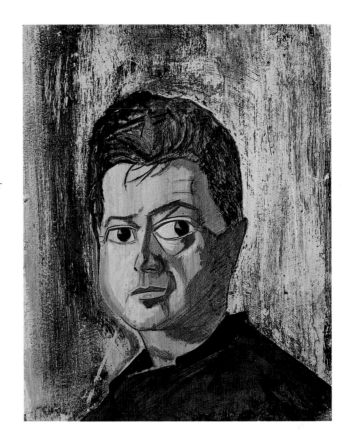

121
Reginald Gray, *Portrait of Francis Bacon*, 1960, oil on board, 53.4 × 46.4 cm, London, National Portrait Gallery

tion of British experimentation with European-influenced avant-garde art. Zwemmer's art gallery in Litchfield Street was a spin-off from the Charing Cross Road bookshop, opened in 1922 by the Dutch bookseller Anton Zwemmer. At the other end of Litchfield Street, Gallery One was opened by the poet Victor Musgrave in 1953 using £18 he had won in a poetry competition. The Gallery survived two moves, one within Soho and one to Mayfair, before it closed in 1963. "Of all London galleries", it was said of Gallery One in 1957, at which time it occupied an upstairs room at 20 D'Arblay Street, "it might be said to resemble most closely the little galleries in and around the Rue de Seine, not least because of the character of its environs".[15]

Gallery One's exhibition programme reflected Musgrave's idiosyncratic taste for Expressionist, "outsider" and "intellectual primitive" artists. It was international in outlook, as was the work of Musgrave's Russian-born photographer wife, Ida Kar (1907–1974), who contributed artists' portraits to the gallery's catalogues besides pursuing her own career. Gallery One earned its reputation in the time-honoured way of exhibiting controversial work, including in 1957 the first British solo exhibition by Yves Klein (1928–1962), whose blue "monochrome propositions" created with a household paint roller

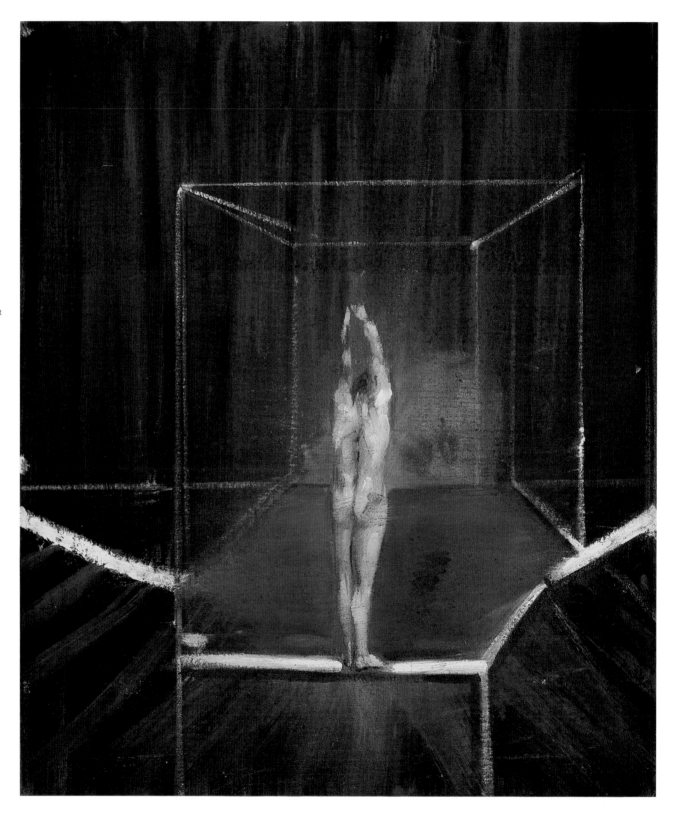

122
Francis Bacon, *Study of a Nude*, 1952–53, oil on canvas, 59.7 × 49.5 cm, Norwich, University of East Anglia, Sainsbury Collection

were denounced by the journalist Bernard Levin as "one of the most blatant artistic hoaxes of the 20th century". The show was defended by Colin MacInnes, then living above Gallery One and a firm supporter of Musgrave, as "amusing, creative and intelligent – words which even an admirer of Mr Levin's writing could not use to describe his article".[16]

Other international figures championed by Gallery One included Enrico Baj (born 1924) who exhibited his "interplanetary paintings" in 1959, and the Indian painter Frank Souza (born 1924) who came to London from Bombay in 1949 and who might have starved without Musgrave's support. Souza and another Gallery One artist, the Greek Londoner John Christoforou (born 1921; fig. 124), both enjoyed something of a cult following in 1950s London but have since been rather forgotten: Christoforou moved to Paris in 1956; Souza to New York in the 1960s. The experimental sculptor Peter King (1928–1957) and the abstract artist Alexander Weatherson (born 1930) also figured in Musgrave's stable of favourites: Weatherson, a friend of Colin MacInnes, designed the book jacket for his partly Soho-set novel *City of Spades* (1957; fig. 125). Musgrave kept up his reputation for idiosyncratic individualism until the gallery's closure, organizing the first London exhibition for the young Bridget Riley (born 1931) in 1962 and in the same year putting on a "Festival of Misfits", which included performances by 'living sculptures' and was an early manifestation of the Fluxus group.

Soho also played a part in the parallels of life and art pursued by a more cerebral group of avant-garde artists, the Independent Group, which grew out of a discussion group at the Institute of Contemporary Arts. The ICA, founded in 1948 with an inaugural exhibition in the basement of the Academy Cinema on Oxford Street, was designed as an arts organization that was "experimental, international and capable of unifying all the arts".[17] The Scottish–Italian sculptor, draughtsman, designer and printmaker Eduardo Paolozzi (born 1924; fig. 126) was a key member of the Independents, as was the photographer Nigel Henderson (1917–1984). Both taught at Central School in the early 1950s, Henderson sending his creative-photography students out into the streets for inspiration, Paolozzi – having turned down the offer of a sculpture post at Central in 1948 in favour of staying in Paris – teaching textile design from 1949 to 1955 when he moved to St Martin's as a sculpture tutor (fig. 127).

The Independent Group sought pointers towards a new post-war world, one in which the traditional boundaries between 'high' and 'low' culture, 'life' and 'art' would evaporate. Soho provided the perfect backdrop for their particular post-war aesthetic, which turned for the first time to America as much as Europe, finding inspiration in the visual bricolage of Soho

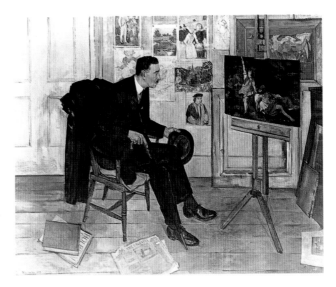

123
John Minton, *Portrait of Neville Wallis*, 1952, oil on canvas, 140 × 170 cm, Brighton, Brighton Museum and Art Gallery

124
John Christoforou, *Portrait of a Woman*, 1961, oil on canvas, 123.6 × 91.9 cm, Nottingham, Nottingham Castle Museum

125
Alexander Weatherson, book jacket design for *City of Spades* by Colin MacInnes, 1957

126
Cathleen Mann, *Eduardo Paolozzi*, 1952, oil on canvas, 127 × 101 cm, London, National Portrait Gallery

newsagents and the second-hand book stalls of the Charing Cross Road rather than the National Gallery. The Group drank at the Dog and Duck in Frith Street and met formally at the French House in Dean Street on Saturdays to explore "mass communication, science fiction and Americana. Subjects of that kind which were very much in the minds of the younger generation of art students and students of all sorts really."[18] Paolozzi and Henderson were both Colony Room habitués, and it was here that Paolozzi met, and is said to have been influenced by, Francis Bacon, whose distorted vision of the post-war "damaged man" moved him.[19]

Jazz in its bebop form was another source of American modernism that Soho could supply. Henderson undertook jazz-related photojournalism, and produced many negatives of saxophonist Ronnie Scott's various bands during the 1950s. Henderson, Paolozzi and the painter Alan Davie (born 1920), then also at the Central School, were enthusiasts for the splintered musical language of bebop as heard in Soho's few modern jazz clubs (fig. 128). The more danceable 'revivalist' – later 'trad' – jazz attracted a larger following, including John Minton, a regular at the London Jazz Club in Oxford Street, "where he danced under the nose of the band, ducking beneath the trumpet and dodging the slide trombone like a matador flirting with the horns of the bull which might one day kill him. Like George (Melly) who danced in much the same way, he made his pleasure look dangerous."[20] At the Gargoyle Club in Meard Street Rodrigo Moynihan (1910–1990) and his wife Eleanor were often to be seen "jiving till the sweat poured down their faces".[21]

By the mid-1950s mainstream society was beginning to catch up with Soho. Elizabeth David's cookery books, such as *French Country Cooking* (1961), 'decorated' with John Minton's illustrations, brought olive oil and garlic into the middle-class kitchen. In the key year of 1956 the first performance of *Look Back in Anger* destroyed the complacent English 'drawing-room' drama and inaugurated the Angry Young Man school of literature. In the same year, the exhibition *Modern Art in the United States* at the Tate Gallery introduced the work of Abstract Expressionist painters such as Jackson Pollock to the British public, and helped legitimize America as a source of 'high' as well as mass culture.

The first Soho Fair, too, was in 1956. This celebration of the special character of the 'village' of Soho was organized by local businesses in an effort to promote themselves and attract customers from outside the immediate vicinity. Gallery One held an exhibition of work by local artists, including Gillian Ayres (born 1930), who was then living above the AIA Gallery in Lisle Street. Not all the Soho insiders welcomed this opening-up of their special territory to the outside world. Colin MacInnes was one of them: "He was anti-establishment. So when the establishment entered it all, he deeply resented it."[22] MacInnes drifted away to Spitalfields, his outsider's instincts leading him unerringly to the part of London that would provide a home and an inspiration to the next generation of artists.

127
Eduardo Paolozzi,
The Philosopher, 1957,
bronze, 188 cm, London,
The British Council

128
Nigel Henderson, *Jazz Modernists*, c. 1953,
photograph, London, Tate

East End 1960–2000

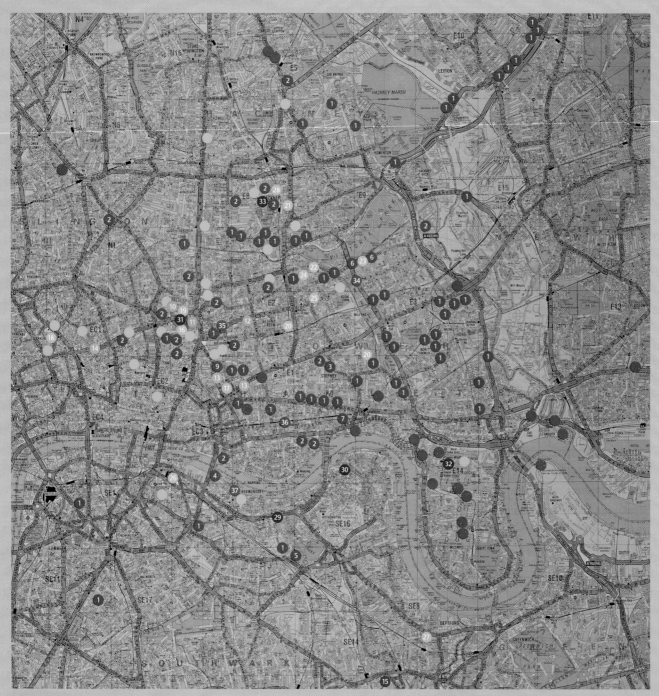

Studios & homes

1. Acme houses & studios, 1972–
2. SPACE studios, 1968–
3. The Old Jewish School studios
Stepney Green, 1971–
4. Butlers Wharf studios
1973–81
5. Dilston Grove studios
1969–
6. Chisenhale Studios
1980–
7. Cable Street Studios
566 Cable Street, 1984–
8. Nigel Henderson
46 Chisenhale Road, 1945–52
9. Gilbert and George
Fournier Street, Spitalfields, 1967–

Meeting-places

10. The Lux Centre
2/4 Hoxton Square, 1997–
11. The Bricklayers Arms
Charlotte Road
12. Pellici's Café
103 Bethnal Green Road

Supporting trades & organizations

13. Atlantis
146 Brick Lane, 1993–99
7/8 Plummers Row, 1999–
14. Artangel
36 St John's Lane, 1985–

Art schools & academies

15. Goldsmiths College
New Cross

Exhibition spaces & dealers

16. Factual Nonsense Gallery
44a Charlotte Road, 1992–96
17. Whitechapel Art Gallery
Whitechapel High Street, 1901–
18. The AIR Gallery
Rosebery Avenue, 1978–88
19. White Cube²
48 Hoxton Square, 2000–
20. Interim Art
21 Beck Road, 1984–99
21 Herald Street, 1999–
21. Matt's Gallery
Martello Street, 1979–92
42/44 Copperfield Road, 1992–
22. The Showroom
44 Bonner Road, 1988–
23. Chisenhale Gallery
64 Chisenhale Road, 1986–

24. The Approach Gallery
1st Floor, 47 Approach Road, 1997–
25. Camera Work Gallery
121 Roman Road, 1977–2000
26. Delfina
50 Bermondsey Street, 1996–
27. Hales Gallery
70 Deptford High Street, 1992–
28. Flowers East
199/205 Richmond Road, 1988–

Inspiring sites & architecture

29. Building One
Drummond Road,
Modern Medicine exhibition, 1990
30. PLA Building
Surrey Docks, *Freeze* exhibition, 1988
31. Shoreditch Town Hall
32. Canary Wharf Tower
33. Ellingfort Road

Public Art

34. *House* **by Rachel Whiteread**
Grove Road, 1993
**35. The Shop by Tracey Emin
& Sarah Lucas**
103 Bethnal Green Road, 1993
36. Cable Street mural by Ray Walker
37. *Invention* **by Eduardo Paolozzi**
Shad Thames, 1989

Unnumbered coloured spots indicate
lesser-known artistic locations

*Reproduced by permission of the
Geographers' A–Z Map Co. Ltd*
This product includes mapping data
licensed from Ordnance Survey Crown
Copyright 2000, Licence number
1000017302

1960–2000
Colonizing the East End

1960–2000
Colonizing the East End

The identity of the East End as a place of deprivation, poverty and undiluted working-class culture persisted until well after the Second World War, becoming overlaid with a certain gangster glamour in the 1960s. Today, London east of the City is still seen as 'other', having a separate, identifiable character and claiming a certain independence of outlook from the rest of the metropolis; but its cultural status has been transformed. Parts of the East End are believed to house the highest population of artists in Europe, and the East End generally is seen as occupying the centre, rather than the margins, of artistic practice in London. How has this happened?

At root the explanation is a simple story of supply and demand, with buildings at its heart. Before the Second World War the East End was a crowded, working-class district, with vast acres of nineteenth-century terraced housing, and the world's largest, oldest and busiest port as its main source of employment. By the 1970s the social and economic landscape had been wrenched into a new shape: the population was shrinking; the docks were closing as London's port activities migrated downriver to Tilbury; factories and houses stood boarded up and empty, awaiting clearance in the name of comprehensive redevelopment schemes. And, as the value of the East End's condemned buildings fell to rock bottom, so the supply met a rising market demand from an unexpected source: artists.

The story of the East End and artists is not, however, entirely one of simple economics. The East End's distinctive landscape, scarred by bomb damage in the 1950s and urban decay in the 1980s, has suited artists looking for new ways to connect their art with the realities of life in post-war London. The porous social fabric of an area that has a long tradition of tolerating 'outsiders' of all kinds has offered a sympathetic home to generations of artists whose views, interests and cultural outlooks align themselves naturally to non-Establishment culture, rather than the intellectual Bohemianism of a previous generation. The East End has been home to successive waves of incomers: Huguenot, Jewish, Bangladeshi, Somali, Ugandan and West Indian immigrants, and radicals – whether of a socialist, religious, philanthropic or anarchist bent. In such mixed company, artists pass almost unnoticed – or at least they did until the 1990s, when the presence of so much creative energy in one place began to draw media attention on an unprecedented scale.

The movement of artists into the East End over the last thirty years has often been described as phenomenal. In terms of the sheer numbers involved, London's late twentieth-century creative quarter dwarfs all the others described in this book, a phenomenon that partly reflects the expansion of the art colleges in the 1960s and the resulting injection of large numbers of art students into London's population. The East End's relationship with artists in the post-war period has also tended to obscure the district's pre-war artistic life.[1] The once-visible rich Jewish culture inspired a few West End artists, largely Jewish themselves, to venture east, producing such master-pieces as William Rothenstein's magnificent eight paintings of the Machizake Adass Synagogue in Spitalfields, executed between 1904 and 1907, and David Bomberg's *The Mud Bath* (1914), based on Schevzik's Vapour Baths in Brick Lane. Locally born artists found encouragement in the Whitechapel Art Gallery, which began holding annual exhibitions for local amateurs in 1904. The Camden Town School had an East End offshoot in the East London Group, formed around the evening classes run in Bow by the Slade-trained painter John Cooper. Several established painters, including Sickert himself, took an active interest in the group, which exhibited at the Lefevre Gallery in the 1930s, showing pictures whose subjects never strayed far from the industrial landscapes of Bow and Mile End. In the 1940s the same urban landscapes – this time torn apart by bombs and reformed into strange, surreal scenes – drew a variety of painters to the East End, sometimes on official war-artist duty. John Minton and Graham Sutherland (1903–1980) were among those whose work records the traumatic effect of the war on the East End's physical fabric.

Brutalism and community

One of the first to be attracted to the very qualities of the East End – the slums, decaying Victorian alleys and bomb-damaged streets – that repelled most people was the photographer Nigel Henderson, who moved with his wife, the sociologist Judith Henderson, to 46 Chisenhale Road, Bow (then in the borough of Bethnal Green), in 1945 (fig. 129). Henderson, a member of the Independent Group (see Chapter 7), was as fascinated by inner-city decay as by the conventionally beautiful. His photographs of bomb-damaged Bethnal Green, taken around 1950, were not just social documentation but also aesthetic explorations, as were the junk collages he put together with his friend Paolozzi, a frequent visitor to Chisenhale Road. The inspiration for collage was everywhere in the East End, where party walls exposed by bombing displayed their pathetic shreds of peeling wallpaper, and every corner shop window seemed a ready-made work of art, with "placarded, fly posted, glass surface panes, winking with light, faces looking out from the magazine covers and surrounded by the small necessities of life string and sealing wax and fags and playing cards".[2] It was this layering of reflection, glass window pane and shop interior that inspired Henderson to build up collages to achieve three-dimensional depth and texture.

It was through Henderson that the East End also came to affect the work of the 'New Brutalist' architects Alison and Peter Smithson. Close friends of Henderson, they showed his photographs of Bethnal Green children playing in the streets to the 1953 meeting of CIAM (International Congress of Modern Architecture), held at Aix-en-Provence, to reinforce their theories – radical for the time – about community life and the role of architectural form in creating and sustaining it.[3] Henderson, the Smithsons and Paolozzi all famously collaborated on the installation *Patio and Pavilion*, produced as their contribution to the 1956 exhibition *This is Tomorrow*, held at the Whitechapel Art Gallery. *This is Tomorrow* is often viewed as an early sighting of pop art, but it also stands as the apotheosis of a particular mood of post-Hiroshima angst. *Patio and Pavilion* was intended to communicate fundamental human needs – shelter, food and a stable habitat. Based on the Hendersons' own back garden, which included an old bath and a garden shed, the ramshackle structure also drew inspiration from the traditional rooftop pigeon lofts of Bethnal Green. Dominating the whole installation was Henderson's glowering collage *Head of a Man* (fig. 130), an archetypal image of the post-war damaged man.

The Whitechapel's director from 1952 to 1968 was Bryan Robertson, whose programme of well-publicized, high-quality

129
Nigel Henderson, *Inside 46 Chisenhale Road*, c. 1952, photograph, London, Tate

130
Nigel Henderson, *Head of a Man*, 1956, photographic collage, 168.6 × 130.8 cm, London, Tate

exhibitions of an eclectic range of art "transformed [the gallery] from a philanthropic educational resource for East Enders into the country's leading centre for contemporary art".[4] Robertson showed not only established stars such as Hepworth and Davie, but also up-and-coming young artists and many important foreign painters. He forged especially strong links with the United States, and throughout the 1960s the Whitechapel held exhibitions of the work of leading contemporary American artists (including Jackson Pollock, Mark Rothko, Robert Rauschenberg, Jasper Johns and Helen Frankenthaler), which constituted "the fullest source of information on the New York School to be found anywhere this side of the Atlantic".[5]

The Whitechapel's importance in providing some institutional anchor for the East End's relationship with art cannot be overstated. Since its foundation in the 1880s it had aimed to promote the work of local artists and foster a love of art among local residents. Although Bryan Robertson's new direction was criticized by some in the 1960s for turning the gallery's face towards the west rather than the east ("at the moment, the Whitechapel surely cannot consider itself successful when a woman, living three streets from it, showing me her first painting, asked: 'Is it all right? I don't know if the paint's put on right because you see I've never seen a real painting.'"),[6] the long-term consequence was to position the Whitechapel perfectly for the demographic changes of the last decades of the twentieth century when 'local artist' came to mean professional incomers as much as indigenous amateurs. The annual exhibition for local artists became the Whitechapel Open in 1977, and this was extended in 1988 by the Open Studios programme, which provided access to a far greater number of East End artists than could be accommodated in the gallery show. By 1996 the Open Studios programme involved over a thousand artists from sixty-six studio blocks: the exhibition, which by this time had spilled over into two satellite venues, showed the work of two hundred artists selected from a submission of twelve hundred.

Colonizing space

After Henderson, whose family moved away from the East End to an Essex village in 1952 (taking with them the family next door), the 1960s saw other isolated examples of individual artists migrating east. Richard Smith (born 1931) moved his studio to an ex-factory in Bath Street, Finsbury, in 1961; Gerald Laing (born 1936) took on an ex-rag-trade building in Spitalfields in 1962.[7] Also in the 1960s Richard Wentworth (born 1947) leased a redundant Mission Church in Dilston Grove, Southwark Park (the first such studio venture south of the river), and in 1967 a young St Martin's student, subsequently to become George of Gilbert and George (born 1943 and 1942 respectively), rented cheap rooms in Fournier Street, Spitalfields (fig. 131). Significantly, Richard Smith

had recently returned to London from New York, where one of the most striking things about the new wave of Abstract Expressionists was the sheer size of many of the paintings. Big art requires big studios: the New York School painters had colonized the lofts of Greenwich Village to find space for their enormous canvases. Those London-based artists who wanted to work on a similarly large scale found the equivalent opportunities in Docklands, where the first phase of closures had begun in 1965 with the winding down of the East India Docks, followed in 1968–70 by the closure of St Katharine's, the London and the Surrey Docks.

The pioneer of Docklands' warehouse studios was the organization SPACE (Space Provision, Artistic, Cultural and Educational) founded in 1968 by a group of artists, among them Bridget Riley and Peter Sedgley (born 1930). Sedgley, the driving force of the group, had discovered empty warehouses at St Katharine's Dock, near Tower Bridge, in Wapping in May 1968, while looking both for a studio for himself and a home for the Artists' Information Registry (AIR), an organization steeped in the 1960s counter-culture ethic and designed to promote the principle of workers' control in the art market.[8] After negotiating terms, the Greater London Council allowed the artists to occupy the site at a peppercorn rent on a very temporary basis while a competition for the wholesale redevelopment of the complex ran its course. The studios opened in April 1969. Run on egalitarian lines (although an initial proposal that the artists might share open-plan communal space was not adopted) and eventually accommodating over one hundred and fifty artists, the St Katharine's Dock colony "housed a comprehensive cross-section of artists, a radical alternative to traditional academies of art".[9]

The St Katharine's studios lasted until 1972 when the GLC awarded a 125-year lease of the site to the developers Taylor Woodrow and the artists were moved out to make way for the Tower Hotel and associated commercial developments, then seen by the GLC as a better bet for long-term regeneration. SPACE moved on to other short-term lease buildings, notably a former Jewish school in Stepney Green. Scheduled for demolition when the artists first moved in, the school survived and is now co-owned by the artists who work there, including Albert Irvin (born 1922), one of the original SPACE artists. Irvin's large canvases perfectly illustrate the underlying importance of real physical space to artists drawn towards the American vocabulary of Abstract Expressionism. They also carry an echo of their East End origins in that Irvin can title his paintings with the names of streets and places around his E1 studio (fig. 132). Although the use of street names is essentially an idiosyncratic naming system – the canvases do not depict the places whose name they bear – Irvin recognizes resonances between places and paintings.[10]

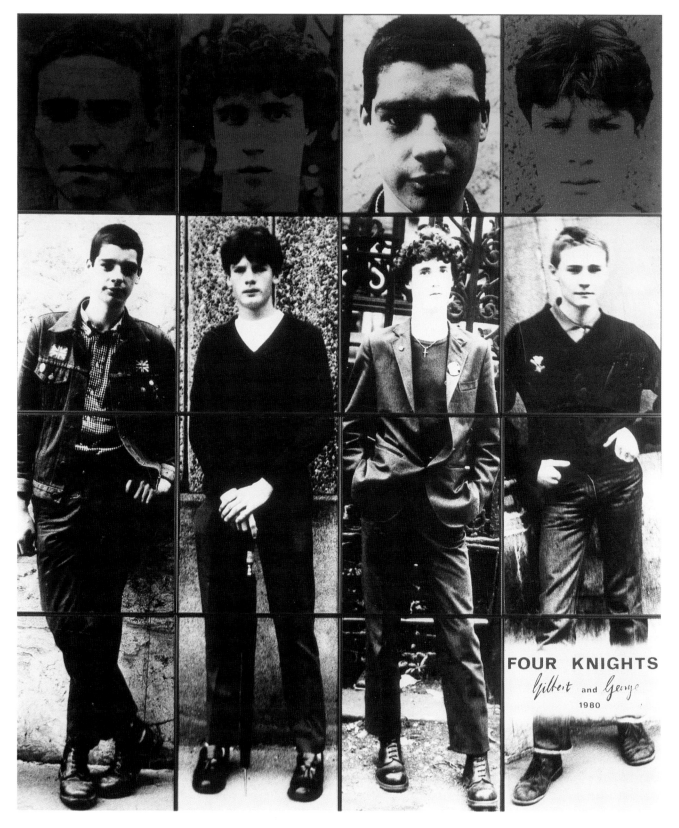

131
Gilbert and George, *Four Knights*, 1980, photograph and mixed media, 241 × 201 cm, Southampton, Southampton City Art Gallery

132
Albert Irvin, *Mile End*,
1980, acrylic on canvas,
213 × 305 cm,
Huddersfield, Huddersfield
Art Gallery

133
Jock McFadyen, *Canal
Lovers*, 1993–94, oil on
canvas laid on board,
90 × 73.4 cm, London,
Museum of London

SPACE provided one of two organizational models for artists in search of accommodation. The second was Acme, founded in 1972 as a device to enable a group of hard-up recent graduates from Reading University's Department of Fine Art to find somewhere to live in London. Whereas SPACE was about finding studios, Acme, in its early days, was about housing as well as workspace. Like SPACE, the organization operated through the GLC's property holdings, but the type of building it leased from the Council was 'short-life housing', those compulsorily purchased, vacant, boarded-up houses that stood empty while awaiting demolition. As David Panton, who co-founded the organization along with Jonathan Harvey, recounts:

> We first approached the Council in the spring of 1972, having seen a vast amount of empty property in East London, due eventually for demolition, but which looked suitable for our needs. The Council said no, they were not prepared to deal with us as individuals, but suggested we formed a housing association that could accept responsibility for returning the short-life property on time ... we were offered two derelict shops in Bow in

spring 1973 on a nominal rent of £3 per week with an expected life of 21 months, which had been empty for over 2 years.[11]

From the GLC's point of view the arrangements with the seven artists, now formally constituted as the Acme Housing Association, were far preferable to the squatting and vandalism that the properties might otherwise attract. Within a few months the Council had offered Acme more property on a similar short-life, self-help basis, an offer that came as a bombshell to the artists, who had originally aimed only to house themselves. The opportunity was taken, however, and within two years Acme was the largest single manager of short-life housing in London, leasing seventy-six houses, which provided living and studio space for ninety artists and housed over a hundred and thirty people (fig. 133).[12] In some places artists came to occupy whole streets, notably Beck Road in Hackney, where the inhabitants included Helen Chadwick (1953–1996). Beck Road became a doubly significant site for East London art, thanks to Maureen Paley's gallery, Interim Art. Paley, a film-maker and artist, moved into Beck Road as an Acme tenant in 1979 but in 1984 began

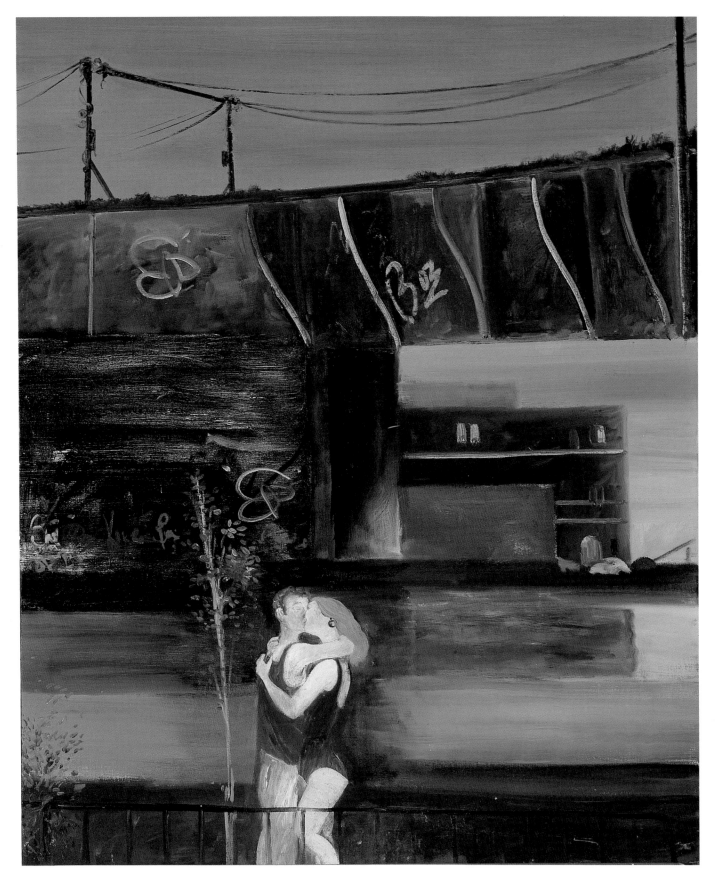

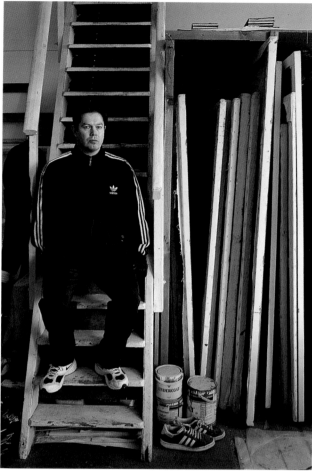

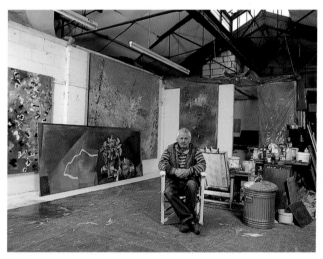

clockwise from top left
134
Torla Evans, *A Corner of
John Bartlett's Studio,
Bonner Road Studios*, 2000,
London, Museum of
London

135
John Chase, *John Bartlett in
his Studio*, 2000, London,
Museum of London

136
Torla Evans, *Anthony
Whishaw in his Studio*,
2000, London, Museum
of London

using her home as a gallery, exhibiting the experimental art for which the gallery is now internationally known.

By the late 1970s the number of Acme properties had increased to 200 and the organization had developed relationships with new sources of housing stock, notably the Department of Transport, which compulsorily purchased houses standing in the way of new road schemes. But the introduction of local authority tenants' right to buy in the 1980s altered the housing market, and as the effects of this began to bite and property values rose, Acme entered its second phase, turning its attention to studio blocks in ex-industrial buildings. Acme's first studio block was a former meat-pie factory in Acre Lane, Brixton, converted to twenty-eight artists' studios in 1976.[13] Others included a brush factory in Bonner Road, Bethnal Green, acquired in 1981 and now housing forty-six studios (figs. 134 and 135). Largest of all was the Carpenters Road site at Stratford, acquired in 1985. Formerly Yardley's cosmetics factory, this massive building provided 66,000 square feet of space that now houses 160 artists' studios. Like the short-life houses these ex-industrial buildings are held on leases, which, although they tend to be

slightly longer than the housing leases, still leave the buildings vulnerable to movements in the property market. The decision to site the International Cross-Channel Rail Station at Stratford sounded the death knell for the Carpenters Road studios, which found themselves in the middle of Europe's most lucrative development site: the studio block is due to be demolished within the next few years.

Throughout the 1970s both SPACE and Acme zealously promoted other forms of self-help action for artists. Peter Sedgley's AIR issued information manuals and directories covering everything from legal help to artists' materials. AIR also opened a gallery in Shaftesbury Avenue, moving eventually to Rosebery Avenue. Like the registry itself, the AIR Gallery was intended to cut out the Establishment middlemen of existing gallery owners and dealers, and by the time it closed in 1988 the gallery had earned a reputation for showing innovative work, including the work of black artists. Acme also opened a West End gallery: in 1976 a disused banana warehouse in Covent Garden was converted into the Acme Gallery, which it operated a similarly challenging programme until 1981, when it was

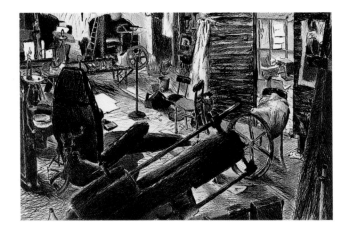

returned to the GLC for demolition. Both organizations were involved in the development of Robin Klassnik's Matt's Gallery, which was founded in 1979 at a SPACE property in Martello Street, Hackney, but relocated in 1992 – with Acme's help – to its present premises in Mile End. Acme also expanded its self-help activities through publishing.

Not every artist moving into the East End wanted to live or work under the aegis of a large organization. (Today, not everyone can, since demand continues to exceed supply – Acme currently has 580 artists on its studio waiting list.) If SPACE and Acme provided artists with two models of collaborative self-help, a third model was provided by the artists who colonized the empty warehouses of Butlers Wharf on the south bank of the river between 1973 and 1980. Here there was no formal organization, just a word-of-mouth, semi-legal, renting process, whereby each person came to their own separate arrangement with the largely *laissez-faire* property owner. The resulting colony, which occupied over 200,000 square feet of space and was possibly the largest colony of artists in London at the time,

137
Michael Heindorff, *Stephen Cripps's Studio at Butlers Wharf in the 1970s*, 1995, etching printed in black ink, 17.2 × 26.2 cm, London, Museum of London

138
Janet Brooke, *Alien Territory*, 2000, screenprint, 38 × 50 cm, London, artist's collection

included such legendary figures as Derek Jarman (1942–1994) and the pyrotechnic sculptor Stephen Cripps (1953–1982), whose studio is commemorated in a set of etchings by another occupant, Michael Heindorff (born 1949; fig. 137). On their hurried departure from Butlers Wharf, following an alarming fire and the arrival of property developers, some of the artists moved to a former aircraft-propeller factory in Chisenhale Road, Bow, where the studios have just celebrated their twentieth anniversary.

Today there are many hundreds of studio complexes and many thousands of artists in the East End. Some have come east in search of space. The Royal Academician Anthony Whishaw lives in West London and commutes daily to his Acme studio in Bonner Road, which can accommodate his large, contemplative works (fig. 136). Others, such as the printmaker Janet Brooke (born 1947), live and work in the East End. Brooke is a reminder that not all artists came east as part of a counter-culture adventure. Her presence in Mile End is largely accounted for by her job at Newham College of Further Education, where she taught printmaking from 1974 to 2000. Brooke's main source of inspiration remains the inexhaustible visual richness found in the East End's urban landscapes (fig. 138). Not all artists look west for their market. For the community art groups that emerged in the 1970s, the focus was very firmly local. Typical of many was the Tower Hamlets Arts Project, established in January 1976 to promote activities on the theme of "Us, the People of Tower Hamlets".[14] The paintings convenors were Dan Jones and Anne-Margret, who saw murals as the ideal bridge between art and community. Their legacy of public art includes the massive mural by Ray Walker (1945–1984) in Cable Street, depicting the street's famous anti-fascist battle.

With all this diversity, it is tempting to see the East End as a microcosm of the entire story of British art over the past thirty years. A reminder that this is not necessarily so is provided by the work of black artists. The East End cannot be said to have been a particularly significant site for the growing recognition in the 1970s and 1980s of a distinctive black tradition in British art. The key London institutions, events and groupings in this process were largely located elsewhere: the Caribbean Artists Movement was associated with West London; the Black Art Gallery began life in 1983 in Finsbury Park. However, the East End is by no means absent from the story. In 1987 the Chisenhale Gallery hosted *The Essential Black Arts*, curated by Rasheed Araeen (born 1935), a key figure in the radicalization of black arts in the 1970s. The Cameraworks gallery in Bethnal Green, founded in 1977, helped promote the work of Black and Asian photographers throughout the 1980s. More recently the University of East London has become the home of the African and Asian Visual Arts Archive (AAVAA), under the codirectorship of the artist Sonia Boyce (born 1962) and the photographer and writer David A. Bailey.[15] Given the demographic and cultural make-up of East London today, it is inevitable that the development of community arts in East London should have steered towards non-English cultures. The Multicultural Arts Consortium, established in October 1993 at Toynbee Studios in Spitalfields, is an example of an organization "committed to arts and multiculturalism as a means of fostering community development".[16] East London also houses two of London's most artistically innovative carnival bands, Perpetual Beauty, based in Hackney, and Masquerade 2000, based in Leytonstone, both of which are regular award-winners at the Notting Hill Carnival.

Art and urban chic

Rachel Whiteread (born 1963) is one of many artists with East End connections who have been shortlisted for the Turner Prize. In 1993, the year she won the prize, she was working from the Carpenters Road studio blocks and had recently been propelled into the nation's consciousness through her extraordinary *House* (fig. 139). Erected in Grove Road, Bow, from October 1993 until its controversial demolition in January 1994, this monolithic concrete cast of the inside of a Victorian house gave viewers a moving and shocking focus for contemplating the East End's long history of dispute, dislocation and distress.[17]

East End-related Turner prize nominees have included Richard Wilson (selected in 1988 and 1989), an ex-Butlers Wharf artist; Fiona Rae (selected in 1991), who occupied a council flat in Haggerston Road; and Cornelia Parker (selected in 1997), an occupier of Acme short-life housing. The list includes many more famous names and underlines the gradual alignment of the East End with the contemporary art 'establishment' in the late 1980s and 1990s, a process that coincided with the parallel alignment of a new generation of contemporary art with a newly fashionable urban sensibility.

Warehouse spaces provided the common ground for both art and fashionable urban lifestyle in the 1990s. The seminal warehouse exhibition was *Freeze*, held in Surrey Docks in 1988, a self-help effort by a group of recent graduates from Goldsmiths College led by Damien Hirst (born 1965). *Freeze* was marked out from other artist-organized exhibitions by the slickness of every aspect of its presentation, from the list of distinguished guests invited to the private view, to the well-produced catalogue. This professionalism "came from the artists' awareness of the hyper-professional world of international art. Or at least the illusion of hyper-professionalism that the international art world tried in those days to maintain at all times."[18] Although the style of the early warehouse shows such as *Freeze* and its successor, *Modern Medicine*, was designed to exploit the modern-art establishment by showing art that was, in Matthew Collings's phrase, "utterly system-friendly",[19] the impulse that led the Young British Artists

139
Rachel Whiteread, *House*, 1993–94

140
Damien Hirst, *Untitled,*
from the group portfolio
'London', 1992, four-colour
screenprint, 62.5 × 86 cm,
London, Tate

to arrange their own exhibitions was the same as that which had led to the founding of the Royal Academy in 1768: the need to exhibit among like-minded artists, and the desire to control their public image to their own advantage. Fittingly, it was the Academy's *Sensation* show in 1997 that turned several of these Young British Artists, including Tracey Emin (born 1963), Damien Hirst and Marc Quinn (born 1964) into household names.

The press outrage that followed *Sensation* merely added to the East End's emerging reputation as the principal artists' quarter in London, a reputation that ambitious young artists had already been exploiting for over a decade. As Alice Sharp wryly noted in 1990, "The media is very interested in this area, when artists come from this area they are much more likely to be latched on to. Artists want to be in Hackney because they know they can get the profile out of it."[20] The East End's reputation as a key location for young British artists was intensified by the growing insider buzz around Shoreditch and Hoxton, where, it was rumoured, extraordinary things happened at the Bricklayers Arms on Charlotte Road, and the studio parties attracted a potent mix of increasingly notorious names. The man largely responsible for the Hoxton buzz was visionary art entrepreneur Joshua Compston (1970–1996), creator of the Factual Nonsense Gallery at 44a Charlotte Road – "purveyors of

the ND(SFM) Notorious Dream (Struggle For Modernism)" – and *éminence grise* behind such legendary events as the "Fête Worse than Death", held in 1993 and 1994. Compston's energetic life and untimely death are commemorated with a plaque on the Factual Nonsense building, the Factual Nonsense Archive held at the Tate, and a group portfolio of eleven 'London' screenprints by his artist friends and collaborators. Published by Charles Booth-Clibborn's Paragon Press in 1992, one set was given to the Tate in 1996 in Compston's memory (fig. 140).[21]

Tracey Emin and Sarah Lucas (born 1962) made their own contribution to the legends with *The Shop*, a clever subversion of consumer culture and the role of the gallery in promoting and validating artists' work (fig. 141). *The Shop*, which operated behind an unassuming frontage between a take-away food premises and a leather merchant's on Bethnal Green Road, was another example of how the cheap property of the East End enabled artists to work and exhibit. Emin went on to open a museum in Waterloo, in which she literally made an exhibition of herself, using traditionally 'feminine' techniques such as patchwork and embroidery to commemorate people and events that were significant in her life. The wit, irony and honesty of Emin's work has been largely overlooked in articles about her in the general press, to the point where it seems as though the

141
Tracey Emin and Sarah
Lucas, *The Last Night of The
Shop 3.7.93*, 1993, fabric
with paper badges,
151 × 133 cm, private
collection

artist is choreographing her relationship with the critics in a masochistic ritual of mutual dissection.

The visible evidence of in-crowd activity remained hidden to outsiders until the late 1990s. A *Daily Telegraph* journalist going in search of the new Notting Hill in Hoxton in 1996 was disappointed. "Many speak highly of Hoxton Square, but I wandered round twice and found only St Monica's Boxing Club, a martial arts centre and Thomas Fox and Co. which sells reconditioned safes. Apparently there is a vibrant party scene in the studios here."[22] Within a year the scene broke cover. In Hoxton Square, The Lux opened in September 1997, a newly built complex of workspaces, cinema and video gallery for London Electronic Arts and the London Film Makers' Co-operative. In the same corner of Hoxton Square the revamped Blue Note Club was joined from spring 2000 by the White Cube[2] gallery, run by the leading BritArt dealer Jay Jopling. On the other side of the Bishopsgate Goods Yard, Brick Lane, having only just been rebranded "Banglatown" by Tower Hamlets Council, suddenly sprouted Internet cafés and designer-furniture shops among the curry houses. A former member of staff at the Whitechapel Art Gallery recalls how, in the late 1990s, "every time I walked down Fashion Street, a new space would have opened. Three weeks later it would be gone, but in the meantime several hundred people would have been to see the show and they would all be talking about it."[23]

Regeneration and the future

David Panton has likened the movement of artists into the East End's cheap property as the inevitable filling of empty space: "nature abhors a vacuum".[24] Artists have not, however, been the only ones to feel this irresistible pull: the forces of gentrification, regeneration, and private- and public-sector ambition have also been strong players in the East End over the last thirty years, and the invasion of artists has sometimes had to jostle for space with these 'harder' economic invasions. It is something of a truism to say that artists are leaders in the process of urban regeneration, and that wherever they go, fashion, money and commercial development follow.[25] Although the East End experience does seem to bear this out, it also underlines the role played by public-sector funding and interventionist planning decisions. Hoxton's reinvention as a cultural quarter is as much a consequence of Hackney Council's activities as it is of studio parties: The Lux would not have been built without Council-awarded European Regional Development Funding and a partnership between the Council and the developer Glasshouse Investments Ltd.[26]

Jonathan Harvey makes the point that local government's recognition of the role played by artist-led organizations has come late in the day.[27] Until very recently artists were treated with some suspicion by local government: at best, as with the

142
Julian Bell, *Arrest at Nevada Bob's*, 1999, oil on canvas, 83 × 74 cm, London, Museum of London

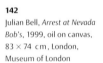

143
Tom Hunter and James
Mckinnon, *London Fields
East: The Ghetto* (detail),
1994, photograph and
mixed media,
80 × 536 × 194 cm,
London, Museum of
London

GLC, as solutions to vacant property problems; at worst with outright hostility. The demolition of Rachel Whiteread's *House* in 1994, as ordered by Bow Neighbourhood Committee in defiance of outsiders' opinion, exemplified a view of artists as importers of alien, élitist values irrelevant to the local community. Another example of artists in conflict with the 'official' forces of East End regeneration was the long-term squatting of Ellingfort Road in Hackney. This affair, which set the artists' vision of the long-term viability of the housing stock directly against the Council's, produced one extraordinary artwork – *London Fields East: The Ghetto* by Tom Hunter and James Mckinnon (fig. 143), both residents of the threatened houses. Like *House*, *The Ghetto* also comments on East London's perennial issues: land use, housing stock, communities, and who should have the power to determine their future.

Acme is in no doubt that its work has been in spite of, rather than because of, local-authority regeneration programmes, and blames the politicized nature of local government for muddying the water of decision-making over building stock; property developers, on the other hand, offer a 'clean deal'. Local-government funding has not entirely passed over artist-led organizations. The canal-side warehouse that houses the Chisenhale complex is leased at low rent from Tower Hamlets Council, which also provides the gallery with funding for its education programme, but such instances have been the exception rather than the rule. Generally, it is only within the last few years that local and national government have come to acknowledge the importance of 'the cultural industries' in raising the status of run-down districts. The respectability that artists craved in the eighteenth century has thus arrived in the twentieth century from an unexpected quarter, creating what many might think is an uneasy alliance between artists and the hard-nosed end of government.

What does the future hold for this alliance? As the case studies pile up of inner-city areas transformed into vibrant cultural quarters, there seems little reason to doubt that planners will look ever more keenly on the presence of artists in their areas, seeing art activity as a significant indicator of regeneration potential. Art in the form of public art already plays a visible role in regeneration strategies, and here East London provides an important case study in the London Docklands Development Corporation's lavish provision of public art during the 1980s and 1990s. Today the East London borough of Barking and Dagenham is leading one of the largest public art projects in the United Kingdom. The A13 Artscape project has a budget of £9 million, made up of funding from the National Lottery, the Highways Agency and the borough's Single Regeneration Budget.[28] The justification for public spending on this scale is very far from being 'art for art's sake'.

The vision of an ideal future for for many of East London's artist-led organizations is not so much public art as property ownership. Having colonized and settled their buildings they now, quite understandably, wish to secure them for the future. The artists who run the studio complexes at Chisenhale and Cable Street are desperately trying to buy their buildings – a difficult task given the sums of money involved. Acme sees its future in freeholds rather than leaseholds. A Lottery award in 1997 combined with a depression in the property market enabled Acme to take the first steps towards providing more secure long-term premises for artists by purchasing and converting two buildings, a 1911 fire station in Poplar and a large Victorian warehouse in Copperfield Road, Mile End. The former will create "the first permanent, fully accessible, low-cost, combined working and living spaces for professional fine artists in the United Kingdom",[29] offering twelve artists at a time three-year residencies in which they can develop their work. The latter houses fifty-seven studios, Matt's Gallery and Acme's own offices. An earlier example of the benefits of property ownership is provided by the group of ex-SPACE artists who, having moved into the Jewish School in Stepney in the 1970s, bought it outright in 1985. The twenty years' worth of paint splatterings on Albert Irvin's studio floor (fig. 144) is an exuberant testament to the freedom that permanent workspace brings.

Estimates of the number of artists living in the East End vary, but only a handful can make a living from their art, let alone achieve lasting fame. Recent research by the Arts Council suggests that an artist would be lucky to earn £5000 a year from producing his or her own work.[30] Most artists teach or have other jobs in order to make ends meet, and many fall by the wayside. For every Young British Art star, there are dozens who never make it. And for those who do manage to earn more than £5000 a year through their art, the world is getting smaller. Artists such as Langlands and Bell (fig. 145), who live in Whitechapel but exhibit internationally and on the Internet, have no overriding professional need to locate themselves in the East End. The decision to live or work somewhere thus becomes a matter of personal choice rather than – as it was for the artists in London's earliest artists' colonies – professional or commercial advantage. If cheap property continues to be the main factor in personal choice then perhaps it is not so far-fetched to speculate that "maybe Eastern Europe is the new East London".[31] Will artists continue to migrate to the East End, given that property prices are rising? At the time of writing, a two-bedroom flat in a converted furniture factory just off Bethnal Green Road was being advertised on the Internet for sale at £399,950. Although David Panton believes that "artists have moved to the East End and are staying put",[32] one wonders whether the next generation will follow them.

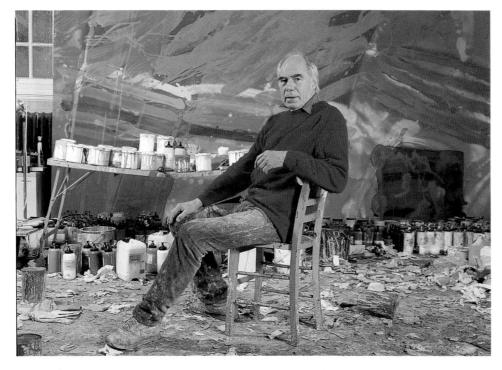

144
Richard Stroud, *Albert Irvin in his Studio*, 2000, photograph, London, Museum of London

145
Langlands and Bell, *Traces of Living*, 1986, mixed media, 80 × 520 × 61 cm, London, artists' collection

Chapter 1

1. Mary Edmonds, 'Limners and Picturemakers: New Light on the Lives of Miniaturists and Large-scale Portrait-painters Working in London in the Sixteenth and Seventeenth Centuries', *Walpole Society*, XLVII, 1978–80, p. 63.
2. Nicholas Hilliard, 'A Treatise Concerning the Arte of Limning', MS Laing, Edinburgh University, quoted in Katharine Coombes, *The Portrait Miniature in England*, London 1998, p. 32.
3. Petition by the inhabitants of the Precincts of St Ann Blackfriars and Whitefriars to Queen Elizabeth (1580), now *State Papers* 12/137, quoted in Edmonds 1978–80, p. 64.
4. Susan Foister, 'Foreigners at Court: Holbein, Van Dyck and the Painter Stainers' Company', in D. Howarth (ed.), *Art and Patronage at the Caroline Courts*, Cambridge 1993, pp. 32–50.
5. Edmonds 1978–80, pp. 177–88, contains a good summary of the work carried out and payments received by the Serjeant-Painters of the sixteenth and seventeenth centuries.
6. Ellis Waterhouse, *The Dictionary of Sixteenth and Seventeenth Century British Painters*, Woodbridge 1988, p. 142.
7. Peter W.M. Blayney, 'The Bookshops in Paul's Cross Churchyard', *Occasional Papers of the Bibliographical Society*, no. 5, London 1990.
8. E.G. Duff, *A Century of the English Book Trade*, London 1905, p. 62.
9. Other paintings by Gipkym are in the Edward Alleyn collection at Dulwich Picture Gallery. See *Edward Alleyn, Elizabethan Actor, Jacobean Gentleman*, exhib. cat., ed. A. Reid and R. Maniura, London, Dulwich Picture Gallery, 1994, pp. 39–52. Our thanks to Pamela Tudor-Craig for sharing her research on Gipkym.
10. Foister 1993, p. 39.
11. Sir Thomas Elyot, *The Boke Named the Gouernour*, London 1531, p. 57.
12. David Ormrod, 'The Origins of the London Art Market, 1660–1730', in M. North and D. Ormrod (eds.), *Art Markets in Europe, 1400–1800*, Aldershot 1998, pp. 167–86 (p. 171).
13. Cited in Christopher Hibbert and Ben Weinreb (eds.), *The London Encyclopaedia*, London 1983.
14. *Office of Works Accounts*, E 351/3268 (1634–35), cited in Edmonds 1978–80, p. 125.
15. Foister 1993, p. 33.
16. William Aglionby, *Painting Illustrated in Three Catalogues*, London 1685, n.p.
17. See J. Douglas Stewart, *Sir Godfrey Kneller and the English Baroque Portrait*, Oxford 1983.
18. Edward Croft Murray, *Decorative Painting in England, 1538–1837*, London 1962, p. 73.
19. George Vertue, 'Notebooks', 6 vols., *Walpole Society*, XVIII, XX, XXII, XXIV, XXVI, XXX, 1929–52, I, p. 54.
20. John Thomas Smith, *Nollekens and his Times*, 2 vols., London 1829, I, p. 185.
21. Edmonds 1978–80, p. 187.
22. *Sir Peter Lely, 1618–80*, exhib. cat. by O. Millar, London, National Portrait Gallery, 1978, p. 7.
23. For Kneller's premises in Great Queen Street see L. Gomme (ed.), *The Survey of London*, 'The Parish of St Giles in the Fields', London 1914, V, pt. 2, pp. 55–56.
24. Alan Dent, *My Covent Garden*, London 1973, p. 32.
25. Joseph Farington, *Memoirs of the Life of Joshua Reynolds*, London 1819, p. 16.
26. Brian Allen, *Francis Hayman*, New Haven CT and London 1987, p. 40.
27. Allen 1987, pp. 36–37, gives this as part of a longer quotation from a newspaper article by 'T.B.' of 1766 that was originally cited in W.T. Whitley, *Artists and their Friends, 1700–99*, London 1928, I, p. 219.
28. Will of Joseph Vanhaeken (Van Aken), proved 18 July 1749, Prob. 11/772/234.
29. Horace Walpole, *Anecdotes of Painting* [1780], ed. J. Dalloway and R.N. Wornum, London 1849, II, p. 715.
30. The artist Winstanley is described as sending canvases out with a painted face tacked on to a larger canvas.
31. Thomas James Mulvany, *Life of James Gandon, Esq.*, Dublin 1846, p. 212.
32. Vertue 1929–52, III, p. 117.
33. Vertue 1929–52, III, p. 123.
34. Smith 1829, II, p. 269.
35. See David Solkin, *Richard Wilson*, exhib. cat., London, Tate Gallery, 1982, pp. 20–21.
36. Timothy Clayton, *The English Print, 1688–1802*, New Haven CT and London 1997, p. 3.
37. Robert Campbell, *The London Tradesman*, London 1747, p. 105.
38. John Calfe trade card, Heal Collection (89.26), British Museum, London.
39. Whitley 1928, I, p. 332.
40. Joseph Austin trade card, Heal Collection (89.3), British Museum, London.
41. Whitley 1928, I, pp. 330–36.
42. Pepys's diary, quoted in Antony Griffiths, *The Print in Stuart Britain, 1603–1689*, London 1998, p. 29.
43. Allen 1987, pp. 103–04.
44. See Jacob Simon, *The Art of the Picture Frame: Artists, Patrons and the Framing of Portraits in Britain*, London 1996.
45. Sir Ambrose Heal, *London Furniture Makers, 1660–1840*, London 1953, 1988, pp. 11, 14.
46. Heal 1953, 1988, p. 97; illus., p. 88.

Chapter 2

1. Smith 1829. Hogarth's early fixation on Thornhill is covered by Ronald Paulson, *Hogarth*, 3 vols., Cambridge 1991–93, I.
2. Brenda Ralph Lewis, 'Hummums and Whore-houses', *Strange Stories from Covent Garden*, 3, April–May 1982, pp. 20–25 (p. 22).
3. *Weekly Journal or Saturday's Post*, 24 October 1724.
4. Paulson 1991–93, I, pp. 119–22.
5. Jenny Uglow, *Hogarth: A Life and a World*, London 1997, p. 236.
6. John Nichols, *Biographical Anecdotes of Mr Hogarth*, London 1781, quoted in Peter Quennell, *Hogarth's Progress*, New York 1955, p. 116.
7. It was subsequently used as a hotel. One anonymous commentator remembered "the place when it was Hogarth's … these d—d fellows have put a billiard table in the very room my old friend built to paint in." *The European Magazine*, June 1801, p. 442.
8. David Mannings, *Sir Joshua Reynolds: A Complete Catalogue of his Paintings*, 2 vols., New Haven CT and London 2000, I, p. 23.
9. Farington 1819, p. 46.
10. For a full list of the identities and professions of the men portrayed see Elizabeth Einberg's catalogue entry, *Manners and Morals: Hogarth and British Painting, 1700–1760*, exhib. cat., London, Tate Gallery, 1987, p. 85.
11. Vertue 1929–52, III, p. 71.
12. The raffle was won by Joseph Goupy, painter and etcher: see *Manners and Morals*, 1987, p. 85.
13. Mark Girouard, 'Coffee at Slaughter's?' in *Town and Country*, New Haven CT and London 1982, p. 16.
14. Vertue 1929–52, III, p. 91.
15. Girouard 1982, p. 16, and Allen 1987, p. 4.
16. Sir Joshua Reynolds, *Discourses on Art*, ed. Robert R. Wark, New Haven CT and London 1997, III, 14 December 1770, p. 50.
17. Reynolds 1997, IV, 10 December 1771, pp. 57–58.
18. Jonathan Richardson, *An Essay on the Theory of Painting*, London 1715, p. 31.
19. Robert Campbell, *The London Tradesman*, London 1747, pp. 96–97.
20. E.H. Ramsden, 'The Sandby Brothers in London', *The Burlington Magazine*, LXXXIX, January 1947, pp. 15–18.
21. The fullest account of London's various eighteenth-century academies is by Ilaria Bignamini, 'George Vertue, Art Historian, and Art Institutions in London, 1689–1768', *Walpole Society*, LIV, 1988.
22. Timothy Clayton 1997, p. 13. Although it is not certain, this academy was probably held at premises owned by Kneller at 57 Great Queen Street.
23. John Pye, *Patronage of British Art*, London 1845, pp. 20–21.
24. Michael Kitson (ed.), 'Hogarth's Apology for Painters', *Walpole Society*, XLI, 1968, pp. 46–111 (pp. 65–66).
25. Kitson 1968, p. 94.
26. Vertue 1929–52, III, p. 123.
27. Edward Edwards, *Anecdotes of Painters*, London 1808, quoted in Clayton 1997, p. 188.
28. Clayton 1997, p. 209.

Chapter 3

1. Cited in Dick Cashmore, Alan Unwin and Donald Simpson, *Twickenham 1600–1900: People and Places*, London 1981, p. 50.
2. Kenneth Garlick and Angus MacIntyre (eds.), *The Diary of Joseph Farington*, 17 vols., New Haven CT and London 1978–98, VI, p. 2463.
3. Vertue 1929–52, II, p. 121.
4. John Bowack, *Antiquities of Middlesex*, 2 parts, London 1706, p. 43.
5. Elizabeth McKellar, 'Peripheral Visions: Alternative Aspects and Rural Presences in Mid-Eighteenth-Century London', in Dana Arnold (ed.), *The Metropolis and its Image: Constructing Identities for London, c. 1750–1950*, London 1999, p. 43.
6. Ephraim Hardcastle (pseud. William Henry Pyne), *Wine and Walnuts*, London 1820, II, pp. 234–35. Although not entirely reliable, this entertaining volume is indicative of the way in which art and artists were perceived at this date.
7. Peter Bicknell, 'The Picturesque, the Sublime and the Beautiful', *The Alpine Journal*, LXXXV, p. 35 (offprint).
8. James Peller Malcolm, *Londinium Redivivum; or, an Ancient History and Modern Description of London*, 4 vols., London 1802–07, I, pp. 11–12.
9. Thomas West, *A Guide to the Lakes: Dedicated to Lovers of Landscape Studies, and all who have Visited or intend to Visit the Lakes in Cumberland, Westmorland and Lancashire. By the author of the Antiquities of Furness*, London 1778.
10. John Thomas Smith, *Remarks on Rural Scenery*, London 1797, p. 9.
11. Hardcastle 1820, II, p. 225.
12. A.B. Chamberlain, *George Romney*, London 1910, p. 212.
13. For the most recent account of Romney in Hampstead see David A. Cross, *A Striking Likeness: The Life of George Romney*, Aldershot 2000, esp. ch. 11.
14. Albion Cottage, near Whitestone Pond (1819); 2 Lower Terrace, near Judges Walk (1821–22); Stamford Lodge, near the centre of the village overlooking West Heath (1823); Hooke's Cottage, near Fenton House (1825); 25 Langham Place, Downshire Hill (1825).
15. John Constable, letter to C.R. Leslie, 28 November 1826, in R.B. Beckett (ed.), *John Constable's Correspondence*, 6 vols., Ipswich 1962–68, VI, p. 228.
16. John Constable, letter to John Fisher, 28 November 1826, in Beckett 1962–68, VI, pp. 227–28.
17. For the history of 'skying' see Anne Lyles, 'That Immense Canopy: Studies of Sky and Cloud by British Artists, c. 1770–1860', in *Constable's Clouds: Paintings and Cloud Studies by John Constable*, exhib. cat., ed. E. Morris, Edinburgh, National Gallery of Scotland, 2000, pp. 135–50.
18. C.R. Leslie, *Memoirs of the Life of John Constable* [1845], London 1995, p. 274.
19. See John E. Thornes, 'Constable's Meteorological Understanding and his Painting of Skies', in Morris 2000, pp. 151–59.
20. John Constable, letter to John Fisher, 3 November 1821, in Beckett 1962–68, VI, p. 81.

21. For the full story see David Linnell, *Blake, Palmer, Linnell & Co.*, Lewes 1994, pp. 79–86.
22. John Constable, letter to Charles Bonner, 2 July 1833, in Beckett 1962–68, V, p. 164.
23. John Constable, letter to John Fisher, 23 October 1821, in Beckett 1962–68, VI, p. 76.
24. Mireille Galinou and John Hayes, *London in Paint*, London 1996, pp. 139–40.
25. For full details see John Lewis Roget, *A History of the Old Water-colour Society*, 2 vols., London 1891.
26. Quoted in Peter Jackson, *George Scharf's London: Sketches and Watercolours of a Changing City, 1820–50*, London 1987, p. 92.
27. Quoted in C.M. Kauffmann, *John Varley, 1778–1842*, London 1984, p. 12.
28. Kauffmann 1984, p. 35.
29. Advertisement for patent graphic telescope, c. 1811, Science Museum (1934-121/121).
30. A.T. Story, *The Life of John Linnell*, London 1892.
31. G.E. Bentley (ed.), *Blake Records*, Oxford 1969, p. 292 .
32. Alexander Gilchrist, *Life of William Blake*, 2 vols., London 1863, II, p. 294.
33. Note in Linnell's hand on reverse of mount of drawing from the Fitzwilliam Museum, Cambridge (PD 58–1950).

Chapter 4
1. Garlick and MacIntyre 1978–98, III, entry for 16 December 1798, p. 1112.
2. For a list of all the artists associated with the area see Ann Cox-Johnson, *Handlist of Painters, Sculptors and Architects Associated with St Marylebone, 1760–1960*, London 1963.
3. Andrew Saint, 'The Building Art of the First Industrial Metropolis', in Celina Fox (ed.), *London World City, 1800–1840*, New Haven CT and London 1992, p. 69.
4. These appear in early nineteenth-century guide books, for example *The New Picture of London*, London 1818, p. 271.
5. Dorothy Richardson, *Travel Journals*, 5 vols., MS., John Rylands Library, University of Manchester, Ryl. Eng. MS 1123, ff. 311–12.
6. Leigh Hunt, *The Autobiography of Leigh Hunt with Reminiscences of Friends and Contemporaries*, London 1850, pp. 147–48.
7. 'Particulars and Conditions of Sale of the Very Spacious Gallery, Studio and Grand Exhibitions Rooms of the Late Benjamin West ... together with the desirable Residence, No. 14 Newman Street ... will be sold by Auction, by Mr. Geo. Robins ... On Monday, the 25th day of May, 1829', Westminster Archives, P1648.
8. Indenture of 12 September 1829, Westminster Archives, P1243.
9. Henry Howard (1769–1847), a painter of mythological and historical subjects and portraits, James Ward (1769–1859), who had more success as an animal painter than in his ambitious history and landscape subjects, and John Jackson (1778–1831), a

portrait painter, lived at nos. 5, 6 and 7 respectively; Henry Thomson (1773–1843), a history painter, was at no. 15; George Dawe (1781–1821), another portrait painter, at 22; and a painter of dramatic mythological scenes, Thomas Stothard (1755–1834), was at no. 28. Information from Colston Sanger, 'Agasse in London', in *Jacques-Laurent Agasse, 1767–1849*, exhib. cat., ed. Renée Loche and Colston Sanger, London, Tate Gallery, 1992, p. 36.
10. William Blake, 'Introduction', in *An Island in the Moon*, ed. Michael Phillips, Cambridge 1986, p. 8.
11. Mrs Bray, *The Life of Thomas Stothard, RA*, London 1851, p. 29.
12. Bray 1851, p. xxiii.
13. Allan Cunningham, *The Lives of the Most Eminent British Painters, Sculptors and Architects*, 3 vols., London 1830, III, p. 207.
14. Ann Cox-Johnson, *John Bacon, RA 1740–1799*, London 1961, p. 17. Also London Metropolitan Archives (E/BN/21).
15. Cunningham 1830, III, p. 243.
16. Rupert Gunnis, *Dictionary of British Sculptors 1660–1851*, London 1964, p. 25.
17. John Bacon's will proved 19 August 1799, London Metropolitan Archives (E/BN/21).
18. Ludwig Schorn, 'Kunst-Blatt', a supplement to *Morgenblatt für die gebildeten Stände*, 9, 12 and 16 April 1827. This translation is in *John Flaxman*, exhib. cat. by D. Bindman, London, Royal Academy of Arts, pp. 30–32.
19. Cunningham 1830, III, p. 362.
20. He held the post from 1810 until his death.
21. Margaret Whinney and Rupert Gunnis, *The Collection of Models by John Flaxman at University College, London*, London 1967, p. 1.
22. Verse attached to watercolour sketch in Museum of London (46.4).
23. For a fuller account of this and similar groups see *The Sketching Society*, exhib. cat. by J. Hamilton, London, Victoria and Albert Museum, 1971.
24. This watercolour was a preparatory sketch for a lost painting of 1835; a number of oil sketch portraits for the same work are now in the National Portrait Gallery, London.
25. The assembled company are the two Chalon brothers, C.J. Robertson (died 1832), Joshua Cristall (1768–1847), Thomas Uwins, R. Thomas Bone (1790–1840), S.J. Stump (died 1863), J. Robson (died 1833), J. Partridge and W. Clarkson Stanfield.
26. A collection of seventy-four sketches by various members of the Society, collected by John Partridge between 1833 and 1844, is now in the Department of Paintings, Prints and Drawings, Victoria and Albert Museum, London (PD.86a (19)).
27. *The New Picture of London*, London 1818, p. 273.
28. Oliver Millar, *The Victorian Pictures in the Collection of Her Majesty The Queen*, Cambridge 1992, p. 194.
29. William Makepeace Thackeray, 'The

Artist', in *Heads of the People*, London 1840–41, pp. 580–81.
30. Bray 1851, pp. 29–30.
31. Thackeray 1840–41, pp. 576–79.
32. Sanger 1992, p. 39.
33. Teresa Newman and Ray Watkinson, *Ford Madox Brown and the Pre-Raphaelite Circle*, London 1991, p. 29. Virginia Surtees (ed.), *The Diary of Ford Madox Brown*, London 1981, entry for 15 June 1747, p. 4.
34. See W.P. Frith, *My Autobiography and Reminiscences*, 3 vols., London 1887–91, I, p. 23.
35. Henry Festing Jones, *Samuel Butler, Author of Erewhon, 1835–1902, A Memoir*, 2 vols., London 1919, I, p. 201. For an alternative interpretation of this painting see Elinor Shaffer, *Erewhons of the Eye: Samuel Butler as Painter, Photographer and Art Critic*, London 1988, pp. 16–23.
36. Brown wrote these comments in a catalogue of 1865. See *The Pre-Raphaelites*, exhib. cat., London, Tate Gallery, 1984, p. 111.
37. Frith to Park Village West and then no. 7 Pembridge Villas (Bayswater/Notting Hill borders); Ward to Marlborough Terrace and then Lansdowne Road, Notting Hill; Phillip to Campden Hill Road; Egg to Campden Hill and then Kensington; O'Neil to Kensington.
38. The Clique is described in John Imray, 'A Reminiscence of Sixty Years Ago', *Art Journal*, LX, 1898, p. 202.
39. See *Hospitalfield: Patrick Allan-Fraser and his Art Collection*, exhib. cat. by W. Payne, Edinburgh, National Gallery of Scotland, 1990.

Chapter 5
1. For a helpful discussion of this see Joseph Lamb, '"The Way we Live Now": Late Victorian Studios and the Popular Press', *Visual Resources*, IX, 1993, pp. 107–25.
2. Georgiana Burne-Jones, cited in Caroline Dakers, *The Holland Park Circle*, New Haven CT and London 1999, p. 52.
3. M.S. Watts, *George Frederick Watts: The Annals of an Artist's Life*, London 1912, I, p. 140.
4. Maurice B. Adams, *Artists' Homes*, London 1883, p. 5.
5. Adams 1883, p. 5.
6. Mark Girouard, *Sweetness and Light*, New Haven CT and London 1977, p. 97.
7. For an account of Gambart's commercial tactics see Jeremy Maas, *Gambart: Prince of the Victorian Art World*, London 1975.
8. L.V. Fildes, *Luke Fildes RA: A Victorian Painter*, London 1968, p. 43.
9. Paula Gillett, *The Victorian Painter's World*, Gloucester 1990, p. 195.
10. Fildes 1968, p. 142.
11. Obituary, *Illustrated London News*, 11 October 1873, p. 350.
12. *Ibid.*
13. With thanks to Philip Ward Jackson for providing a copy of his unpublished lecture, 'Carlo Marochetti: Maintaining

Distinction in an International Sculpture Market', 1999.
14. Lizzie Darbyshire, '"The Studios of Celebrated Painters": A Series of Portraits by John Ballantyne RSA', *Apollo*, 147, May 1998, pp. 21–27, (p. 22).
15. A full list of the subjects painted is given in Darbyshire 1998.
16. 'A Brave Girl', in *The London Journal*, September 1876, p. 166, quoted in Nancy Rose Marshall and Malcolm Warner, *James Tissot: Victorian Life/Modern Love*, New Haven CT and London 1999, p. 133.
17. For a detailed discussion of the work of the St John's Wood Clique see *'And When Did You Last See Your Father?'*, exhib. cat., ed. Edward Harris and Frank Milner, Liverpool, Walker Art Gallery, 1993.
18. See Anthony Bailey, *Standing in the Sun: A Life of J.M.W. Turner*, London 1997, pp. 367–68.
19. Tom Pocock, *Chelsea Reach: The Brutal Friendship of Whistler and Greaves*, London 1970, p. 44.
20. Virginia Surtees (ed.), *Diary of Ford Madox Brown*, New Haven CT and London 1981, p. 144.
21. Henry Treffry Dunn, *Recollections of Dante Gabriel Rossetti & his Circle or Cheyne Walk Life*, ed. Rosalie Mander, Westerham 1984, p. 24.
22. Fiona McCarthy, *William Morris*, London 1994, p. 122, ascribed to Holbrook Jackson, *The Eighteen Nineties*, London 1913.
23. Dunn 1984, p. 18.
24. Tom Cross, *Artists and Bohemians: 100 Years with the Chelsea Arts Club*, London 1992, p. 29.
25. Hibbert and Weinreb 1983, p. 215.
26. E.R. Pennell and J. Pennell, *The Life of James McNeill Whistler*, London 1911, p. 250.
27. The story of how Godwin's design had to be prettified to satisfy the Metropolitan Board of Works is given in Mark Girouard, 'Chelsea's Bohemian Studio Houses: The Victorian Artists at Home, part 2', *Country Life*, CLII, 23 November 1972, pp. 1370–74.
28. Although the verdict was in Whistler's favour, the legal costs ruined him; he later took to wearing the farthing awarded him in damages on his watch chain.
29. G.P. Jacomb-Hood, *With Brush and Pencil*, New Haven CT and London 1925, p. 44.
30. Letter cited Roget 1891, II, p. 370.
31. Cross 1992, p. 7.
32. R. Brangwyn, *Brangwyn*, London 1978, pp. 32–34.
33. Giles Walkley, *Artists' Houses in London, 1764–1914*, Aldershot 1994, p. xxiv.
34. The word 'Bohemia' was first used to described the nomadic, creative lifestyle by Thackeray in *The Cornhill Magazine* (1861). Even then the description was retrospective, as he explained, "I have lost my way to Bohemia now" (OED).
35. Jacomb-Hood 1925.
36. See John Millner, *The Studios of Paris*, New Haven CT and London 1988.
37. Jacomb-Hood 1925, p. 68.

38. Anna Robins, 'Feuds and Factions at the New English Art Club', in *The New English Art Club Centenary Exhibition*, exhib. cat. by Anna Robins and Francis Farmar, London, Christie's, 1986, n.p.
39. George Clausen, 'The English School in Peril: A Reply', *The Magazine of Art*, 1888, p. 224, cited in *Impressionism in Britain*, exhib. cat. by K. McConkey, London, Barbican, 1995, p. 32.
40. McConkey 1995, p. 32.
41. Founder-members included Solomon J. Solomon (1860–1927), Philip Wilson Steer, Stanhope Forbes (1857–1947) and Henry Tuke (1858–1929).
42. George Bernard Shaw, *The World*, London 1886.
43. This painting is now lost.
44. *The Builder*, 14 April 1888.
45. Jacomb-Hood 1925, p. 79.
46. Arthur Ransome, *Bohemia in London* [1907], London 1984, p. 77.
47. *Westminster Gazette*, October 1901, quoted in Cross 1992, p. 21.
48. Louise Jopling (Mrs Jopling-Rowe), *Twenty Years of my Life, 1867–87*, London and New York 1925, pp. 6–7, 12.
49. Advertisement issued by Wheeler and Son, Chelsea Public Reference Library (Chelsea Misc. Vol. V, piece 750).
50. *Daily Telegraph*, 29 March 1920, n.p., cutting in Chelsea Public Reference Library (SB 1284).

Chapter 6

1. See Jane Beckett and Deborah Cherry, 'London', *The Edwardian Era*, exhib. cat., ed. J. Beckett and D. Cherry, London, Barbican, 1987, p. 36.
2. Wendy Baron, *Perfect Moderns: A History of the Camden Town Group*, Aldershot 2000, p. 15.
3. Wendy Baron, *The Camden Town Group*, London 1979, p. 3.
4. Baron 1979, p. 3.
5. William Rothenstein, *Men and Memories: Recollections of William Rothenstein, 1872–1900*, London 1931, p. 167.
6. From the conclusion to Sickert's preface to *A Collection of Paintings by London Impressionists*, exhib. cat., London, Goupil Gallery, December 1889, cited in *Sickert Paintings*, exhib. cat., ed. W. Baron and R. Shone, London, Royal Academy of Arts, 1992, pp. 58–59.
7. Tom Cross, *The Slade Tradition*, London 1971.
8. Baron 2000, p. 19.
9. Walter Sickert, in *The New Age*, VII, 26 May 1910, quoted in *Camden Town Recalled*, exhib. cat. by W. Baron, London, Fine Art Society, 1976, p. 5.
10. Quoted in Baron 2000, p. 24.
11. Sir Louis Ferguson, *Harold Gilman: An Appreciation*, London 1919, p. 19.
12. Quoted in Baron 2000, p. 35.
13. Baron 1979, p. 28.
14. The sixteen were: Walter Bayes (1869–1956), Robert Bevan (1865–1925), Malcolm Drummond (1880–1945), Harold Gilman (1876–1919), Charles Ginner (1878–1952),

Spencer Gore (1878–1914), Duncan Grant (1885–1978), J.D. Innes (1887–1914), Augustus John (1878–1961), Henry Lamb (1883–1960), Maxwell Gordon Lightfoot (1886–1911), Wyndham Lewis (1882–1957), James Manson (1879–1945), William Ratcliffe (1870–1958), Doman Turner (c. 1870–1938) and Walter Sickert (1860–1942).
15. Jacques-Émile Blanche, *Portraits of a Lifetime*, London 1937, p. 301.
16. Walter Sickert, 'Idealism', *The Art News*, 12 May 1910, p. 217.
17. Walter Sickert, 'The Language of Art', *The New Age*, VII, 28 July 1910, pp. 300–01.
18. *The Sunday Times*, 18 June 1911.
19. Roger Fry, letter to Lady Fry, 14 June 1913, in Denys Sutton (ed.), *The Letters of Roger Fry*, London 1972, pp. 370–71.
20. John Skeaping, *Drawn from Life: An Autobiography*, London 1977, p. 86. He is describing the late 1920s.
21. See Tim Craven, *The Euston Road School*, exhib. cat., Southampton 1999, and Jenny Pery, *The Affectionate Eye: The Life of Claude Rogers*, Bristol 1995, for good general accounts of the School.
22. Pery 1995, p. 93.

Chapter 7

1. Pery 1995, p. 43, quoting Claude Rogers's papers at the Tate Archive.
2. Skeaping 1977, pp. 74–81.
3. Clive Bell, writing early in 1920, quoted in Charles Harrison, *English Art and Modernism, 1900–1939*, New Haven CT and London 1981; edn used London 1994, p. 146.
4. As quoted in Sarah-Jane Checkland, *Ben Nicholson: The Vicious Circles of his Life and Art*, London 2000, p. 133.
5. Paul Nash, 'The Artist in the House', *The Listener*, 16 March 1932.
6. Charlotte Perriand, quoted in Alan Powers, *2 Willow Road*, London 1996, p. 6.
7. Roland Penrose, 'Hampstead and Surrealism in the Thirties', in *Hampstead in the Thirties: A Committed Decade*, exhib. cat., ed. M. Collins, London, Camden Arts Centre, 1974, p. 37.
8. Penrose, in Collins 1974, pp. 37–38.
9. Daniel Farson, *Never a Normal Man*, London 1977, p. 125.
10. Tony Gould, *Inside Outsider: The Life and Times of Colin MacInnes*, London 1986, p. 110.
11. George Melly, 'Muriel and the Artists', in *Artists of the Colony Room Club: A Tribute to Muriel Belcher*, exhib. cat., ed. Michael Parkin, London, Parkin Gallery, 1982, n.p.
12. Melly 1982, n.p.
13. Patrick Heron, 'The School of London', *New Statesman and Nation*, 9 April 1949, p. 351.
14. Malcolm Yorke, *The Spirit of Place: Nine Neo-Romantic Artists and their Times*, London 1988, p. 157.
15. Gallery One press-cuttings book, Tate Archive (TGA 8714/7): cutting from the *New Statesman and Nation*, 10 August 1957.
16. Gallery One press-cuttings book. The original Levin article is from *The Spectator*,

5 July 1957.
17. Margaret Garlake, *New Art New World: British Art in Postwar Society*, New Haven CT and London 1998, p. 21.
18. D. Morland, unpublished memoir quoted in D. Robbins (ed.), *The Independent Group: Postwar Britain and the Aesthetics of Plenty*, Cambridge MA 1990, p. 33.
19. Diane Kirkpatrick, *Eduardo Paolozzi*, London 1970, p. 27, quoted in Fiona Pearson, *Paolozzi*, Edinburgh 1999, p. 35.
20. Phillip Oakes *At the Jazz Band Ball: A Memory of the 1950s*, London 1983, p. 177.
21. Farson 1977, p. 129.
22. From a conversation between Tony Gould and Bernard and Erica Kops, 16 October 1979, quoted in Gould 1986, p. 139.

Chapter 8

1. Peter Marcan, *Artists and the East End: A Survey and Catalogue*, London 1986.
2. Nigel Henderson, 'Life of the Street', in *Photographs of Bethnal Green, 1949–52*, exhib. cat. by N. Henderson, Nottingham, Midland Group, 1978, p. 55.
3. Theo Crosby, *Urban Structuring: Studies of Alison and Peter Smithson*, London 1967; includes some of Henderson's photographs.
4. Garlake 1998, p. 28.
5. Garlake 1998, p. 80.
6. Shirley Pountney, 'Visual Arts in Tower Hamlets', *East London Papers*, University House, London, XII, no. 1, Summer 1969, p. 59.
7. David Mellor, *The Sixties Art Scene in London*, London 1996, p. 54.
8. Mellor 1966, pp. 191–205.
9. Paul Moorhouse, *Albert Irvin: Life to Painting*, London 1998, p. 70.
10. Moorhouse 1992, p. 87, and personal comment from the artist, 8 December 2000. Irvin likens the process of making a painting to walking through city streets, both generating a sense of discovery, an awareness of changing space and colours, and the subtle effects of evocations and associations.
11. David Panton, 'From Rags to Riches: A History and Appraisal of the Phenomenal Growth of the Artists' Community in East London', lecture at *London: Arts Mecca* conference, Museum of London, 21 June 1996.
12. This and subsequent details about Acme from their newsletters, 1972–2000.
13. The building was 'discovered' by the artist Richard Deacon, then working as Acme's housing manager.
14. *The Big Show*, Tower Hamlets Arts Project exhib. cat., London, Whitechapel Art Gallery, 12 November – 13 December 1976. See in particular a feature on murals by Dan Jones and Anne-Margret, pp. 16–17, listing the murals in the borough.
15. <www.uel.ac.uk/aavaa/>.
16. Multicultural Arts Consortium information sheet, 1977.
17. James Lingwood (ed.), *House*, London 1995.
18. Matthew Collings, *Blimey! From Bohemia to Britpop: The London Artworld*

from Francis Bacon to Damien Hirst, London 1997; edn used London 1998, p. 23.
19. Collings 1998, p. 22.
20. 'Interview with Alice Sharp of SPACE Studios', 12 March 1990, <http://vads.ahds.ac.uk/vads_catalogue/oep/spacestudios/interview.html>.
21. <http://www.biblio.co.uk/e-tour/joshua.html>. See also Jeremy Cooper, *no FuN without U: the art of Factual Nonsense*, London 2000.
22. *Daily Telegraph*, 20 July 1996.
23. Jane Sillis, personal comment, 7 October 2000.
24. David Panton, personal comment, September 2000.
25. See, for example, Pedro Lorente (ed.), *The Role of Museums and the Arts in the Urban Regeneration of Liverpool*, Leicester 1996.
26. Andrew Attfield, 'The Making of Hoxton's Cultural Quarter and its Impact on Urban Regeneration in Hackney', *Rising East: The Journal of East London Studies*, I, no. 3, pp. 133–55.
27. Jonathan Harvey, personal comment, December 2000; as are the details about Acme in the following paragraph.
28. S. Honey, P. Heron and C. Jackson, 'Career Paths of Visual Artists', Arts Council Research Report, 11, London 1997.
29. Acme brochure, *The Fire Station Project: Programme 1 (1997–2001)*, London 2000.
30. See <www.a13artscape.org.uk>.
31. A phrase included in the *Evening Standard*, 23 November 2000, as part of the listing entry for an exhibition by Czech artist Frantisek Skala.
32. David Panton, personal comment, 1 June 2000.

Selected Reading

'And When Did You Last See Your Father?', exhib. cat., ed. Edward Morris and Frank Milner, Liverpool, Walker Art Gallery, 1993

Wendy Baron, *Perfect Moderns: A History of the Camden Town Group*, Aldershot 2000

R.B. Beckett (ed.), *John Constable's Correspondence*, 6 vols., Ipswich 1962–68

Louisa Buck, *Moving Targets 2: A User's Guide to British Art Now*, London 2000

Sarah-Jane Checkland, *Ben Nicholson: The Vicious Circles of his Life and Art*, London 2000

Matthew Collings, *Blimey! From Bohemia to Britpop: The London Artworld from Francis Bacon to Damien Hirst*, London 1997

Constable's Clouds: Paintings and Cloud Studies by John Constable, exhib. cat., ed. E. Morris, Edinburgh, National Gallery of Scotland, 2000

Jeremy Cooper, *no FuN without U: the art of Factual Nonsense*, London 2000

Edward Croft Murray, *Decorative Painting in England, 1538–1837*, London 1962

Tom Cross, *Artists and Bohemians: 100 Years with the Chelsea Arts Club*, London 1992

Caroline Dakers, *The Holland Park Circle*, New Haven CT and London 1999

Lizzie Darbyshire, '"The Studios of Celebrated Painters": A Series of Portraits by John Ballantyne RSA', *Apollo*, 147, May 1998, pp. 21–27

Henry Treffry Dunn, *Recollections of Dante Gabriel Rossetti and his Circle or Cheyne Walk Life*, ed. Rosalie Mander, Westerham 1984

Mary Edmonds, 'Limners and Picturemakers: New Light on the Lives of Miniaturists and Large-scale Portrait-painters Working in London in the Sixteenth and Seventeenth Centuries', *Walpole Society*, XLVII, 1978–80

Daniel Farson, *The Gilded Gutter Life of Francis Bacon*, London 1977

Celina Fox (ed.), *London World City*, New Haven CT and London 1992

W.P. Frith, *My Autobiography and Reminiscences*, 3 vols., London 1887–91

Mireille Galinou and John Hayes, *London in Paint*, London 1996

Margaret Garlake, *New Art New World: British Art in Postwar Society*, New Haven CT and London 1998

Kenneth Garlick and Angus MacIntryre (eds.), *The Diary of Joseph Farington*, 17 vols., New Haven CT and London 1978–98

Mark Girouard, 'Coffee at Slaughter's?', in *Town and Country*, New Haven CT and London 1982

Tony Gould, *Inside Outsider: The Life and Times of Colin MacInnes*, London 1986

Hampstead in the Thirties: A Committed Decade, exhib. cat., ed. Michael Collins, London, Camden Arts Centre, 1974

D. Howarth (ed.), *Art and Patronage in the Caroline Courts*, Cambridge 1993

G.P. Jacomb-Hood, *With Brush and Pencil*, New Haven CT and London 1925

James Lingwood (ed.), *House*, London 1995

Manners and Morals: Hogarth and British Painting, 1700–1760, exhib. cat., ed. Elizabeth Einberg, London, Tate Gallery, 1987

Peter Marcan, *Artists and the East End: A Survey and Catalogue*, London 1986

David Mellor, *The Sixties Art Scene in London*, London 1996

Paul Moorhouse, *Albert Irvin: Life to Painting*, London 1998

Lynda Morris and Robert Radford, *AIA: The Story of the Artists International Association*, Oxford 1983

Iain Pears, *The Discovery of Painting: The Growth of Interest in the Arts in England, 1680–1768*, New Haven CT and London 1988

Martin Postle and Ilaria Bignamini, *The Artist's Model: Its Role in British Art from Lely to Etty*, Nottingham 1991

Martin Postle and William Vaughan, *The Artist's Model: From Etty to Spencer*, London 1999

Alan Powers, *2 Willow Road*, London 1996

Anna Robins, 'Feuds and Factions at the New English Art Club', in *The New English Art Club Centenary Exhibition*, exhib. cat. by Anna Robins and Francis Farmar, London, Christie's, 1986

D Robbins (ed.), *The Independent Group: Postwar Britain and the Aesthetics of Plenty*, Cambridge, MA 1990

John Thomas Smith, *Nollekens and his Times*, 2 vols., London 1829

Jane Turner (ed.), *The Dictionary of Art*, 34 vols., London 1996

George Vertue, 'Notebooks', *Walpole Society*, XVIII, XX, XXII, XXIV, XXVI, XXX, 1929–52

Giles Walkley, *Artists' Houses in London, 1764–1914*, Aldershot 1994

W.T. Whitley, *Artists and their Friends, 1700–99*, 2 vols., London 1928

Malcolm Yorke, *The Spirit of Place: Nine Neo-Romantic Artists and their Times*, London 1988

Index

Luton Sixth Form College
Learning Resources Centre